D0883316

KLEE

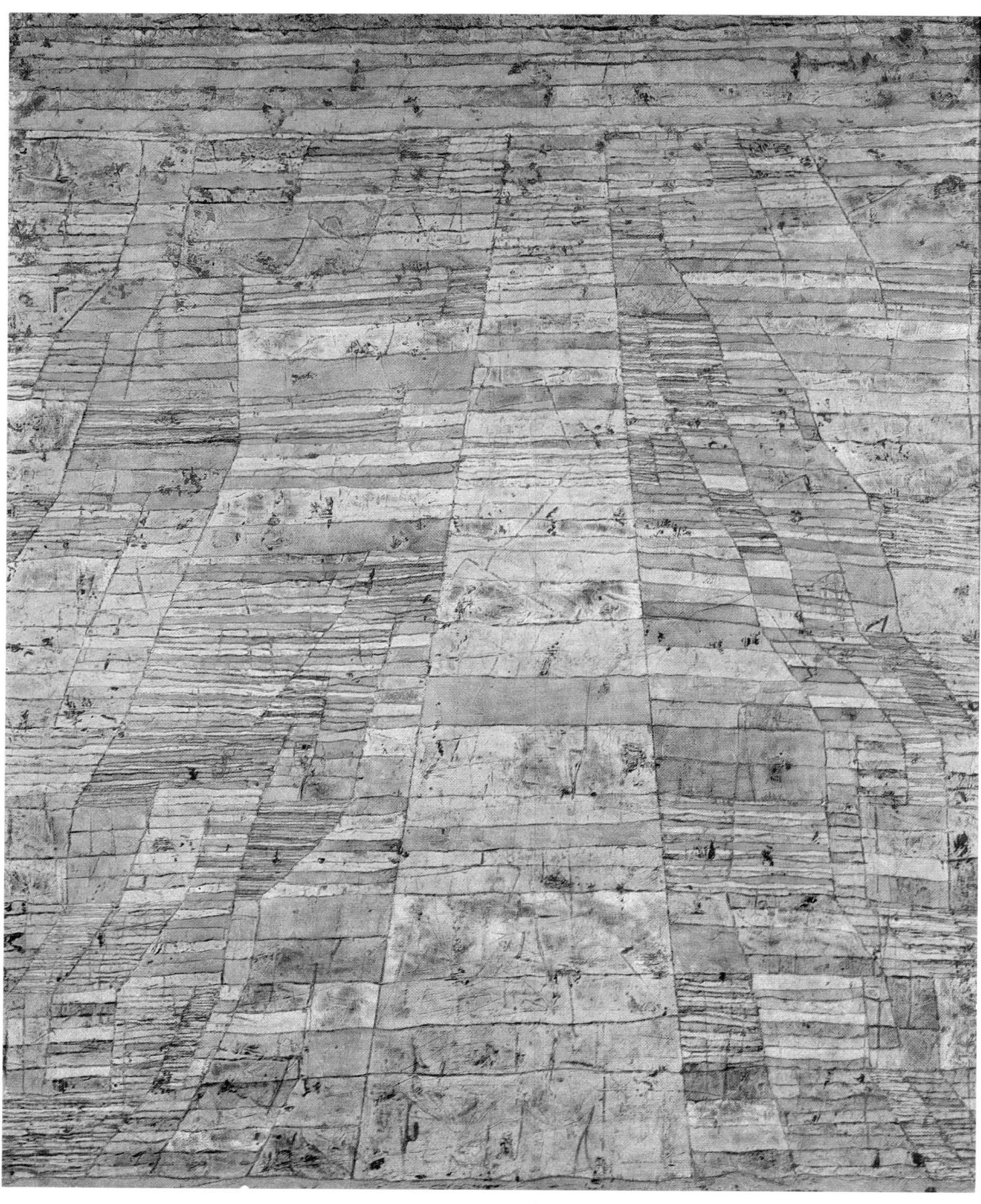

LIFT PICTURE FOR TITLE AND COMMENTARY

P A U L

K L E E

TEXT BY

WILL GROHMANN

THE LIBRARY OF GREAT PAINTERS

HARRY N. ABRAMS, INC. *Publishers* NEW YORK

Translated by Norbert Guterman

MILTON S. FOX, *Editor-in-Chief*

CONTENTS

KLEE

What is really essential, really productive is the Way—after all, Becoming is superior to Being.
—Klee, DIARY (1914), No. 928

A quarter of a century after his death, Klee is still discussed with deep respect, even by young painters. It is as though he were still among us, to be consulted on every problem of life and art. Not just of art: Although he rarely pronounced on the larger issues of life, or made excursions into metaphysics, his work has remained a source of wisdom.

When the occasion to explain a work of art arose, Klee's vocabulary tended toward the strictly technical. In his lectures and essays, and in his teaching at the Bauhaus, what stands out is his preoccupation with the pictorial means. Barely a tenth of his words reflect concern with wider human significance. Klee believed that on this score the viewer himself has something to say. Yet in discussing problems of form, Klee from time to time seems mysteriously impelled to touch upon the mystery of the creation—"Genesis"—the primal source of all Becoming where "the secret key to all things is kept."

Klee possessed a high degree of insight into the world and himself. After his soldier-comrade Franz Marc died in World War I, he reflected at length on what his friend's life had meant, and also on the meaning of his own. With rare frankness, he confessed that Marc had been the more human of the two, the warmer, the more down-to-earth, the less given to abstractions. Klee felt himself to be, in comparison, a neutral crea-

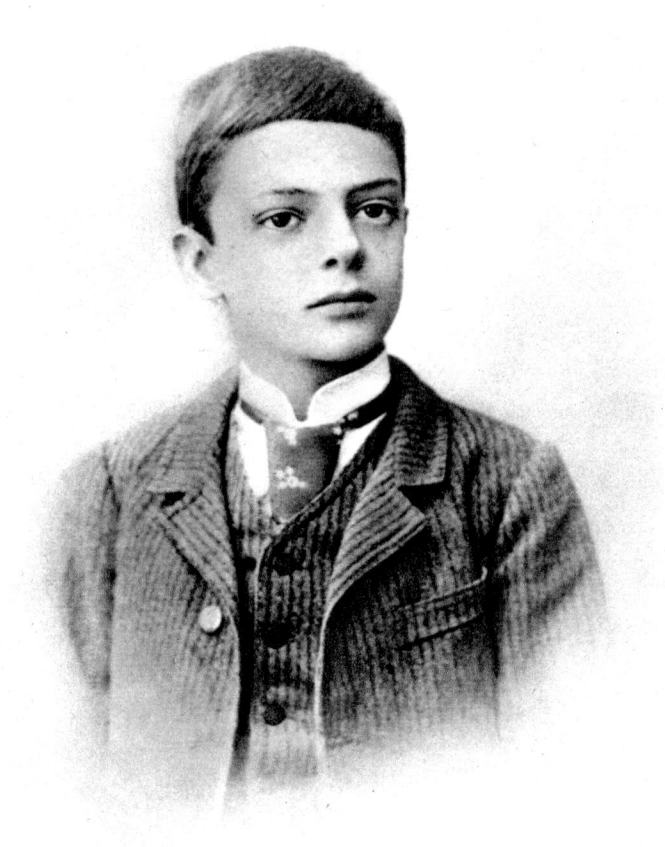

1. Paul Klee, 1892

Klee proceeded as though no painter had existed before him, as though it were up to him to invent the art, starting from scratch. At the same time, he does not leave out nature. What he sees in it, however, is merely a suggestion, a possibility—nothing more. "When you set out, the truth you are looking for lies hidden at the bottom of things" (Diary, 1081).

From the start of his career, as an art student in Munich and during his years in Bern from 1902 to 1906, Klee made one fundamental discovery after another. "The main thing now is, not to paint precociously things I am not ready to paint, but to be a human being or (at least) to become one. . . . I shall be asked to do things any skillful beginner can give the illusion of doing. My constant hope is that I will be inhibited less by lack of ability than by the authenticity of my purpose" (Diary, 411/12). At bottom, Klee's entire development was present from the outset. Development, however, takes time, and Klee was well aware of this—he advanced step by step, unhurriedly, as though he sensed the great responsibilities ahead and the enormous labors he would have to perform. When he died at the age of sixty, he left some nine thousand works.

Music and poetry, too, were always close to Klee. While still a student he played in the municipal or-

ture, someone to whom the earth was remoter than the universe. Restless Faustian striving was not for him. He saw everything from some far-off corner of creation where, as he put it, he discovered pre-existing formulas of man, animal, plant, rock, and the elements. To him, he tells us, art is a metaphor of the creation (Diary, 1008). Has there ever been a painter more apt at analyzing himself and his friends? Who else could have said, speaking of himself: "Here below, I am not to be grasped at all. I am just as much at home among the dead or the unborn. I am closer to the Creation than most people are, yet still far from close enough" (jotting of 1916).

When he painted, as when he wrote, Klee was a philosopher, though this did not prevent him from taking his point of departure from what he called "the smallest things," that is, purely formal motives. From tiny elements, he said, more is built up through repetition than is achieved by sudden bursts of poetic imagination. Poetry can be a result, but never a cause.

2. Paul Klee, 1911

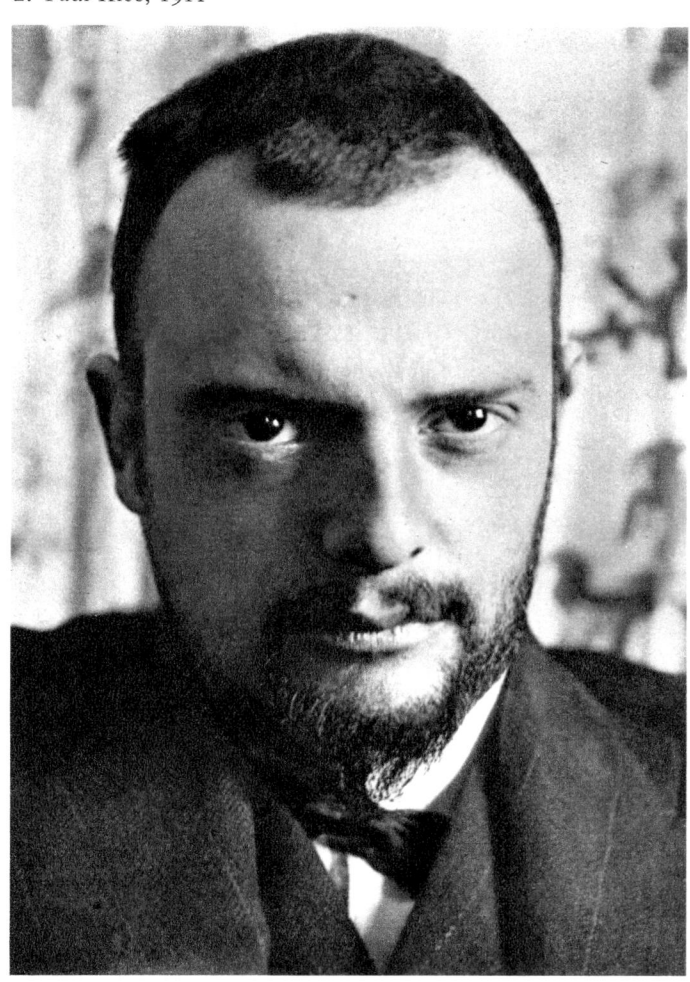

chestra in Bern, having taken lessons for several years. For a long time he hesitated between music and painting as a career, the determining factor in his case being the consideration that "there is more to be done, more to be caught up with" in the art he finally settled on. Most of his poems were written between 1900 and 1908. The thousands of titles Klee invented for his pictures are a direct outgrowth of this poetry, much more than mere designations or literary glosses. We can speak of separate talents merging, as in connection with some of his pictures we can speak of a fusion with music *(Fugue in Red*, 1921).

Klee made use of musical theory in his painting, to stimulate himself and as a means of control. He mastered strict polyphony as well as the sonata form. Until his last illness, he played the violin for an hour every morning before he got down to work. His father, Hans Klee, was a music teacher in Bern, and a paternal great-grandfather had been organist in the town where J. S. Bach was born. Klee's father was also born there. His mother, a native of Basel, had studied at the Stuttgart Conservatory. On the maternal side, according to family tradition, there were ties with southern France and North Africa, and this would throw some light on his physical appearance and fondness for the Near East. He was to feel perfectly at home in Tunisia and Egypt.

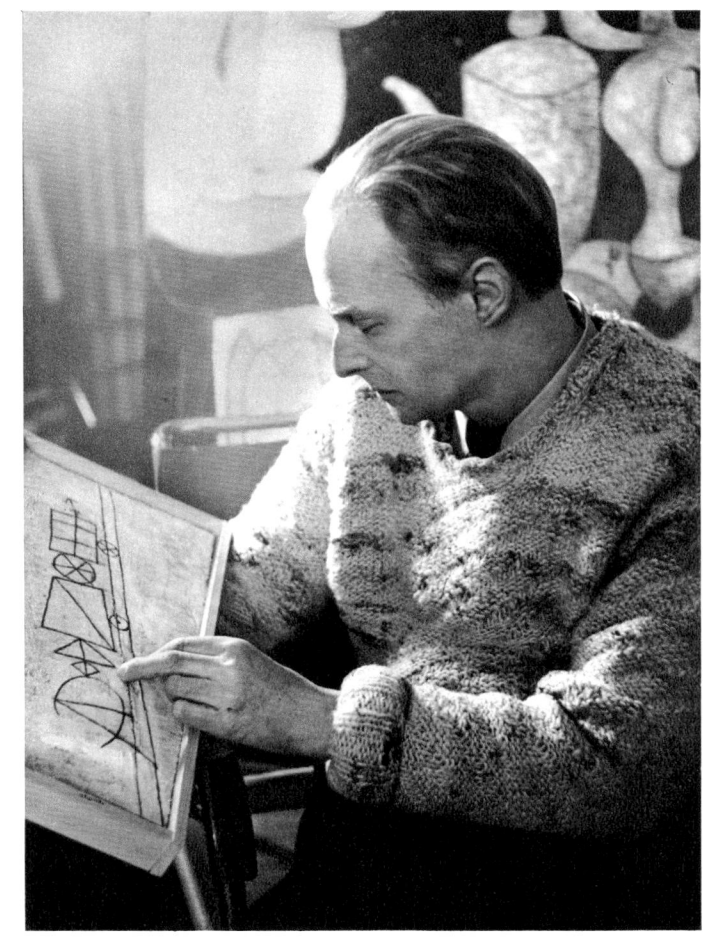

3. Paul Klee, 1940

4. Studio at Weimar, 1925

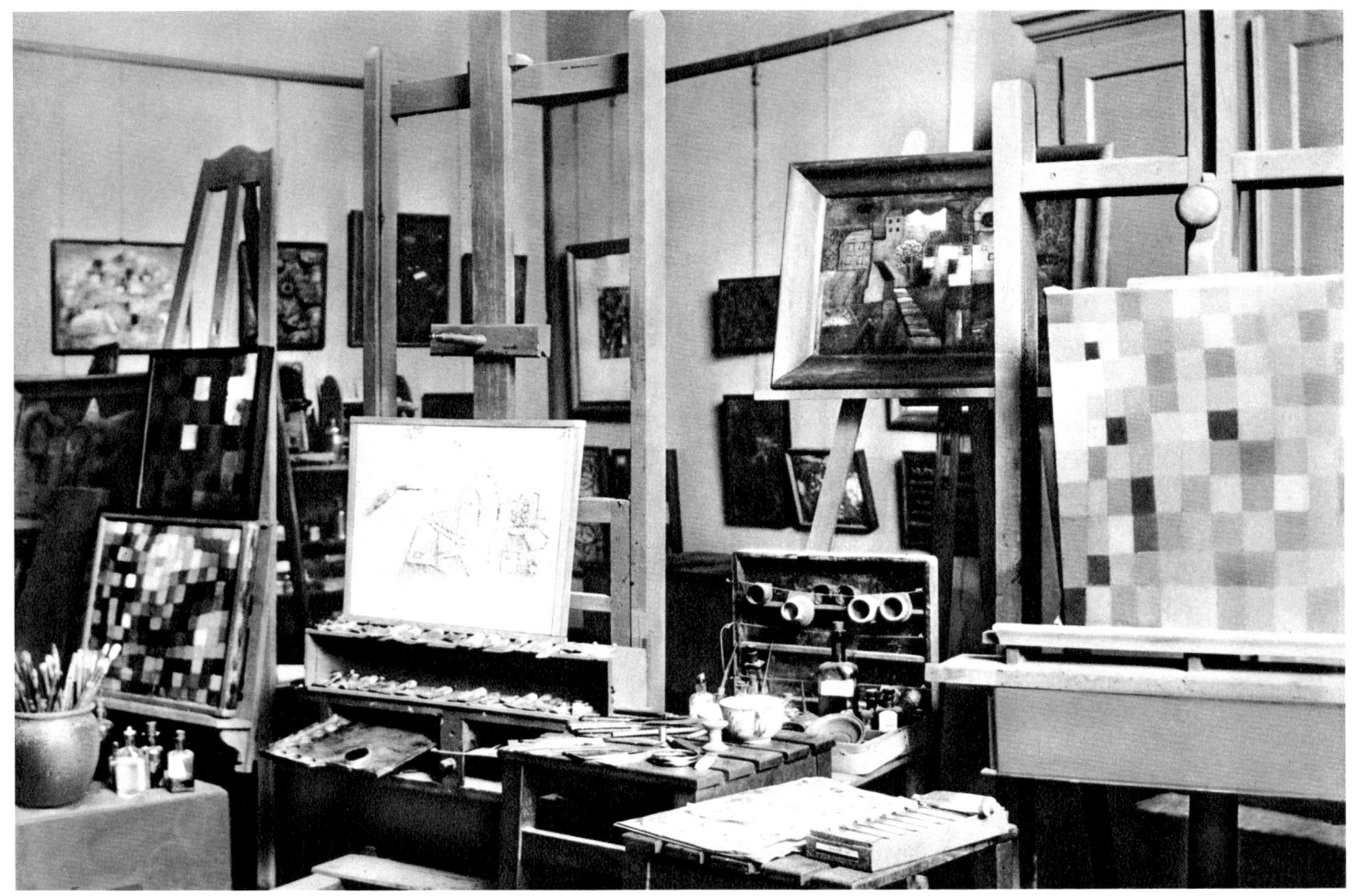

5. THE FATHER: TWO NUDES. 1908. Tusche, pen, and brush, $6^{1}/_{4} \times 2^{3}/_{8}''$. *The Pasadena Art Institute, California*

Pre-Bauhaus Period

Klee's life is well known, at least in outline. So many books and essays have been published, and so many exhibitions of his works have been held since his death that it is enough to recall the facts most relevant to his artistic development. The latter casts more light on his life than his life does on his art.

Klee grew up in Bern, where he obtained his bachelor's degree in 1898. The world was open to him now, and he decided to become a painter. He preferred to study art in Munich, rather than Paris, because he felt closer to German intellectual life. In 1900 he studied

under Franz Stuck, and his work was just as academic as that of his fellow students. He went to concerts and operas a good deal—Richard Wagner, Richard Strauss, and Mozart (of whom he never tired). He did not go to many art shows, but he admired the *Simplizissimus*, founded in Munich in 1896. He wrote detailed letters home, particularly about his musical impressions. In the summer of 1901 he went to Italy with his friend Hermann Haller, who later became a sculptor, and stayed there seven months. The maturity of his judgment is astonishing—he admires Leonardo, the Sistine Chapel, and the Pinturicchio frescoes in the Vatican, but it is Botticelli's *Birth of Venus* he regards as "the most accomplished painting." The *Laocoön*, he says, is only technically a great achievement (letter to his parents, December 4, 1901). Summing up: "Imitate nothing." He did not do much work, preferring for the time being to come to terms with life.

After returning from Italy, Klee lived and worked at home in Bern until his marriage to the pianist Lily Stumpf, which took place in Munich in 1906. We are well informed about this period, thanks to his detailed letters to Lily, in which he discusses his plans, his work, and the books he is reading. The range of his reading is rather awe-inspiring—the Bible, the Greek tragic authors, Aristophanes, Cervantes, Calderón, Voltaire's *Candide*, E. T. A. Hoffmann, Gogol, Dostoevsky, Strindberg, Wedekind; he read Goethe's *Elective*

6. SELF-PORTRAIT. DRAWING FOR A WOODCUT. 1909 Tusche, $5^{1}/_{8} \times 5^{3}/_{4}''$. *Collection Felix Klee, Bern*

7. YOUNG MAN RESTING. 1911. Tusche, $5\,^1/_2 \times 7\,^1/_8''$. *Collection Rolf Bürgi, Bern*

Affinities three times in rapid succession. A fondness for the grotesque and fantastic and for the nocturnal aspects of nature makes itself felt in his reading, as well as in his preferences among the painter-engravers he saw on occasional visits to public collections: William Blake, Goya, and Beardsley.

Klee worked hard at Bern. Between 1903 and 1905 he made fifteen etchings—his first works done on his own. Justly proud of them, he asked Lily to show them to his former teacher, Stuck, with a view to exhibition. In 1906 ten of them were actually hung at the Munich "Secession." Klee refers to all of them as inventions, although only seven carry the title "Invention." He superscribed and commented on some of the etchings on the plate; others he explained in his *Diary* or in his correspondence. Concerning *Virgin in a Tree* (fig. 53), he wrote Lily in 1903: "It may suggest something true enough: that enforced virginity, so highly praised, is good for nothing." He made three versions of *Comedian* (fig. 52), giving the mask a tragicomic expression. One of the most intense engravings is *Perseus: Wit Has Conquered Suffering*. He comments on it in his *Diary*

(582): "The event is physiognomic, it's all in the features of the man whose face mirrors the action. Laughter is mingling with the underlying traces of pain, and gains the upper hand. From this point on, the unmixed suffering in the Gorgon head on one side is carried *ad absurdum*. This face has no nobility, the skull of the snake adorning it is stripped to ridiculous remnants." Klee similarly commented on *Woman and Animal*, *Hero with a Wing*, and *Aged Phoenix*. A tendency to pessimism and satire is unmistakable. Early in 1902 he wrote his father: "In order not to be laughed at, one gives the people something to laugh about, if possible their own image." Elsewhere he refers to Gogol's "world of visible laughter and invisible tears." Klee turns his suffering into song, but the melody is full of doubt and despair.

What might be criticized in the engravings, Klee formulated himself in a letter to Lily (June 12, 1906). He finds that they are worked out plastically, and at the same time are interpretable epigrammatically, but he intends in the future to separate art from graphics and to develop each of the two domains for itself.

8. SPECTER OF A GENIUS. 1922. Oil and watercolor, 20 1/2 × 13 3/4″. *Private collection, Krefeld*

sought by collectors, but that was six years later. Klee's glass paintings are humorous rather than bitter, though satire is not entirely absent, and they are somewhat closer to nature than his drawings and watercolors of the same period. These last are often Impressionistic in character. Those done in black-and-white are close to his black-and-white watercolors. Before applying color, he experimented with the tonalities, "the weights," as he was to call them later. The way the effects come into being led him to reflect on the role of time in art, and it became ever clearer to him that painting is temporal just as music is spatial. The colorful *Garden Scene* (1905) comes close to Matisse, the black-and-white *Street with Carriage* (1907, fig. 16), which limits itself to tonal differentiations, could have been painted by a Fauve.

In 1906 Klee was back in Munich. He was glad that his marriage to Lily had enabled him to move there. Bern had become too small for him. Although he could scarcely count on selling his work as yet, he was confident, because Lily was able to contribute substantially to their household expenses by giving music lessons. Here in Munich there was a concert and opera

"And so my etchings have the defect of all youthful works, namely, they try to do too much." We would say that idea and form are not yet congruent, that the engravings are too allegorical.

Klee now concentrated on purely pictorial problems, and experimented with an unfashionable technique, painting on glass. He produced twenty-six drawings and watercolors on glass at Bern in 1905 and 1906; others followed in Munich between 1907 and 1917. He liked the technique, the indirect, unforeseen effects obtained by incision on the black ground or by the application of pigment. He may have seen eighteenth- and nineteenth-century paintings on glass at Bern; in Munich, during the Blaue Reiter period, they were

9. LOST IN THOUGHT. 1919. Lithograph, 10 1/2 × 7 1/8″. *Collection Norbert Schimmel, Great Neck, New York*

16

season, and he made the most of the opportunity. He saw paintings by Vincent van Gogh and Hans von Marées, Cézanne, and Matisse. Here he found congenial minds. In 1911 he met Kandinsky, Jawlensky, Marc, Macke, Kubin, and Campendonc; in 1912 he met the poets Rilke and Carossa, the art historian Meier-Graefe, and the art dealers Thannhauser and Walden. In 1912 he was represented at the second Blaue Reiter exhibition, and in 1913 at the First German Herbst-salon organized by *Der Sturm* in Berlin. He sold some of his works, and in 1914 he went to Tunisia with Macke and Moilliet, a friend of his youth. There he "discovered" color: "Color and I are one." This trip marks the first high point in his career; the water-colors he executed upon his return are the key achieve-ment of the years prior to his being called up in World War I. With these watercolors he became a member of the modern movement in European art. A visit to Delaunay during his second trip to Paris in 1912 further helped him find his way and oriented him toward light,

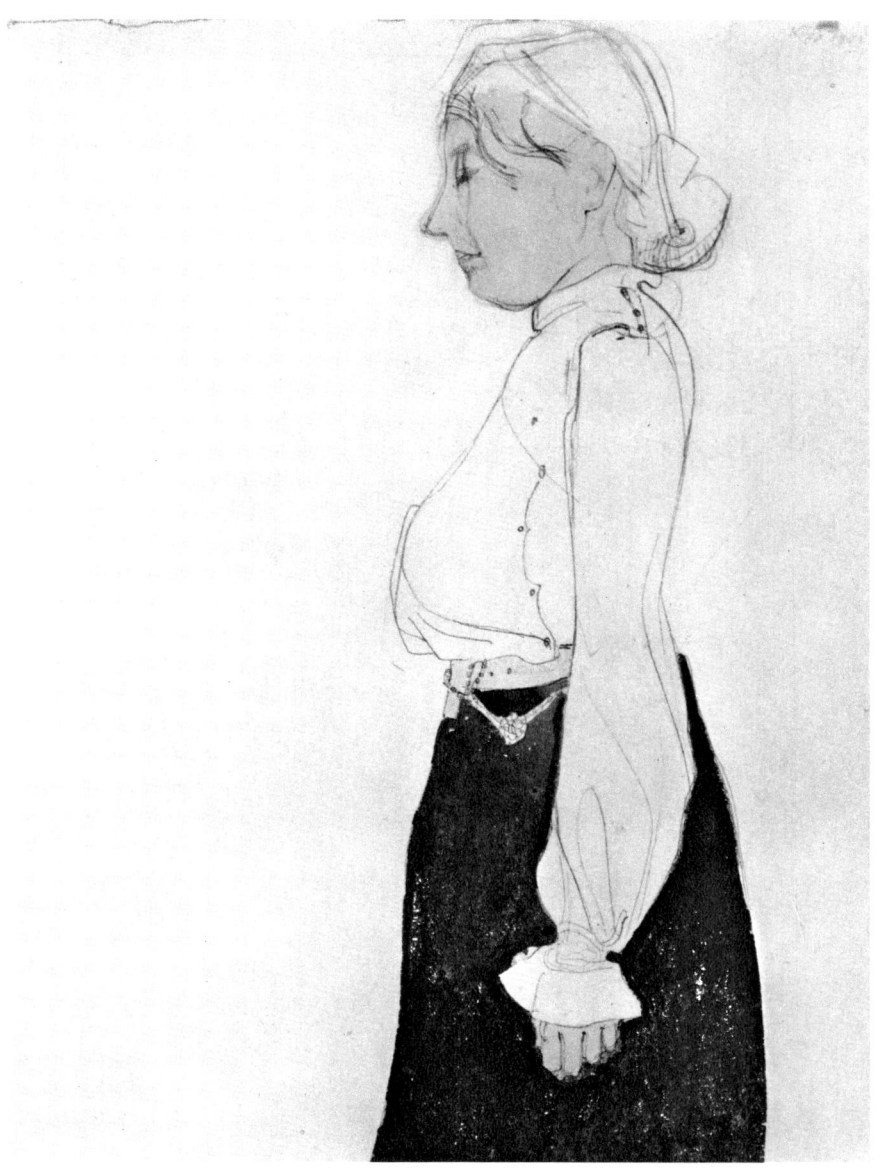

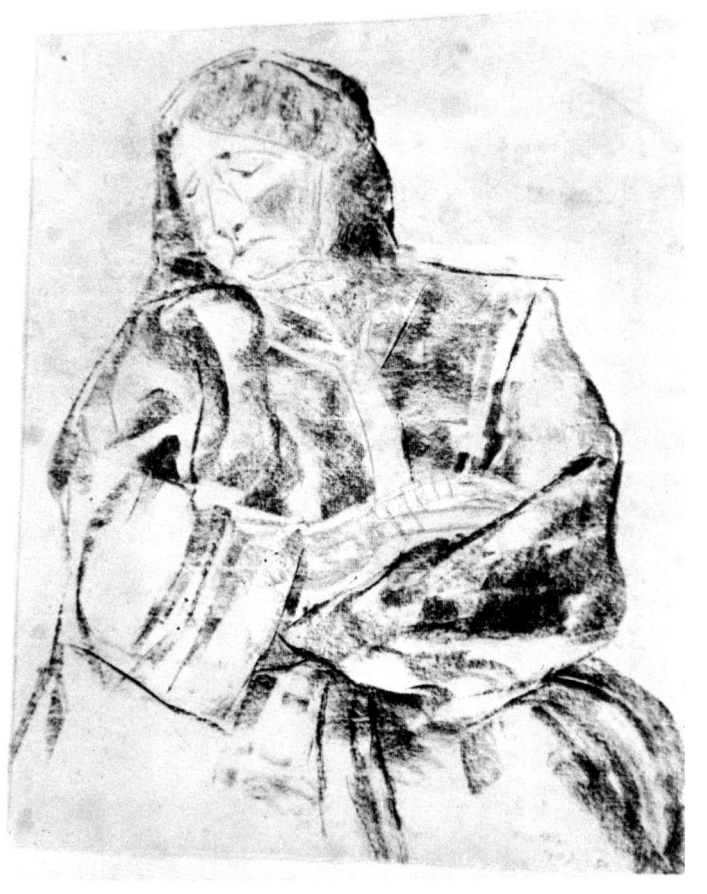

color, movement, and time. He translated an essay by Delaunay for *Der Sturm*, and referred to him as one of the most brilliant contemporary artists. He also received valuable pointers from Kandinsky, whose courage acted as a spur to his own, as Klee was to acknowledge many years later.

We have so far covered a good portion of Klee's life, though leaving out of account his artistic develop-ment. In the years between moving to Munich and the trip to Tunisia and Kairouan, Klee produced relatively few works, but these were to serve as the foundation for his development after the war. Judging from the catalogue he began keeping in 1911, his output in-creased during these years, from 33 works in 1906 to 220 in 1914. Whereas in 1910 he executed 90 drawings as against 21 watercolors, in 1914 he executed 92 draw-

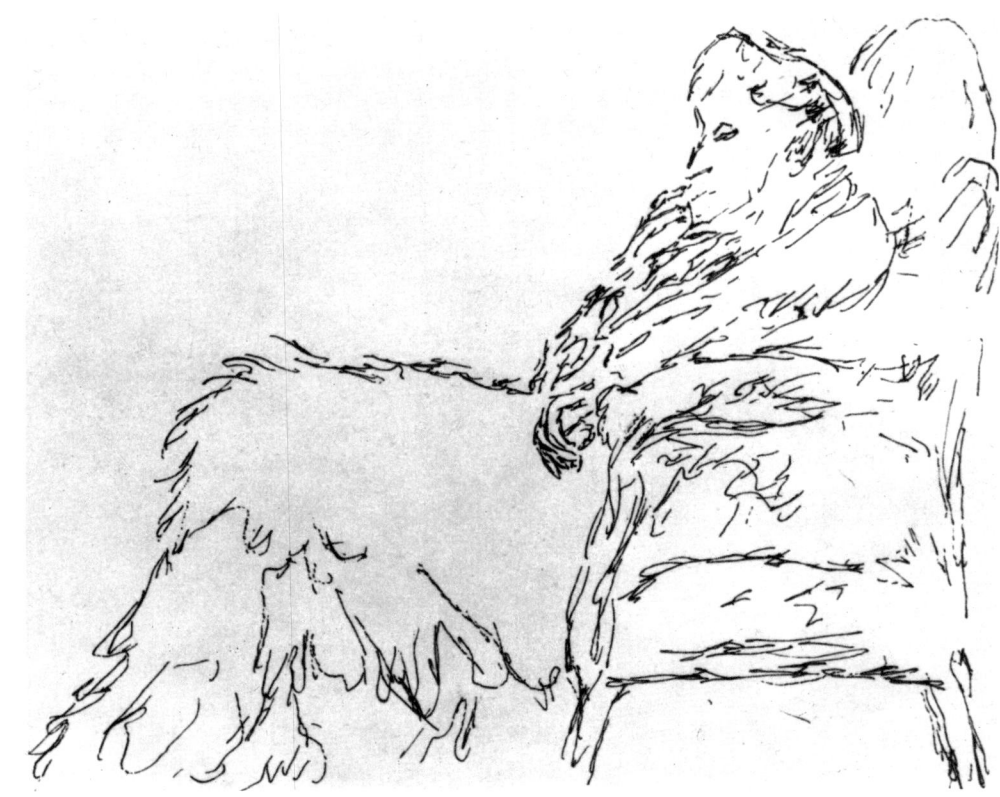

12. SICK WOMAN IN ARMCHAIR (Paul
 Klee's Mother). 1909. Pen, 7 × 8".
 Collection Felix Klee, Bern

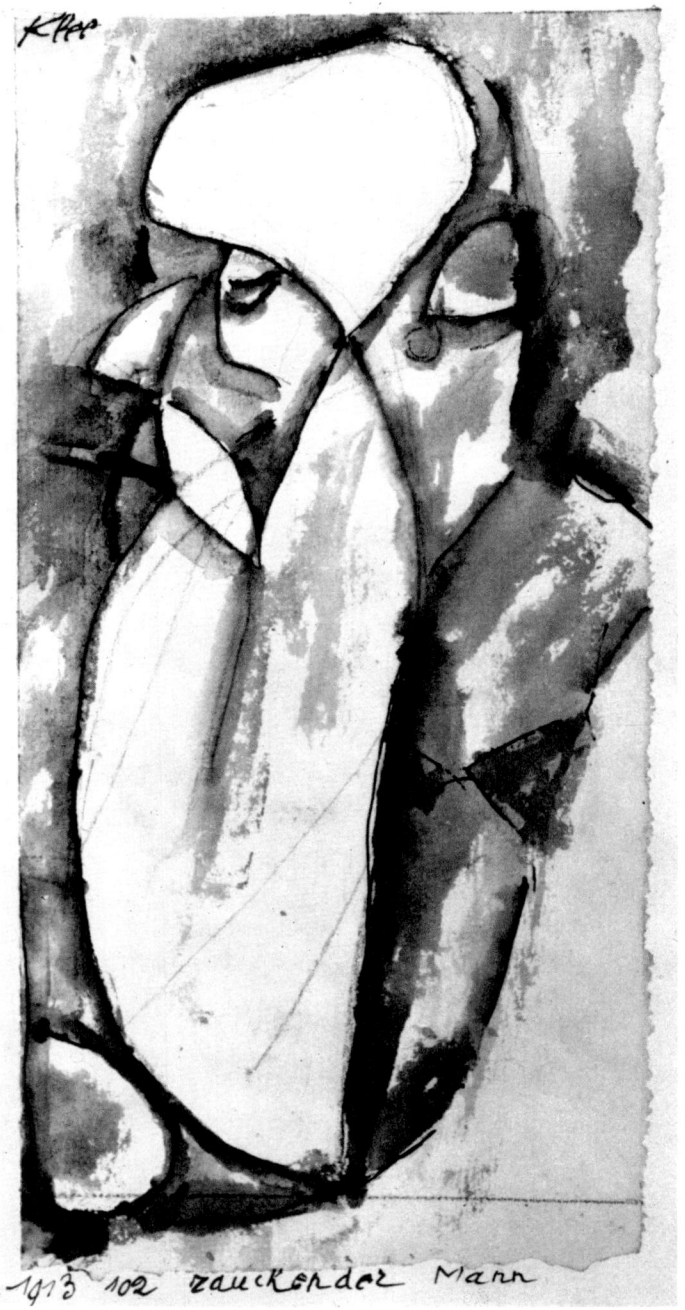

ings and 111 watercolors (including black-and-white watercolors). In Munich and during holidays in Bern and the country around it, he produced many landscape drawings. In these he worked "pictorially, from nature," but "the pure discipline of the means" became more and more important to him. With his drawings for Voltaire's *Candide* (fig. 55), begun in 1911, he attained a level of accomplishment that his friends—and for some time only his friends—recognized as high. Franz Marc offered them to the publisher Piper, and Hans Arp to the Weisse Bücher publishing house, but they were not published until 1920, by Kurt Wolff in Munich.

The advance toward color began in Munich with the paintings on glass and the black-and-white watercolors. From viewing line as "an independent pictorial element" he moved steadily in the direction of a "handwritten illustration style" and "psychic improvisation." On the way toward line, he saw works by Van Gogh and James Ensor at exhibitions in 1908; on the way toward color, he saw some Cézannes in 1909. Klee was a sensitive but at the same time a critical viewer. When he took over something, he did it in his own way. Similarly, he speaks less of Nature than of his

13. MAN SMOKING (Paul Klee's Father). 1913
 Tusche, pen, and brush, $8^3/_4 × 4''$. *Collection Felix Klee, Bern*

own nature. During these years he moved in both directions: "catching up" with Impressionism in certain of his drawings, while in others looking far ahead (e.g., *A Clearing in the Forest*, 1910, fig. 57). Some are even "constructed." The twenty-six drawings for *Candide* represent his furthest advance, not because of their mixture of cheerfulness and pessimism, or because in them this best of all worlds is seen from its ridiculous side, but because the ghostlike figurines suggest action and time within a very sketchily indicated spatial context. He worked on these drawings so hard that subsequently he declined all offers to illustrate books (Chinese verses, for example, and poems by Theodor Däubler). He made one exception only—for Curt Corinth's *Potsdamer Platz* he made ten drawings, which appeared as photolithographs.

Time, "Genesis," were problems that also interested him in his black-and-white watercolors, as he applied the thinned pigment layer by layer, gradually building up depth. He modulated in gray tones as he was later to do in colors, and one day he stumbled on previously unknown light effects, on light capable of bending straight lines, of spreading out and producing entirely new distortions throughout the picture. *Child in Folding Chair* (his son Felix) of 1908, and *Man Smoking* (Klee's father) of 1913 may be mentioned in this context (figs. 13, 14).

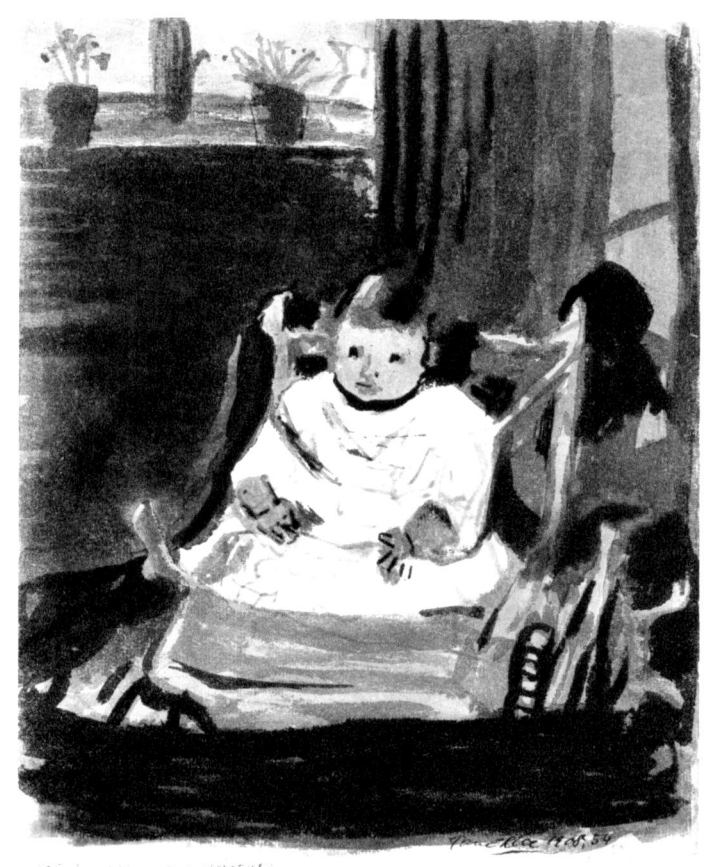

14. CHILD IN FOLDING CHAIR I (Felix Klee). 1908
Ink and wash, $12^{1}/_{4} \times 9^{1}/_{2}$". Collection Dr. F. Trüssel, Bern

15. Klee's handwriting. Page from diary for 1911–12

16. STREET WITH CARRIAGE. 1907
Wash drawing on glass, 13³/₄ × 9″
Collection Frank Laurens, Cincinnati, Ohio

There is something like a feeling of liberation in his exclamation: "This is what 'life's happiest moment' means: color and I are one. I am a painter" *(Diary, 926 o 1914)*. He had been waiting a long time for that moment. "Painting, dreaming, and at the same time, as a third element, myself caught up in both." Like Delaunay, Klee used color as a means to bring space, movement, time, and even objects into the picture. He stayed closer to Cézanne, however, in treating color modulations in honeycomblike single cells. The patterns so produced already anticipate the "magic squares" (1923), but these earlier works are still filled with poetic reminiscences and associations. Indeed, the associations grow more important every year. Out of a crystalline structure of forms and colors emerges a mosque, a palm tree, or even a camel *(Hammamet with Mosque*, page 75). Besides works of this type, Klee painted an *Hommage à Picasso* (1914, fig. 17), his salute to Cubism. He admired the Cubists for their "form thinking," though he did not follow them in their breakdown of the object to the point of total abstraction. He did, however, produce a completely nonobjective work from time to time.

While serving in the army in Bavaria, Klee drew

and made watercolors at his desk. He kept with him a box containing pens, pencils, and colors. After a largely nonobjective *Anatomy of Aphrodite* (1915, page 77), he executed *Dynamic of a Lech River Landscape* (1917) and an "ideographic" work like *Once Emerged from the Gray of Night* (1918). In 1919 there were also some small oils, *Full Moon* (page 83) and *Kiosk Architecture*. Before he left Munich he realized so conceptual a theme as *Greek and Barbarians* (1920). What holds together such varied themes is rigorous adherence to pictorial laws, as they were imposed on him by the logically developed elements of his art. The more cosmic pictures, like the *Lech River Landscape*, and the more philosophical ones, such as the *Aphrodite*, are no less built up, layer by layer, than a work like *Little Tree* (1919, page 81). During the war years Klee was entirely on his own and was obliged to clarify many matters he had hitherto left to instinct.

Even before he had taken off his uniform he wrote "Creative Credo," an essay which was published in 1920 in the symposium *Schöpferische Konfession*. Had it had a wider circulation, this essay might have become a sensation; it could not have failed to be influential, for here Klee lets the reader share in the birth and growth of his pictures, lets him in on the secret of

18. TRILLING NIGHTINGALE. 1917
 Watercolor, 9 × 5 ³/₄″. *Private collection, Germany*

17. HOMMAGE À PICASSO. 1914
 Oil, 15 × 11 ³/₄″. *Private collection, Basel*

their signs and symbols. "Art does not reproduce the visible, rather it makes visible. Formerly we used to represent things visible on earth, things we either liked to look at or would have liked to see. Today we reveal the reality that is behind visible things, thus expressing the belief that the visible world is merely an isolated case in relation to the universe, and that there are many more, other, latent realities. Things appear to assume a broader and more diversified meaning, and often seem to contradict the rational experience of yesterday. There is a striving to emphasize the essential character of the accidental." These propositions were as new as his pictures, but in the restless postwar years they passed without notice. It is characteristic of Klee that he speaks of the most abstract matters in vividly graphic language, illustrating the pictorial subject and development with striking examples: "An apple tree in bloom, its roots, the sap rising in it, its trunk, the cross section with the annular rings, the blossom, its structure, its sexual function, the fruit, the core with its seeds—one single organization of states of growth."

Klee had at first intended merely to elucidate the nature of graphic art, but as he worked on the essay

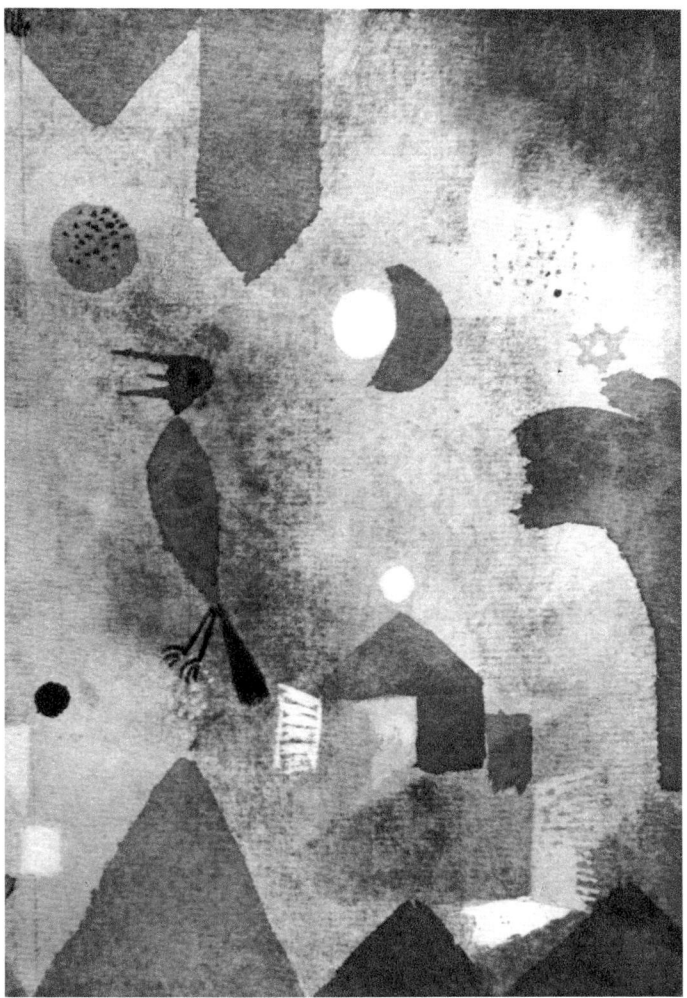

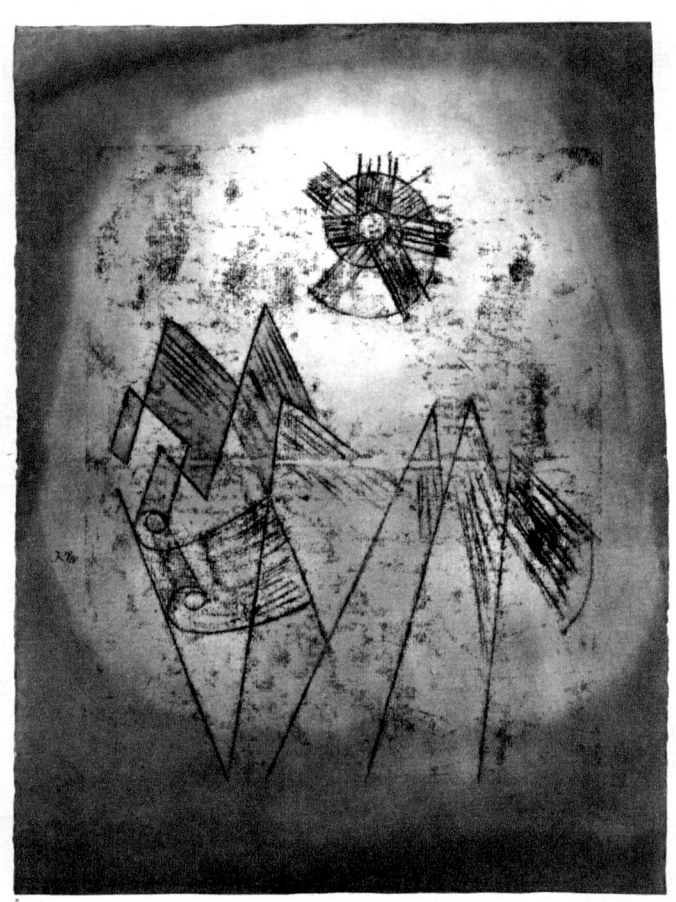

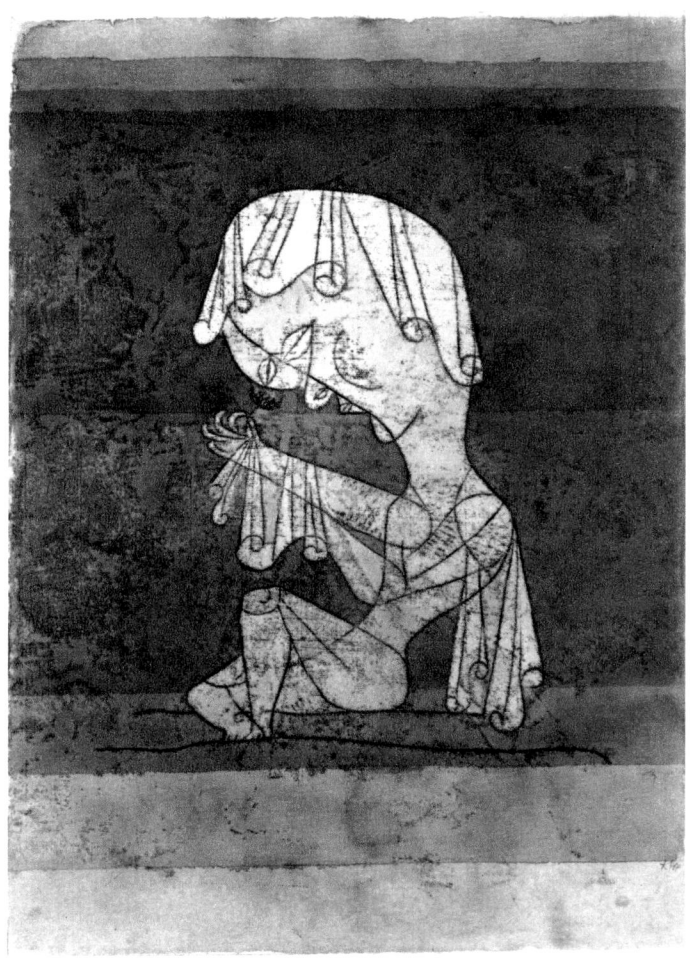

19. IN THE SIGN OF THE SNAIL. 1921
 Watercolor and oil, $15 \times 10^5/_8$". *Collection F.C. Schang, New York*

20. FEMALE SAINT. 1921
 Oil transfer drawing with watercolor, $17^7/_8 \times 12^3/_8$"
 The Pasadena Art Institute, California

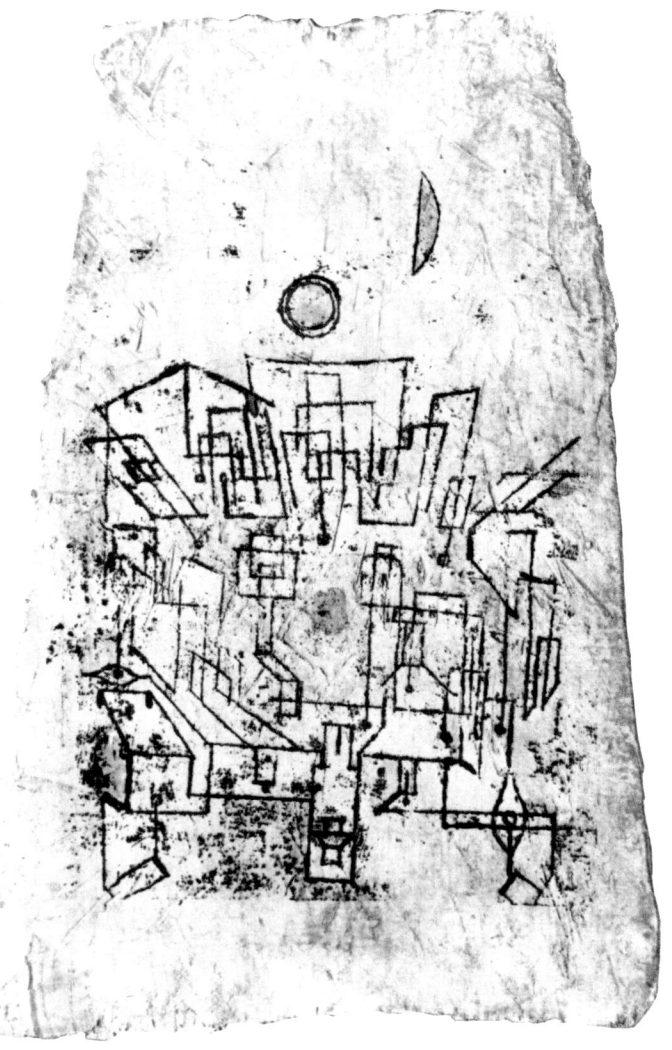

he arrived at insights which are still valid today: "Art is a simile of the Creation. Each work of art is an example, just as the terrestrial is an example of the cosmic." Especially illuminating to the art lover were his comments on individual formations such as the wavy lines a boat makes on a river, scattered dots viewed as the starry sky, etc. This short essay holds more and deeper insights than any other publication of the period. One suddenly realizes just how much there is in those astonishing sketches done over the years 1914–20, in which the variety of the treatments is matched by an increasing number of techniques. Besides paper, Klee paints on fabrics, wood, and cardboard, and occasionally uses chalk and plaster for sizing, whereby the character of the colors is altered, especially

21. ARAB TOWN. 1922
 Watercolor and oil on plastered gauze, $17^3/_4 \times 11^1/_4$"
 Private collection, Bern

when transparent colors are added. The drawing is often impressed on the wash ground or rubbed on with tracing paper, and the work is then varnished besides.

1920 was a happy year for Klee. The Goltz Gallery in Munich gave him an exhibition including 38 paintings, 212 watercolors, and 72 drawings, all the graphic works, and several sculptures. Books and essays about him began to appear, and his illustrations to *Candide* were published, as well as the little essay in *Schöpferische Konfession*. On November 25, 1920, he received the following telegram from the Bauhaus at Weimar: "Dear Paul Klee. We are unanimously summoning you to come to us as an artist at the Bauhaus. Gropius, Feininger, Engelmann, Marcks, Muche, Itten, Klemm." In January 1921, Klee left Munich for Weimar; his family followed in October. Thus began the happiest and most successful period in his life.

The Bauhaus Period: Painting and Teaching

At that time Klee still was bearded and clung to his old fur cap; only when the Bauhaus moved to Dessau did he become "Europeanized." With his sallow complexion and deep-set brown eyes he could almost pass for an Arab; there was even something oriental in his bearing, in the deliberation of his walk and talk. He lived at Oberweimar in a house overlooking the park, with his old furniture and a cat. Evenings he would play the violin, usually accompanied by Lily, but once a week he played quartets with professional musicians. Music strengthened his feeling for form. He knew the score of *Don Giovanni* by heart and was eager to de-

22. STAGE LANDSCAPE. 1922. Oil on cardboard, $18^{1}/_{2} \times 20^{1}/_{2}"$. *Collection Hans Meyer, Bern*

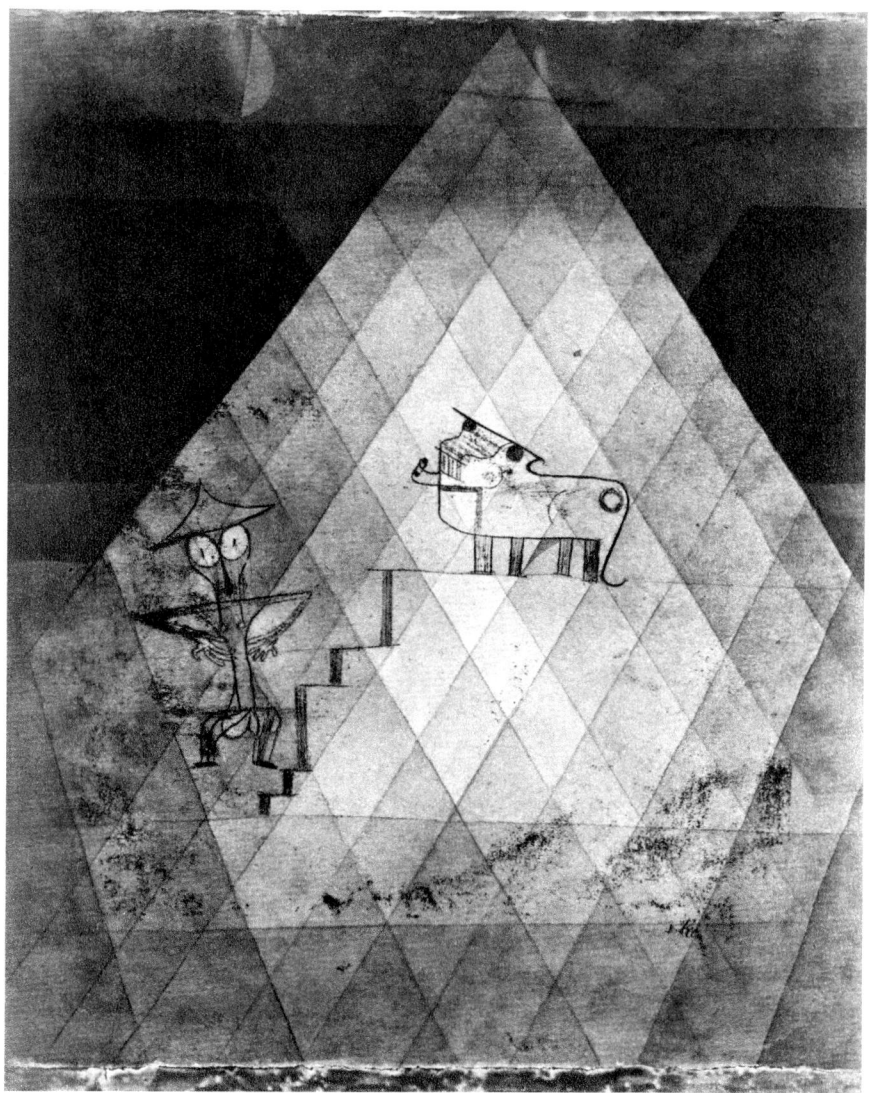

23. AT THE MOUNTAIN OF THE BULL. 1923
Watercolor and oil, 18 1/8 × 13 3/8″. *Private collection, Berlin*

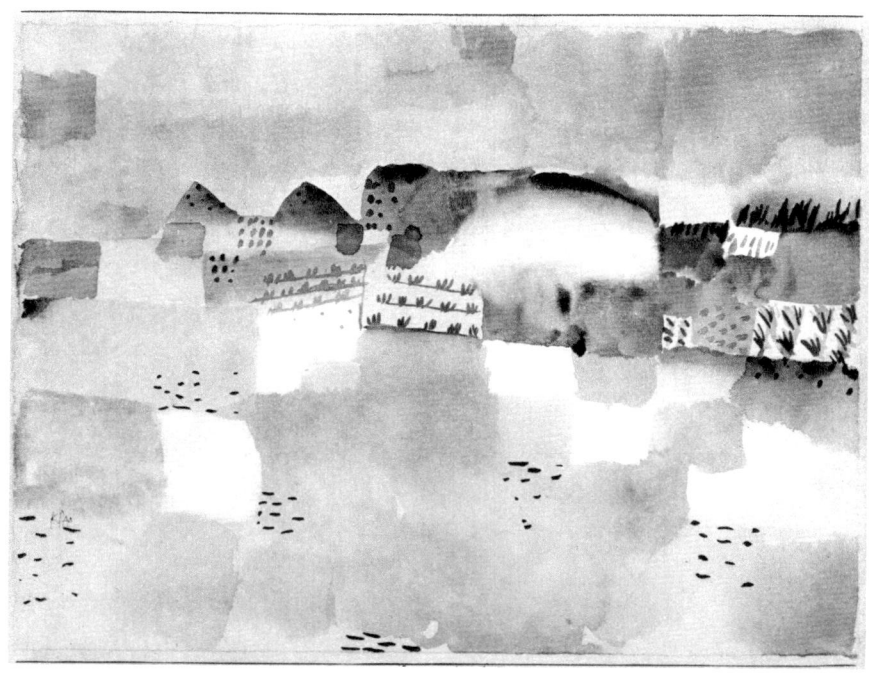

24. FORTIFIED DUNES. 1923
Watercolor. *Collection Dr. Theodore Leshner, New York*

24

sign sets for a production of it at the Dresden Opera, but the commission was given to Slevogt, who submitted several watercolor sketches from which the Opera people worked. With Klee's deep feeling for music, opera sets by him would have been a great event. Of contemporary composers, Klee knew and liked Stravinsky and Hindemith, but he did not play them; he heard their music mostly on records. He played only classical music, Bach and Mozart, hoping that in their works he might be able to discover something like a thorough bass—a general principle that would be valid for both music and painting. This was the harder because, in his opinion, painting had remained at the stage of development music reached in Mozart's *Don Giovanni*.

At the Bauhaus, Klee at last had a big studio with room for a dozen easels; he liked to work on several pictures at the same time. He often had to wait a long time before "they looked at him," and by the time this came about he had usually found the solution and would finish a work with a few strokes. He worked steadily, but never hurried; this was how he was able to produce so much. When he showed work in progress to a friend or other visitor to his studio, he spoke impersonally, discussing the problems the various pictures presented as though they were some other artist's. "Something has gone wrong here—can you see what it is?" In looking for a title he was grateful for suggestions, frequently adopting one, but also quick to change it. "Calypso's Isle" in this way became *Insula Dulcamara*.

At the end of 1921 Kandinsky came back from Moscow, and in the summer of 1922 he joined the Bauhaus as a teacher. This was a piece of good fortune for both Kandinsky and Klee, though for some it was a chance to play them off against each other. How silly. The differences between them were good for the students and for the "theory of form." Later, when there were formal painting classes, most Bauhaus students attended both Klee's and Kandinsky's.

Now financially independent, Klee was able to travel, and in 1924 he realized his dream of visiting the south again. He spent six weeks in Sicily, and this meant more to him than a mere vacation. He was inspired by the vegetation, the colors, the spiritual atmosphere. Later he said that he had produced nothing on Elba, but that in Corsica and Sicily he had felt almost

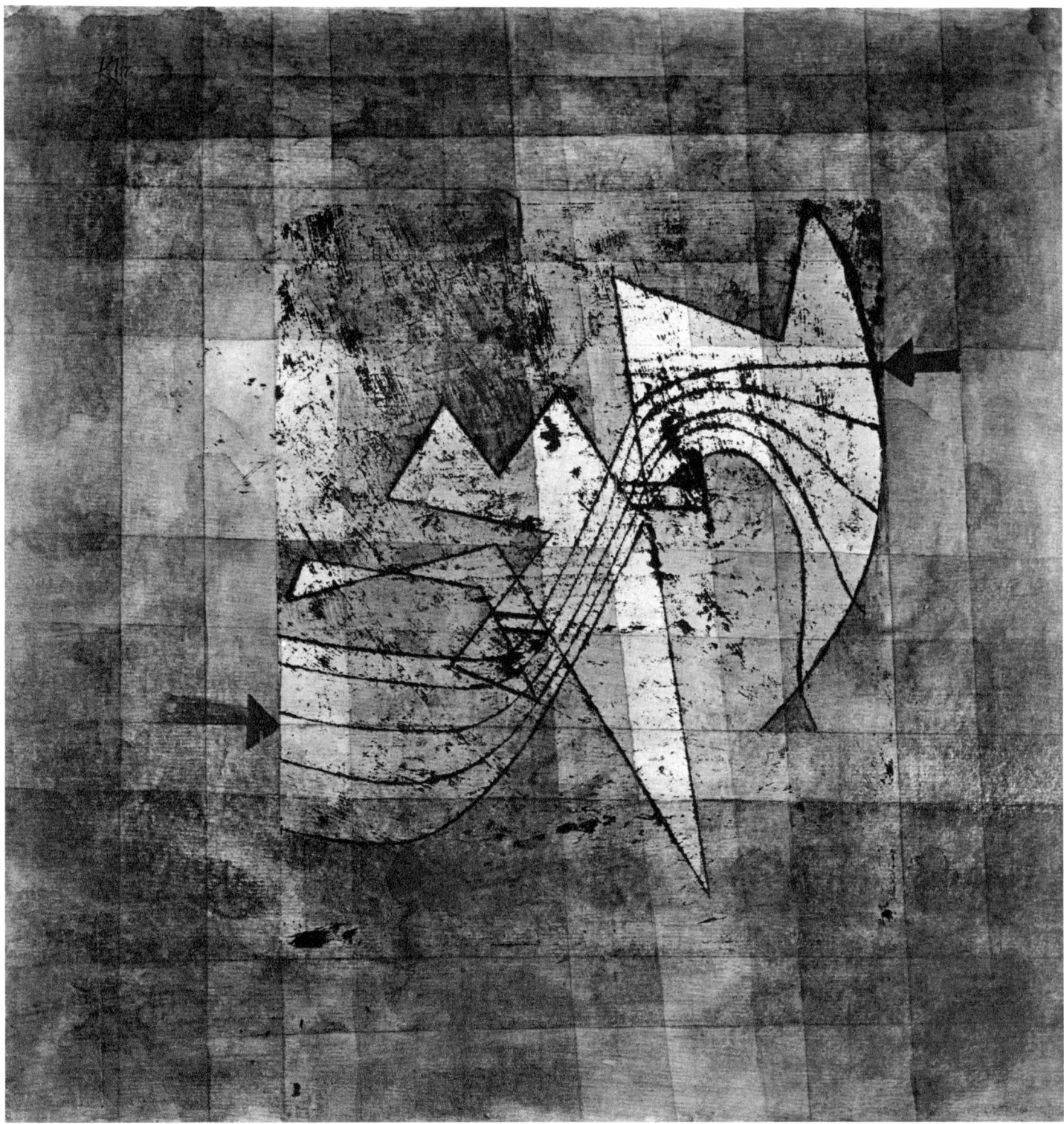

25. MOUNTAIN FORMATION. 1924. Oil and watercolor, $16^{1}/_{2} \times 15''$. *Private collection, Germany*

as though he were on the coast of North Africa. He visited archaeological sites, and at the Greek theater in Syracuse attended productions of Aeschylus (he had read Aeschylus in Greek; up to the end of his life he read Greek and Latin authors in the original). He also visited Gela, where the poet had died. To him, nature and history were so closely interwoven that he felt their unity and did not need guidebooks.

The legendary Bauhaus Festival of 1923 was out-wardly the high point of the Weimar period; there were fifteen thousand visitors to the exhibition and the performances. These last included Oscar Schlemmer's *Triadic Ballet*. Klee met and talked with Stravinsky, Hindemith, and Busoni, and made plans for a joint project with Léon-Paul Fargue. However, the project was never realized.

During the Weimar period, on the occasion of an exhibition at Jena, Klee gave a public lecture the text

of which was unfortunately not published until after World War II ("On Modern Art," Bern, 1945). He wrote the *Pedagogical Sketchbook* (1925), and an essay for the Bauhaus periodical. Surrounded now by so many good friends, Klee no longer felt shy before the public and spoke easily, though his lectures were carefully prepared. In this way he came into contact with the larger world around him, a contact for which he had waited a long time.

More important is the way his work continued to grow, both in quantity and in richness of content. He produced so much that it is necessary to divide his output of this period into works of the Inner, the Middle, and the Outer circle. Furthest inside are the pictures in which he gives symbolic expression to his attitude toward the world. In these, object and pictorial history are inseparable. These works are not abstract, because for Klee what is in question is "less the existence of the object than its kind." In the Middle group of works, form and meaning emerge from a texture of pictorial elements, but without being quite symbolic. The Outer circle comprises works which treat of events in life and nature, as they appear in given situations, though always from the point of view of totality, the sum of all the dimensions involved.

Needless to say, these distinctions are relative, and the groups overlap. They are not defined by the object alone or the form alone, but by both. Klee has been credited with as great a variety of themes as of pictorial inventions, though it is still impossible to say how many realms of nature and spirit he mastered, or just how many pictorial elements he introduced.

Just listing the titles gives some idea of the direction in which his creative mind was moving. Often, in one of his titles, we have the impression that we catch a glimpse, not just of the object, but also of its form and structure. Here are some 1921 titles: *Inscription, Traveling Bird, Arrival of the Air Steamer, Scene from a Hoffmann-like Tale, City in the Intermediate Realm, In the Sign of the Snail, The Gate to Hades, Fortress Structure, Urn Picture, Out-of-the-Way Plants, Fugue in Red, Garden Dry and Cool, Nocturne for Horn, The Order of High C, All Souls Picture*—titles all dating from the first few months of that year. What a variety! It is

26. COLLECTION OF SIGNS. 1924. Pen and watercolor, $9^1/_2 \times 11^3/_4$". *Private collection, U.S.A.*

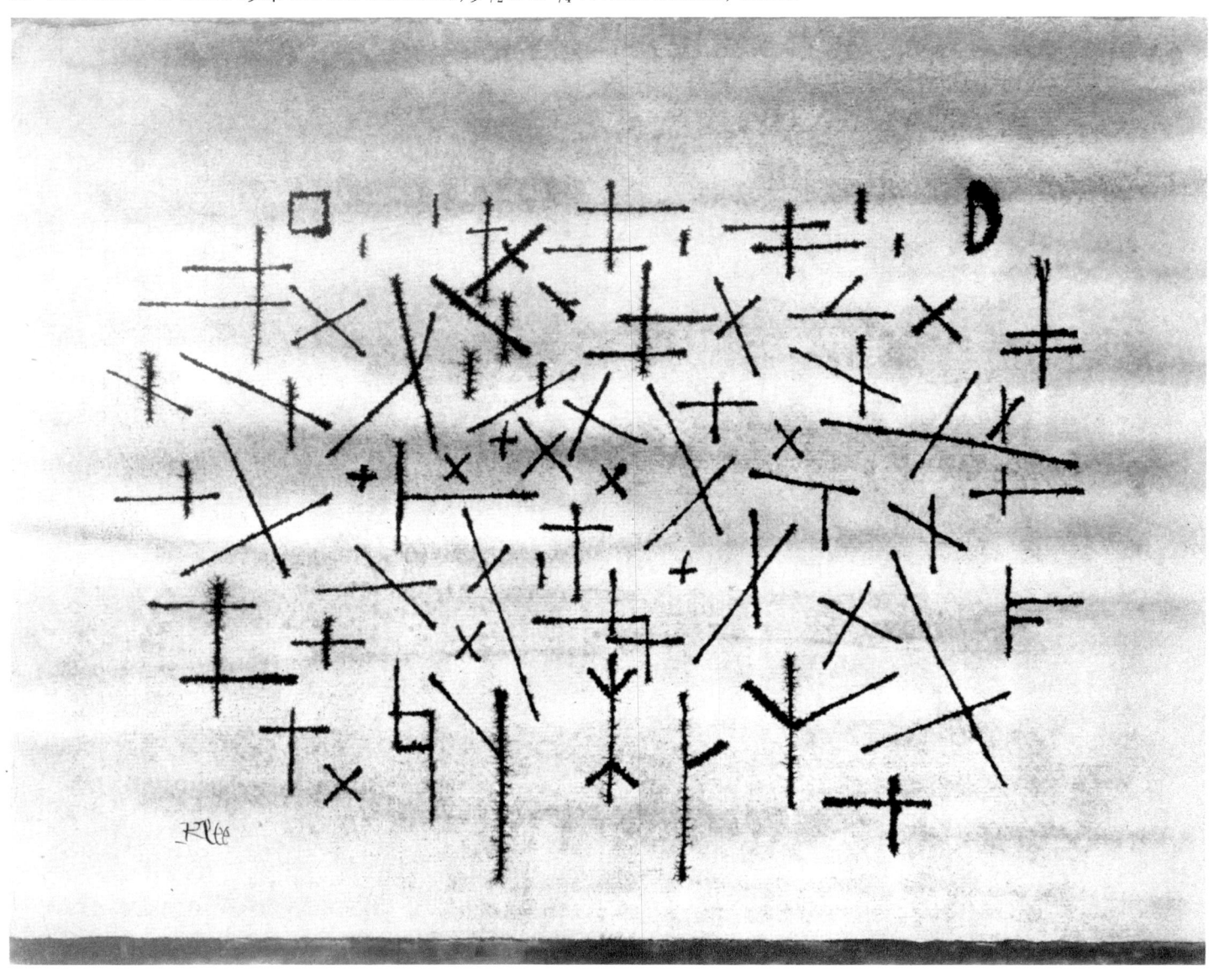

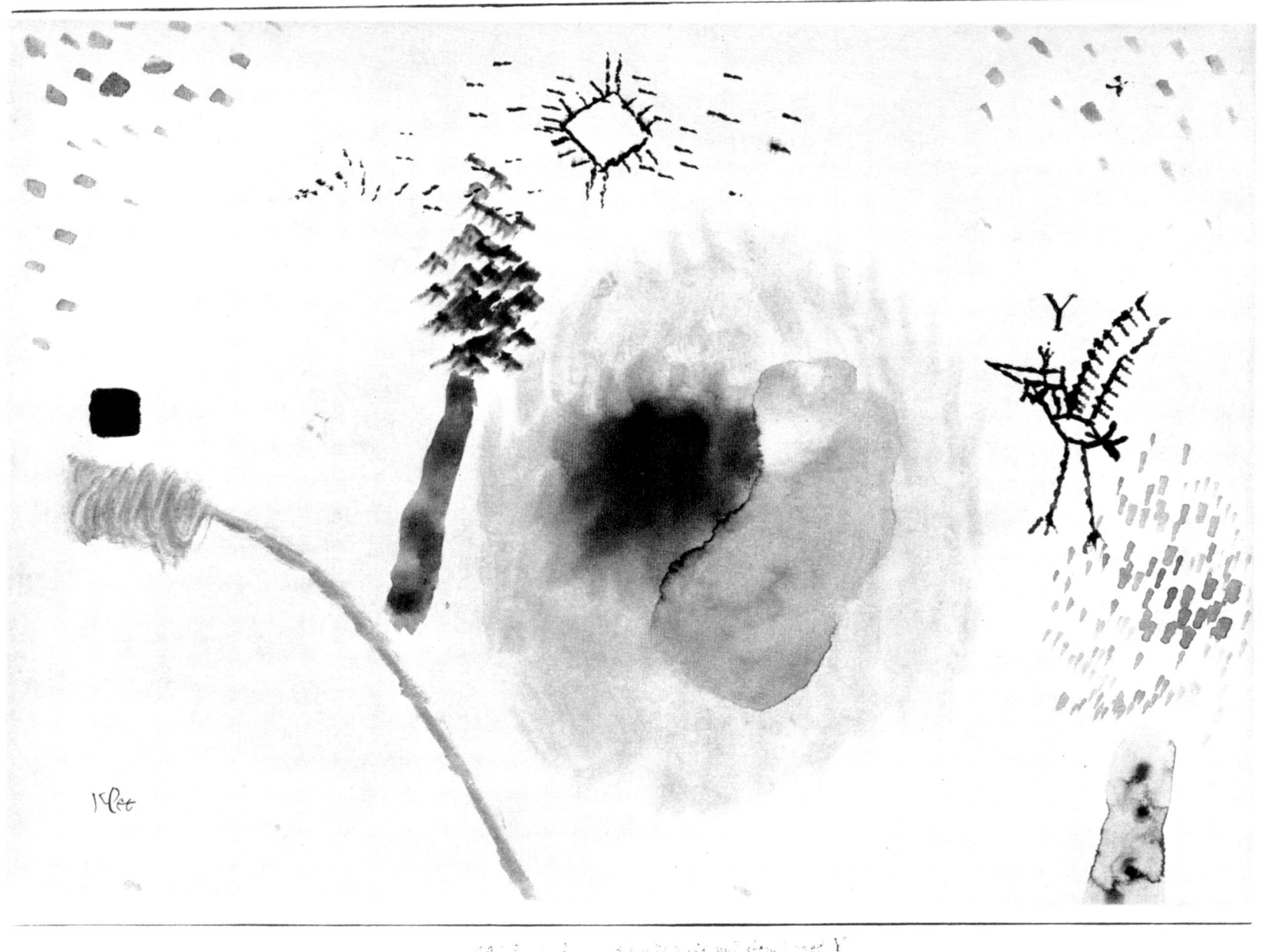

27. LANDSCAPE WITH THE BIRD Y. 1925. Watercolor, $5\,^1/_2 \times 9''$. *Private collection, U.S.A.*

hard to think of a theme to which Klee did not show himself equal. In matters pertaining to nature and human nature, the mind and the unfathomable depths of psychic life, he was without doubt the most knowing of all painters.

Let us try to present examples of each of the three groups in question. *Fortified Dunes* (1923, fig. 24) belongs to the Outer circle. During the summer of that year—the year of the inflation in Germany—Klee spent some time on the North Sea coast and painted a few landscapes in a style close to naturalism. There is a *Fool in Christ* presumably inspired by Gerhart Hauptmann's novel of that name, and a *Portrait of Mme. P. in the South*. Even *Landscape with the Bird Y* (1925,

fig. 27) belongs to the Outer Circle, and among the drawings is *For Little Liese's Autograph Album* (1921, fig. 64), one of the loveliest and most humorous works by the happy painter. The years of struggle are over, and so long as he can stay at the Bauhaus, he feels sheltered both personally and artistically.

Is *Female Saint* (1921, fig. 20) further inside the circle? It definitely comes from a deeper layer of the mind. The folds of drapery with their S-shaped terminations evoke musical recollections, and the marionettelike body belongs rather to Klee's intermediate realm, as does *Dance of the Mourning Child* (1922, fig. 65). There are many figural sketches in this same group—drawings, watercolors, paintings—especially those referring

27

28. VIEW OF A MOUNTAIN SANCTUARY. 1926
Pen and wash, $18^{1}/_{2} \times 11^{3}/_{4}''$
Collection Dr. Bernhard Sprengel, Hanover

and geometric, but in relativizing space they have already become images in our own minds, and thus fall beyond the realm of objects, though not so unmistakably as *Drawing for Perspective of a Room with Occupants* (1921, fig. 61). Here construction tilts over into its opposite: the space affects us suddenly as a world without faith or hope, and the persons projected on the floor are schematic. Klee's architectural works are often expressive, akin to music, otherwise how are we to account for a title like *Chorale and Landscape* (1921), a kind of fuguelike interlocking of squares, or *Arab Town* (1922, fig. 21), made up of displaced rhythms and meanders.

But all this is not yet art in the Innermost circle. When we look at *Ancient Sound* (1925, page 103) or *Mountain Formation* (1924, fig. 25), it becomes evident how we are to distinguish between Klee's objective (or figurative) and his crystalline works. No description quite accounts for the latter. Rather, we have to trace them back to their origin or compare them with related works. We sense the Bauhaus influence, the tendency to abstraction and the constructed—though Klee would prefer we call this a tendency to the "absolute," for the abstract can be very concrete, unspiritual, whereas the absolute is something "in and for itself," something essentially psychic rather than theoretical (as he used to tell his students). He now sees geometric and mechanical problems as elements in a training aimed at the essential, the functional. In this way, he thought, we get to know the prehistory of the visible, to analyze it and justify it. What matters is form, not formalism. We are not to look upon construction as all: nothing can replace intuition (*Bauhaus*, second year of the periodical).

Collection of Signs (1924, fig. 26) is "right," in the sense of the arrangement of notes in a musical score. *In the Sign of the Snail* (1921, fig. 19) is a drawing of some mysterious constellation, close to symbolism, with just a hint of astrology. But what about *Ancient Sound*, to all appearances a dislocated checkerboard pattern? Klee painted many such pictures; they begin in 1923 and continue until the year of his death. Behind their ambiguity lies some ultimate secret, concerning which the "light of the intellect is lamentably snuffed out." A conjuring up of the Absolute, the separation between the Ego and the World is here transcended, and the schema serves as a sort of veil concealing the

to the opera or the stage. *The Singer L. as Fiordiligi* (1923, page 97) could be included in the Middle circle, although the opera pictures mostly tend to the figurative, if only in the sense that they deal with matters of fact. The same is true of *Stage Landscape* (1922, fig. 22) and *Women's Pavilion* (1921, page 93), which has something of the setting for an oriental opera about it.

Architectural works like *City Picture with Red and Green Accents* (1921, page 91) often look very simple

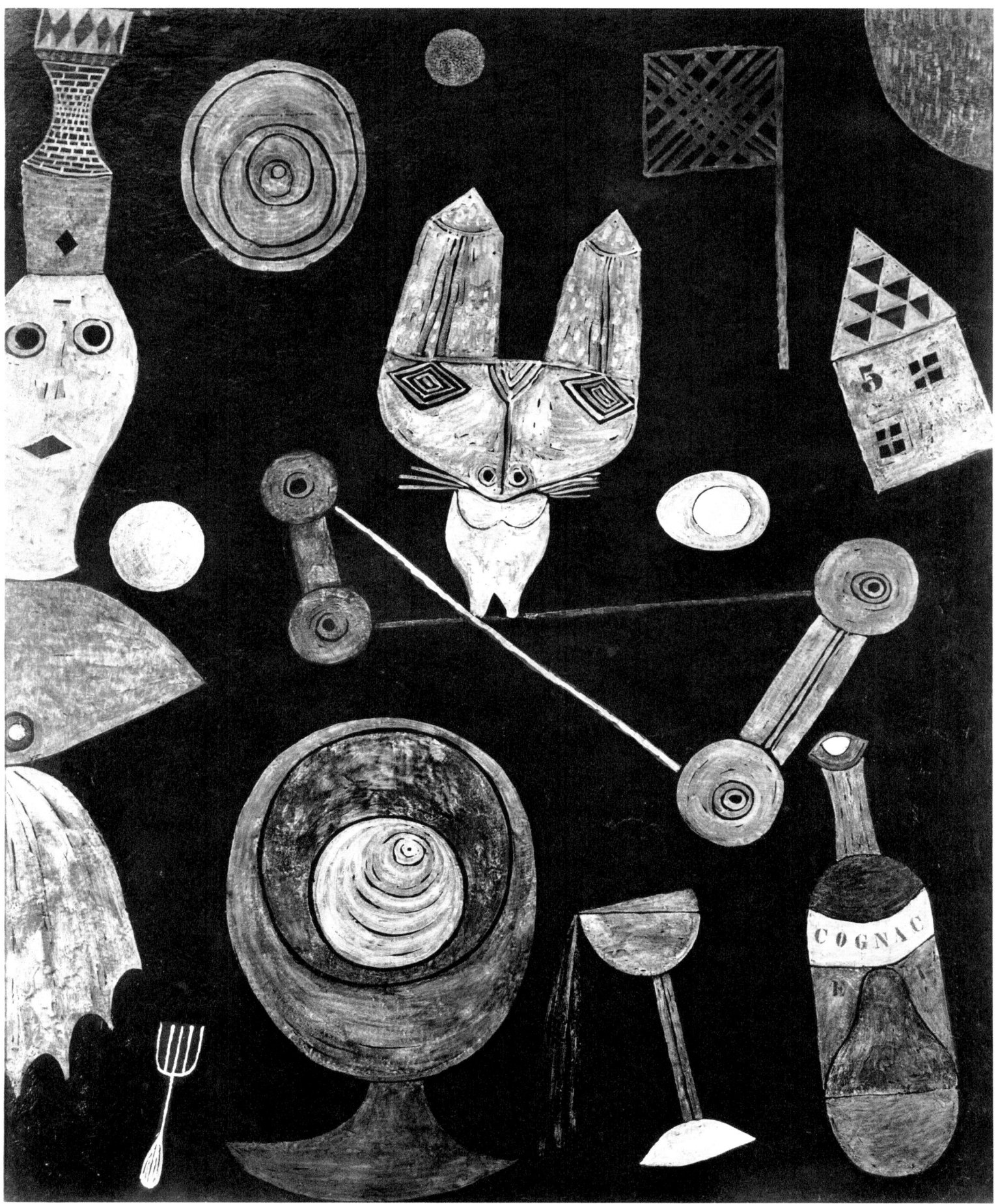

29. COLORFUL REPAST. 1928. Oil and watercolor on canvas. $33 \times 26^3/_8$". *Collection Mrs. Stanley Resor, New York*

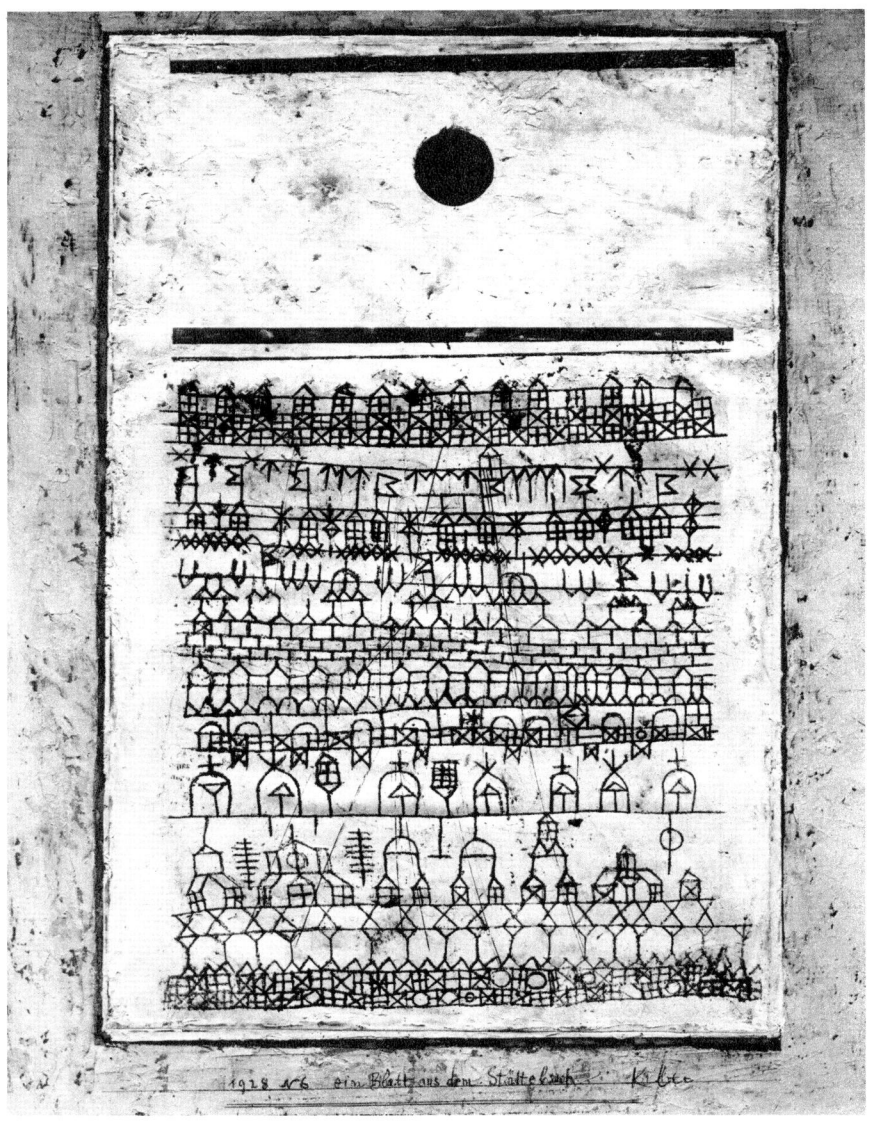

Nonetheless, the intellectual and artistic ferment there, with students of the most varied backgrounds and origins, visitors from all parts of the world representing all branches of knowledge, lectures and discussions on every conceivable topic—all this spurred Klee to fresh conceptions and technical inventions which might never otherwise have occurred to him: for instance, a furry crosshatching comparable to embellishments in music. Klee used this technique to differentiate values, and thereby achieved different degrees of white in his drawings. He also employed a spraying technique which Moholy-Nagy may have used earlier at the Bauhaus—a simple technique of the sort known to nonpainters. Sometimes only parts of the picture are sprayed, the rest having been masked for the operation (*Plan of a Town*, 1930, fig. 33). A third technique is the lacework line which turns up in pictures of gardens, landscapes, and architectural structures, as well as in so major a work as *A Leaf from the Book of Cities* (1928, fig. 30).

30. A LEAF FROM THE BOOK OF CITIES. 1928
Oil on paper mounted on cardboard, $16^3/_4 \times 12^3/_8$"
Kunstsammlung, Basel

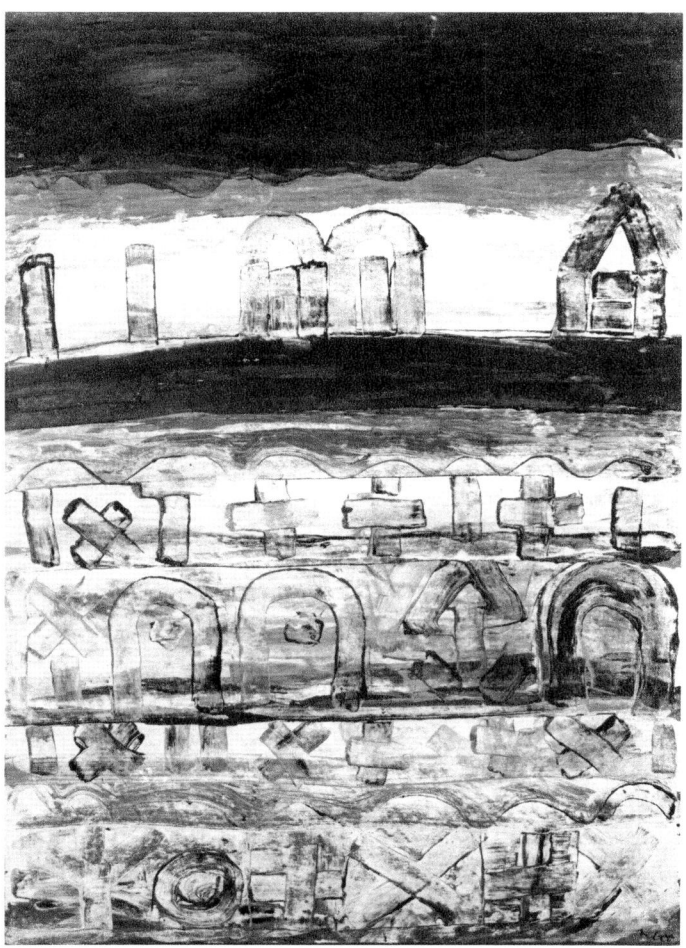

31. NECROPOLIS. 1930
Watercolor and paste color, $32^5/_8 \times 26^3/_8$"
North Rhine–Westphalia State Collection, Düsseldorf

deeper meaning. The same seems to be the case with the "strip" and "grid" pictures, such as *At the Mountain of the Bull* (1923, fig. 23) and *Mountain Formation* (1924, fig. 25). Vertical and horizontal colored strips interweave like warp and woof, producing a network which may be self-contained or into which Klee, by a tracing technique he invented, may introduce a ritual action or a bit of geology, a stratigraphic formation which, harnessed between two hostile arrows, takes on a pink glow toward the middle. A preliminary stage of these more or less poetic or philosophic insertions in the grid-type works is found in the Tunisian watercolors of 1914.

Now that Klee was rescued from solitude, he found himself seized by an overabundance of inspiration. Not that he was influenced by the other Bauhaus masters—only with Kandinsky was there some give and take.

32. BUILT-UP COAST. 1930. Watercolor. *Formerly Collection Curt Valentin, New York*

In Klee everything is connected with everything else; as he grows fonder of technical innovation, he grows fonder of philosophizing, too. In his essay in *Schöpferische Konfession*, he had begun to set down what he meant by the creative act (if we set aside the meditative jottings in his diary). At Weimar he followed up this volume with an essay that appeared in the *Bauhaus-Buch* (1923), titled "Ways of Studying Nature." In it he postulates a square, the four quarters of which represent artist, object, earth, and universe. "The artist is man, and thus part of nature—a fragment of nature in the natural world." According to Klee, the optical-physical approach is outworn; now the artist explores the object's inner being, its cross-sections (anatomy), vital functions (physiology), the laws governing its life (biology), and, lastly, its ties with the universe as a whole—relations both with the earth and with heavenly bodies (terrestrial roots and cosmic unity, statics and dynamics, gravity and flight). Self and Universe are related at every point. The result is pictures which differ from the optical image of the object and yet do not contradict it from the point of view of the totality, for all these considerations merge in the artist's eye. What is produced is not just a complex design, but a complex formal structure.

In 1924 Klee composed his *Pedagogical Sketchbook*, excerpts from his lessons at the Bauhaus with theses and examples. He illustrates the concepts of active, passive, and medial with the water wheel, and he analyzes the arrow as a pictorial element with a depth of insight altogether remarkable among Western artists. "Thought is the father of the arrow: How can I

extend my range in this direction or that? . . . Man's ideal ability to take the measure of things terrestrial and supraterrestrial, contrasting with his physical powerlessness, lies at the source of human tragedy. . . . The more widely we travel, the more we feel the tragedy involved in the necessity that we must become movement without yet being movement. . . . Never quite to reach the point where movement is limitless. The insight that where there is a beginning there is never infinity. Consolation: a little farther than usual!—than possible?"

Most revolutionary of all were the discoveries Klee expressed in his lecture at the Kunstverein in Jena in 1924. Here, in connection with the creative act, he speaks of orientation on the pictorial level, and "orientation in the things of life and nature." He likens these things to the root of a tree, the artist to the trunk, the work of art to the crown. Just as the crown is not an image of the root, so the work of art cannot reproduce the natural order, and the different functions lead to great differences between the two domains. Because the work of art enters the specific dimensions of the pictorial, deformations are inevitable, "for the rebirth

of nature extends that far." Then Klee turns to orientation on the pictorial plane, which, he says, is of special importance to the viewer. He speaks of line, tone, and color; of measure, weight, and quality; of how they are combined to give rise to what we call construction, when we speak abstractly, form or object when we speak concretely, "according to the direction the comparative association takes." To this dimension are added those of content, expression, and, lastly, physiognomy—which points to the dimension of style.

The associations that are conjured up, Klee says, unfortunately cause many misunderstandings between artist and public, for the layman is always looking for similarities, the painter for underlying laws. Associations can be accepted by the artist only when they present themselves under their right names. Then he can complete the picture by adding something to it. The layman is always looking for similarities because he always starts at the end, from the finished form, not from the idea of creation, from creation as the beginning of all things. By contrast, the artist looks upon

33. PLAN OF A TOWN. 1930. Brush drawing, $15^3/_8 \times 19^1/_4$". *Collection Philip C. Johnson, New Canaan, Connecticut*

34. HOVERING (BEFORE THE ASCENT). 1930. Oil on canvas mounted on panel, 33 ⅛ × 33 ⅛″. *Klee Foundation, Bern*

the optical image as a special case, limited in time and space, and prefers to go from the model to the archetype, to the "primal ground of creation, where the secret key to all things is kept." What he produces in this way, it is true, enters into consideration only if his vision has been given form with the suitable pictorial means. This is what Klee calls the "union between the world view and the honest practice of art."

The associations would not have come so easily to Klee had he not begun at the point where all is still possibility, potentiality, so that, at the end of the creative process, all the forces involved merge and crystallize. And there is another factor that presses on to

intelligible form, namely, a certain parallelism between the creative forces in the universe and those in the artist. An unknown law in the object corresponds to an unknown law in the subject (Goethe); the artist is both creature and creator, the world both object and state of mind. Just as "analogies with the totality of laws are reproduced exactly in the tiniest leaf" (Klee), so analogies with the laws governing the universal process are reproduced in the artist.

Only Klee could attain such profound insights. Only a man with so rich a store of images and anticipations was capable of producing works so entirely new. If details seem familiar to the viewer, it is because Bach-

ofen's "elementary grammar of the human soul" remains valid for him as for Klee, and because exploration of hitherto unknown psychic structures always leads to myth-making structural elements.

In July, 1926, when Klee moved to Dessau with Lily and Felix (the new Bauhaus was not officially opened until December 4, 1926), he was not dissatisfied. Unlike Weimar, Dessau could not boast of a brilliant past, but the new two-family house he shared with Kandinsky was comfortable, and they each had a big studio. The houses built for the Bauhaus staff were situated on the edge of a wood in attractive surroundings. There was an old castle with a chapel and a small picture gallery (for Dessau had formerly been a seat of dukes, like Weimar). From his house, Klee could take walks as far as the valley of the Elbe. It was like living on an island, but thanks to the railway Berlin was within easy reach. Dessau had opera performances and concerts of its own, with conductors like Franz von Hoesslin and Arthur Rother. In 1929, Klee attended the performance of Hindemith's opera *Neues vom Tage*, and after the composer called on him he wrote to Lily: "There is a certain spiritual shyness deeply rooted in him"—this referred to their intellectual affinity. Mussorgsky's *Pictures at an Exhibition* was staged in 1928 with Kandinsky's sets and two dancers; Klee's son Felix was the choreographer. There were visits,

lectures, discussions, and the Bauhaus workshops began to get commissions from industry. Everything seemed to be going very well. In 1928, however, Gropius resigned from the Bauhaus to devote himself to private practice. Moholy-Nagy, Marcel Breuer, and Herbert Bayer resigned soon afterward. In 1929 Schlemmer, too, left for the School of Fine Arts in Breslau, and Hannes Meyer was appointed director of the Bauhaus. A convinced Marxist, he ran into trouble both inside the Bauhaus and with the municipal authorities of Dessau. In 1930 he was replaced by Mies van der Rohe, but by then unending pedagogical, organizational, and political crises had destroyed the community spirit. When the Düsseldorf Academy of Fine Arts offered Klee a teaching post he accepted, and resigned from the Bauhaus as of April 1, 1931. He had for some time felt that at Dessau he was spending too much time in classes, meetings, all sorts of extraneous matters. "Everywhere I turn, it's obligations, dealers, material problems, reputation—it's all wrong" (letter to Lily, September 14, 1929).

Although Klee was no longer at the Bauhaus when it was closed by the Nazis, he was relieved from his duties at Düsseldorf, just as he would have been had he remained at Dessau. On April 21, 1933, he was "granted" what was called a "leave of absence." At last he had the complete freedom he had so longed for at Dessau.

The two years he spent at Düsseldorf put no very great strain upon him. He did not have to give much time to teaching, and since he had found no suitable living quarters there he commuted between that city and Dessau, where he had been allowed to stay on in his house. In his spare time he read, as he had so often before, the Greek tragic authors, *Parsifal* in the original ("There is nothing in the modern world more beautiful than the Middle High German epics and the Naumburg cathedral"), the *Mahabarata*, Buddha's sermons, and Mommsen. Whenever possible he traveled repeatedly in the south, visiting Florence, Elba, Corsica, and the Bay of Biscay. In 1928 he went to the southern coast of Brittany, in 1930 to Viareggio, in 1931 to Sicily, in 1932 to northern Italy, in 1933 to southern France. But his most significant journey in this period was his trip to Egypt—a present to himself on his fiftieth birthday. He remained there from December, 1928, to the middle of January, 1929, and kept a record

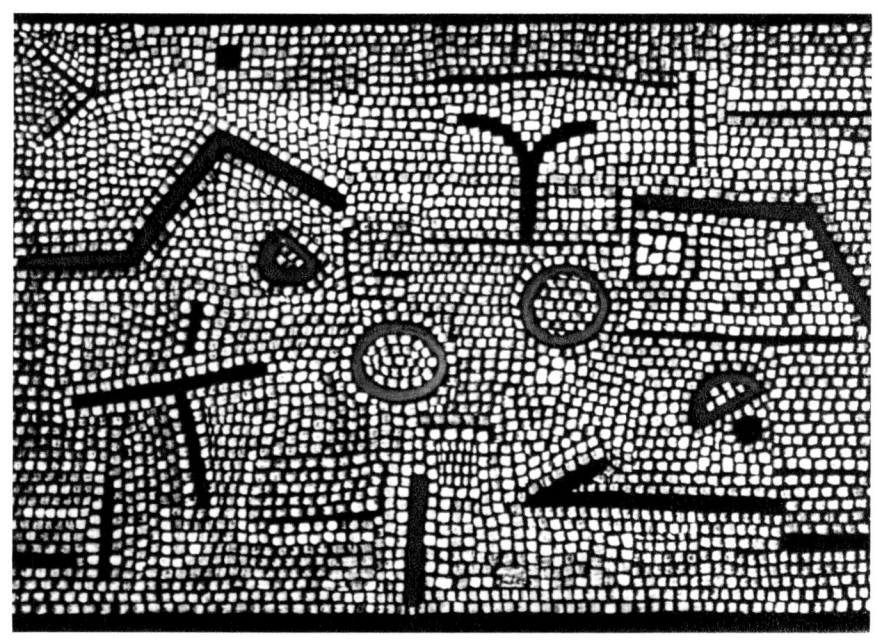

35. MOSAIC FROM PRHUN. 1931
Watercolor on colored paper, 13 × 18". *Collection Rolf Bürgi, Bern*

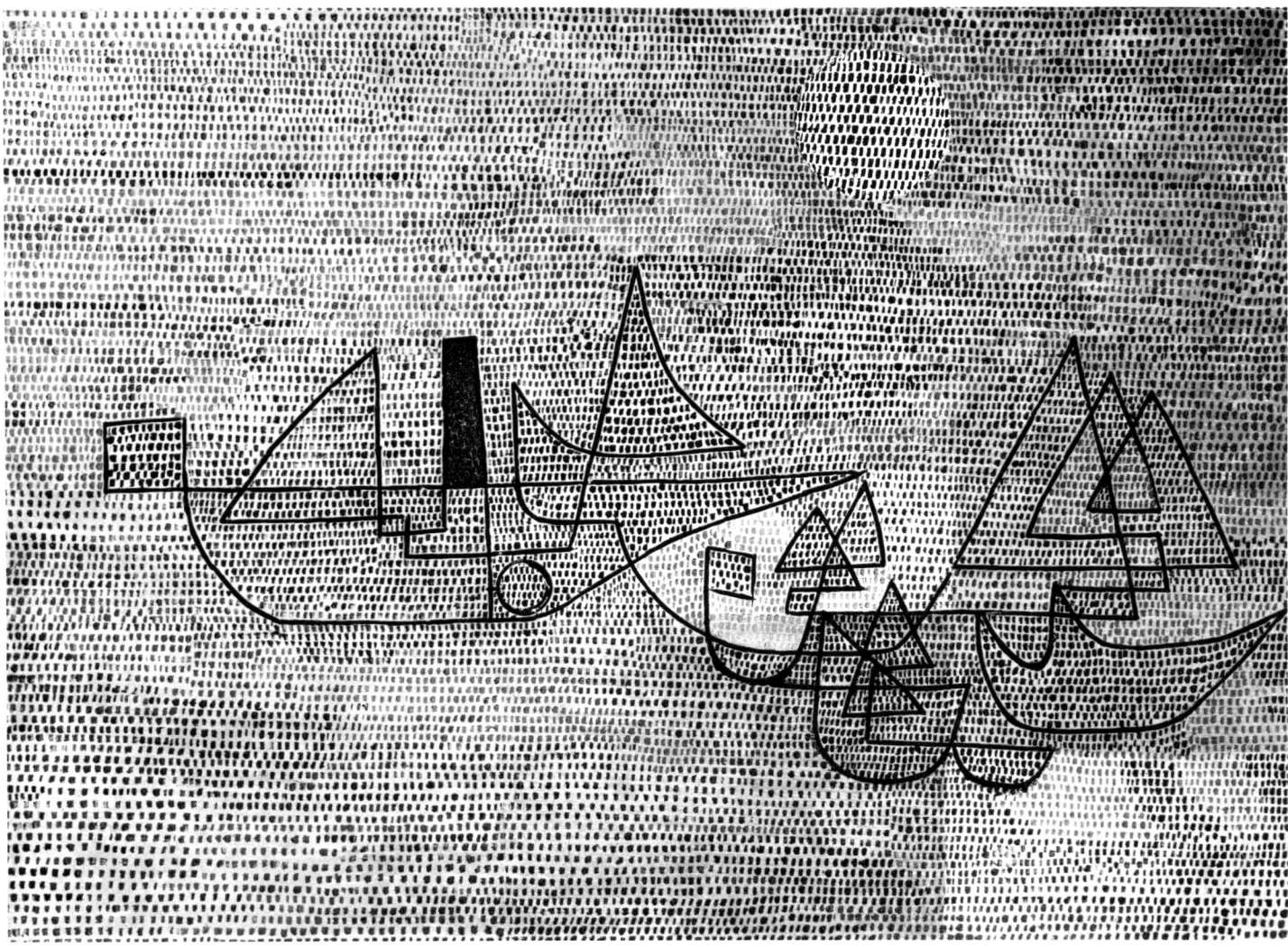

36. STEAMER AND SAILBOATS TOWARD EVENING. 1931. Watercolor on colored paper, 19 × 24". *Private collection, U.S.A.*

of his trip in his pocket diary: Alexandria, Cairo, Luxor, Karnak, Thebes, Aswan. The trip was relatively short, but it was as important to the artist as the trip to Tunisia had been fifteen years earlier. In Egypt Klee found the courage to attain ultimate simplicity, a greatness that very few persons were able to grasp for some time. To him the five-thousand-year-old culture meant a historical moment in which primal beginning, present, and future merge. Klee's Egyptian pictures were the equivalent, in his life's work, of Goethe's *West-Östlicher Divan*.

Besides inner enrichment, 1929 brought him some external success. An extensive monograph about him was published by the Cahiers d'Art publishing house in Paris. The Flechtheim Gallery in Berlin held a Klee exhibition on the occasion of his fiftieth birthday; in 1930 this exhibition went to the Museum of Modern Art in New York—an unusual mark of respect for a German at that time. Flechtheim induced Daniel-Henry Kahnweiler to take an interest in Klee, so that now the artist was also represented in Paris. From 1934

on, Kahnweiler became his sole European dealer, because Flechtheim could not continue his work under the Nazis.

At Dessau, just as at Weimar, Klee produced steadily, but now more and more works fell within the Inner circle. The first noteworthy schema at Dessau is a parallel figuration, which presumably has some connection with musical imitation. Parallel straight lines and curves determine the formal picture, which may also display rhythmic qualities. In expression, the drawings suggest antiquity *(View of a Mountain Sanctuary*, 1926, fig. 28; *Untamed Waters*, 1934, fig. 37).

In 1927 Klee began the series of works with a melodic line; the schema is the more productive because here the continuous flow of the winding lines is more important than rhythm or repetition *(Chosen Site*, 1927, page 109; *Animals in Moonlight*, 1927, fig. 69). But there are also noncontinuous lines in works of great sensibility such as *Dreamlike* (1930, fig. 73). Many schemata now derive from the graphic work; in one letter, Klee observes that at Dessau he threw himself

35

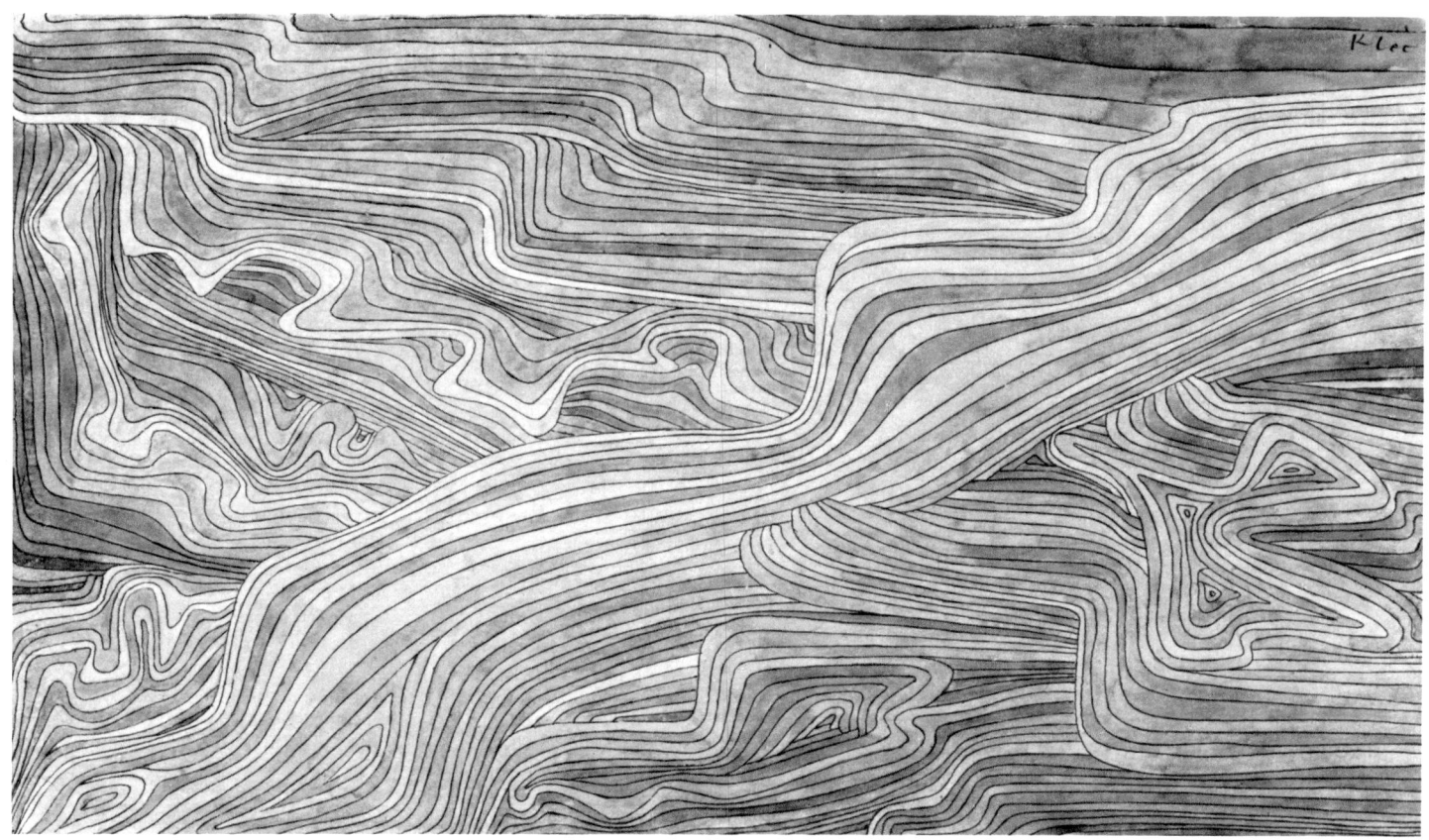

37. UNTAMED WATERS. 1934. Pen and watercolor, $19\frac{1}{4} \times 27\frac{1}{8}''$. *Galerie Beyeler, Basel*

into drawing with "barbaric frenzy." In addition, he also now took his point of departure from color—paste color pictures like *Necropolis* (1930, fig. 31) and those he called "Divisionist." Superficially, they bring to mind Seurat's Pointillism, but are built on entirely different assumptions. Examples are *The Light and So Much Else* (1931, page 125) and *Ad Parnassum* (1932, page 127). Klee is already working with colored light, but he orders his spread of dots not according to the law of *contrastes simultanés*, but by intervals or relations between planes and by graphic signs. One extremely fruitful schema is provided by *Braced Planes* (1930), a work he also referred to as "Studies in the Three Dimensions." Colored squares intersect and interpenetrate; the corners are interconnected to form a second system of relations, so that the result is something like ascending dragons or climbing two-wing airplanes in such works as *Hovering* (Before the Ascent) and *Built-Up Coast*, both of 1930 (figs. 32, 34). Note should also be taken of the "strip" schema employed in the Egyptian pictures, which pictorially records the *Ka* (spirit of the land), as in *Highway and Byways* (1929, frontispiece). Extraordinary versatility enables Klee to realize, with only very slight modifications, *Monument in Fertile Country*, *Fishing Steamer*, and *Clown Pyramidal*, all of 1929.

Needless to say, not all the work of a period fits into the set of approximately thirty schemata; plenty of individual works fall outside entirely. There are "dictatorial" inventions like *Black Prince* (1927, page 107) and "atmospheric" pictures produced by the superimposition of airy colored foils: *Before the Snow* (1929, page 115), for example. In a work like *Small Room in Venice* (1933, page 129), the distinction between interior and exterior has been eliminated. *Small Room* was executed just before Klee left Germany, along with a few other pastels. None of these works, made before his departure, reflects the mood of those troubled years, though Klee had personal experience of the mounting barbarization of Germany. Like Kandinsky and many others he was abused as a Jew and a foreigner, but he never stooped to defend himself. "It seems to me unworthy to answer back to such crude taunts. Even if it were true that I am a Jew or that I come from Galicia, this would not change by one iota the value of my personality or my achievement. In my opinion, a Jew or a foreigner is not as such inferior to a native German, and I must never of my own accord give up this view for to do so would make me ridiculous in the eyes of posterity to the end of time. I'd rather put up with some hardship than become a tragicomic figure currying favor with those in power" (letter to Lily, April 6, 1933).

36

This is not to say, however, that it was as easy as all that for him to say good-by to Germany, for he had many friends there. Moreover, Düsseldorf was a big city, with a good opera house and a pleasant social life. He even had a few enjoyable colleagues, like Campendonc, Oskar Moll, and Edward Mataré. Still, he had occasional moments when it was all too much for him, when he'd reflect that after all the Germans were bad painters, and that what he'd really like would be a studio on Mount Athos.

Return to Bern and Last Years

At Christmas, 1933, Klee was back in his native Bern. His father and his sister Mathilde still occupied the little house at No. 6 Obstbergweg, where he had grown up. A few old schoolfriends rallied round to help him readjust. He promptly found a small three-room flat at No. 6 Kistlerweg, and set up his studio in the biggest room. Though now internationally fa-

mous, Klee was content with such modest quarters. He attended concerts and had musical evenings at home with, among others, Hans Kayser, who played the cello and was author of *Der Hörende Mensch* (*"The Listener"*) and a treatise on the theory of harmony. Klee read and understood the latter despite its difficult mathematical problems. In 1934 he had an exhibition in London; he noted with satisfaction that the range of his influence now extended as far as England. *Handzeichnungen (Drawings)* came out in Germany, but the edition was immediately confiscated. On February 23, 1935, the Kunsthalle in Bern opened a big Klee exhibition, filling two floors; later this traveled to Basel, and so his reputation was also enhanced in Switzerland. During these months his work was often interrupted, but there were also gratifying visits from old friends and from collectors on the trail of his works. Finally, as the sometimes hectic pace of his new life slowed a little, his work progressed. Then, just when it seemed he was settling down to a long period of concentrated work—in the summer of 1935—the first symptoms of

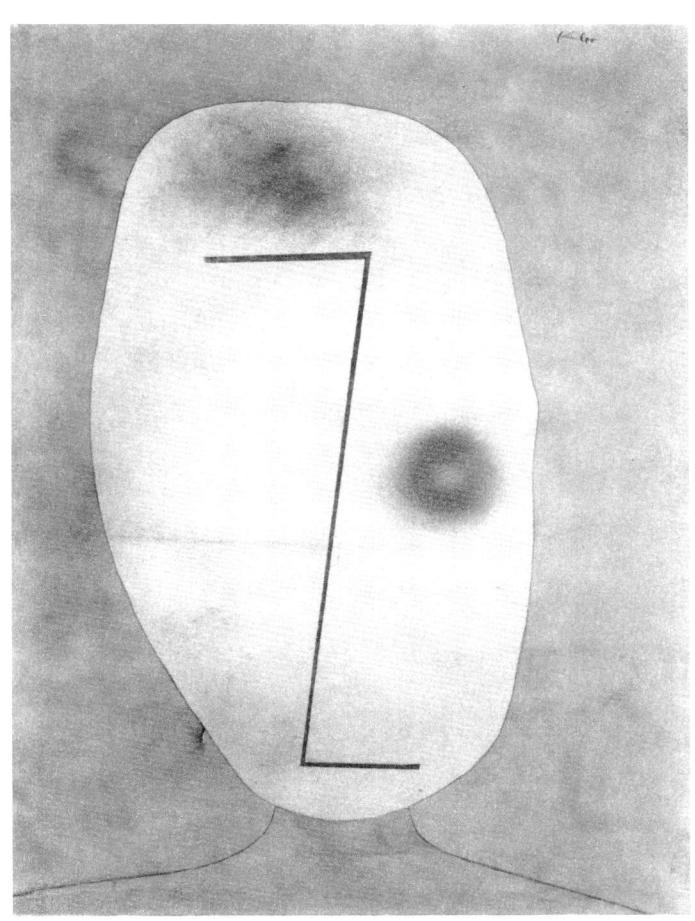

38. MISTER Z. 1934. Watercolor, $25^5/_8 \times 19^1/_4$".
Formerly Collection Clifford Odets, New York

39. SCARECROW. 1935. Oil on canvas mounted on panel, $28 \times 23^5/_8$". *Collection Allenbach, Bern*

40. AFTER THE FLOOD. 1936. Paste color and watercolor, 18½ × 24″. *Collection F.C. Schang, New York*

a serious illness (scleroderma) appeared. He was to die of it five years later.

Klee kept working to the very end, except in 1936, when his output dropped to a mere twenty-five pieces as against his annual average of several hundred. He very often stayed up till midnight working on his drawings. As things calmed down around him, and he had fewer visitors, he only went out of the house for short walks or an occasional trip. Even the slight gradient of the Kistlerweg tired him. "This is now my Matterhorn," he remarked one day coming back home. Two unusual events in 1937 were visits from Georges Braque, who had seen works by Klee at Maja Sacher's in Basel, and from Pablo Picasso when he came to Bern for medical treatment. Klee was especially pleased that Picasso, whom he had revered since his youth, came to see him and deigned to admire his "miniatures." Asked his impressions of Klee, Picasso later said: "Pascal—Napoleon!" referring no doubt to the cast of Klee's mind and his short stature. The Nazi

exhibition of "Degenerate Art" included seventeen works by Klee, but he was hardly affected by this piece of mudslinging. On his last (sixtieth) birthday, he was showered with expressions of friendship and admiration; only Germany was silent. The war was on, and Klee, who once said that he would rather be dead than go through a second world war, had his wish. He was dead before the war was a year old. He entered a sanatorium at Orselina-Locarno in May, 1940; he died at the Sant'Agnese Clinic at Muralto on June 29. The funeral ceremony took place in the Bürgerspital chapel on July 4, and the ashes were interred at the Schosshalden cemetery in September, 1942. On his tombstone are inscribed the words with which he began his *Diary:* "Here below I cannot be grasped at all." It would have been hard to find an apter one. From his graveside one can see the Bentiger quarry, where Klee often made drawings at the very start of his career.

Klee lived in Bern for six and a half years before his

death. In May, 1934 he wrote to the author: "I have started to paint again, with a very small orchestra." At first, to get back in stride, he resumed works already begun, such as *Untamed Waters* (1934, fig. 37). He painted *Figure of the Oriental Theater* (1934) and *Mister Z* (1934, fig. 38). He executed a few works which would have been called *art brut* in the postwar years: *Ravaged Land* (1934, page 133) and *Scarecrow* (1935, fig. 39). These mark the start of his transition to ultimate simplification, reached eventually in the pictures with the rough bars which so puzzled many of Klee's old admirers at first, though they have come to be widely appreciated since.

All the same, it cannot be said that the new overshadows the old. Klee's was never a straight-line development. The various stages of his art form concentric circles around a center, as in a tree each annual ring encompasses the previous one. When Klee painted his "magic squares," it was thought that he would never surpass them. Actually, this was a view suggested at many periods in his career, and yet each successive development was no more than a stage. Only at the very end do we feel that there was no possibility of going any farther, that here he had set down his last line. *Kettledrummer* (1940, fig. 48) is, in this sense, definitive. This is death as drummer—as he sees and imagines himself, not as someone else might represent him. In *Heroic Fiddling* (1938, page 145), the bowing is not merely seen—it is heard, and there is still more here: the close personal and artistic friendship between Klee and Adolph Busch.

Behind the rigorous pictorial formulation, fate invariably lurks: the more rigorous the statement, the more impenetrable the fate; the simpler the elements, the more convincing the visible images. In Klee all things express life in its incomprehensibility—clowns, witches, geometrical lines, flowers, love songs, the 366th day of the leap year. Nothing is fortuitous, everything has its origin and its relation to the medium of truth. When a picture is titled *Jewels* (1937), the viewer thinks of personal adornment, but the painter, in this case, was thinking of the sounds exotic birds make. An *Angel in the Making* (1934) is neither angel nor the genesis of an angel but, as Klee said at the Bern exhibition in 1935, it may be the place where an angel is born. He was more than willing to hear comments on his pictures by his friends (like Goethe in the instance of his *Fairytales*), but few were capable of satisfying Klee on this point.

Most persons find it hard to understand the dialectics of the relation between the visible and the invisible, the static and the dynamic, the active and the passive, the conscious and the unconscious: they want to be presented with a ready-made synthesis, not to be obliged to make it themselves. Klee's habit of involving us in the whole creative process, his stress on the flux of becoming, scares off many from his work. "The work is not law, it is above the law—art as projection from the supradimensional primal ground, symbol of begetting, presentiment, mystery. But one must keep on searching."

41. COMMENTS ON A REGION. 1937
Charcoal, watercolor, newsprint, on colored sheet prepared with paste and chalk, 18⁷/₈ × 12⁵/₈″
Formerly Collection Curt Valentin, New York

42. PARK NEAR L[ucerne]. 1938
Oil on burlap mounted on panel, $39^{3}/_{8} \times 27^{5}/_{8}''$
Klee Foundation, Bern

direction of symbol: the symbol sums up all that has gone into Klee's art, the thing itself, its origin and development, its meaning and metaphysical references, its merging of past, present, and future as one. Quite simply, the viewer is being invited to become a part of the great creative process. "Had I been a god," he writes in his diary, "I should have gone in for a great deal of historical theater, I should have detached the epochs from their ages."

It is admirable that Klee, with all his depth of understanding of the world, and all the mysteriousness of his means, can even at the end speak cheerfully of his art and encourage the viewer to candor. Concerning *Low Tide* (1934), executed at the North Sea coast on his first visit, he says it was like going down into a cellar. Composing *Furnished Arctic* (1935), he says he was thinking about the restaurant up on the Jungfrau, and when composing *Album Sheet for Y* (1935) he had in mind a vegetable garden in the dead of winter. *After the Flood* (1936, fig. 40) he described as a recollec-

43. HURRY. 1938. Paste color on newsprint,
$19^{5}/_{8} \times 13^{1}/_{8}''$. *Klee Foundation, Bern*

But how is the viewer to proceed when a picture comes close to Klee's dream, really does "range very widely over the whole elemental, objective, material, and stylistic domain"? The multidimensionality of his work preoccupied him for a long time, and he regretted that language, unlike painting and music, cannot communicate several processes simultaneously. Multidimensionality emerges at an early date in his work, at the same time as the unconscious, for the unconscious of itself implies the other, which is also there and in turn gives rise to new aspects. It is true, however, that Klee's is not the multidimensionality of Cubism; he sees man against the background of the universe as a whole, at the vegetable, animal, terrestrial, and cosmic levels of life (C. G. Carus). Everything points in the

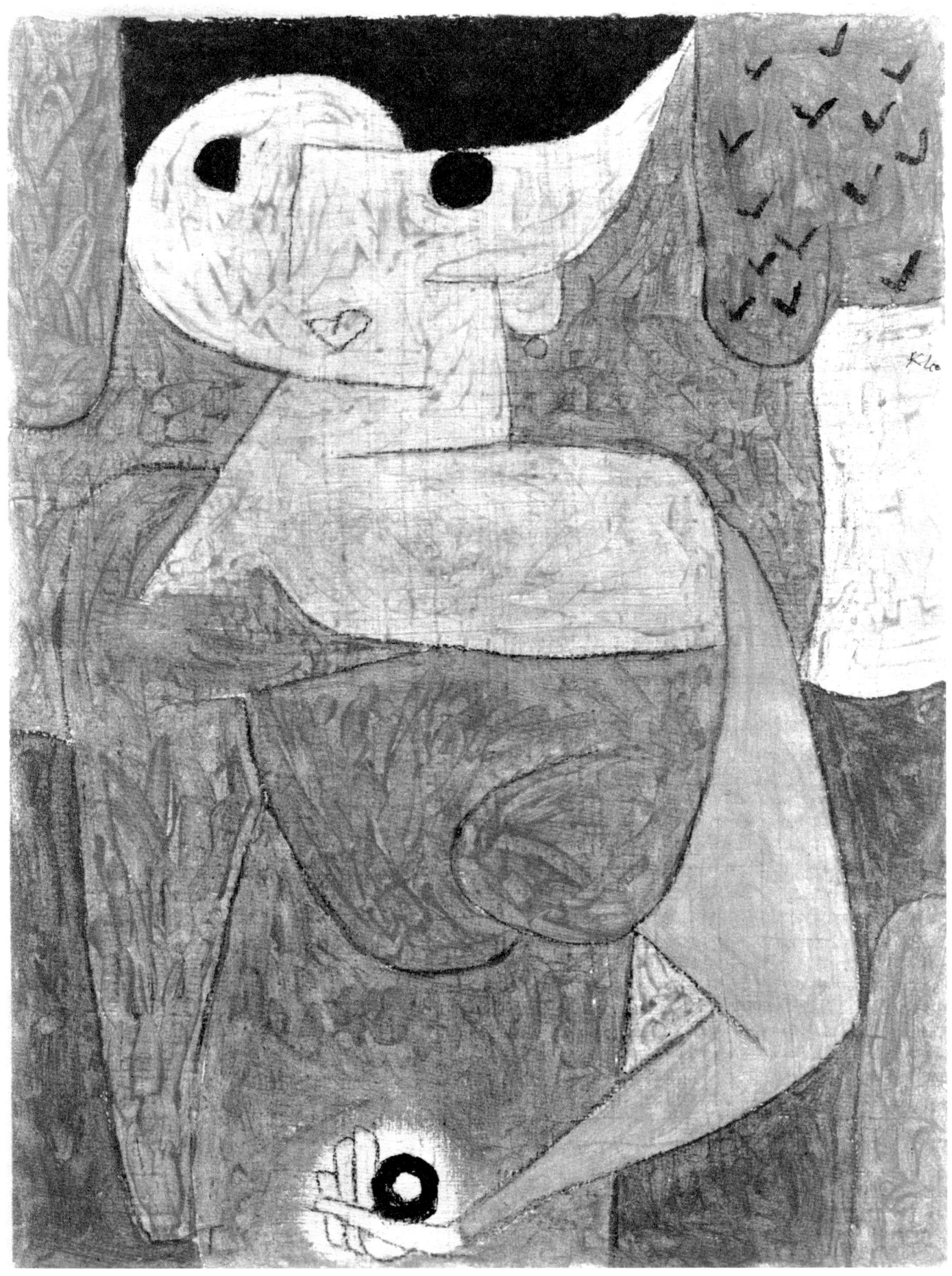

44. OMPHALO-CENTRIC LECTURE. 1939. Paste color on silk and burlap, mounted on panel, $27^5/_8 \times 19^5/_8''$.
North Rhine–Westphalia State Collection, Düsseldorf

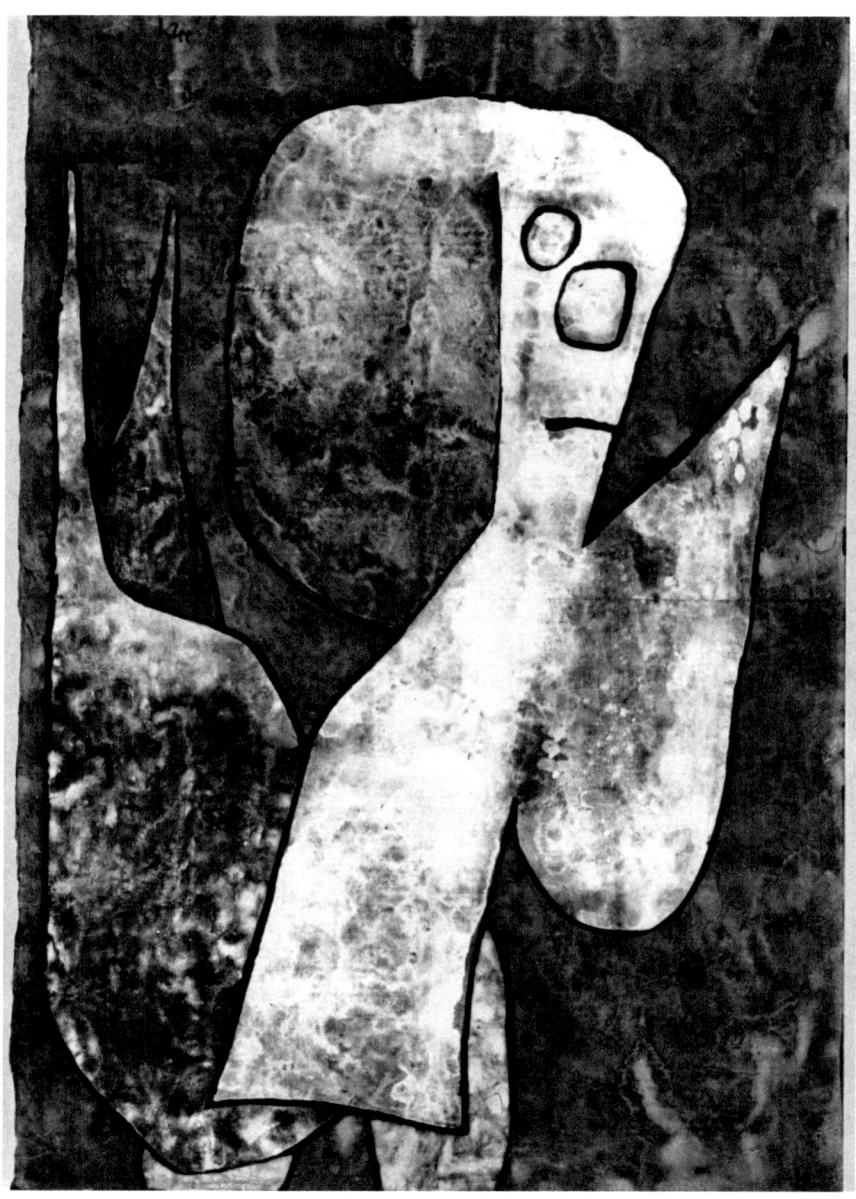

45. POOR ANGEL. 1939
Watercolor and tempera on blackened newsprint,
19¹/₄ × 12³/₄″. *Private collection, Bern*

tion of a trip to Montana in the Valais, where he saw swollen mountain torrents. All this enters into Klee's work; not just his ordinary experiences, but also his peculiar reactions to them. In the end, even the most trivial things are submerged in a network of all-inclusive relationships. His thoughts sometimes take an odd turn: *Growing Weapons* (1935), for example, has nothing to do with weapons, but with cacti. In other instances, what the viewer takes to be evil Klee was thinking of as good—to him the one could not exist without the other.

Between 1934 and 1936 his output was relatively small. The move to Switzerland and the readjustments it entailed, the exhibition early in 1935, and the onset of his illness account for this. Some works of these years are "postscripts" to earlier works. *Blossoming* (1934), for example, is a large oil that links up with the "magic squares" begun in 1923. *Coming to Bloom* (1934, page 135) seems to be a free variation on it. The atmospheric pictures of 1929 are behind *Double Portrait* (1934), and there are earlier, somewhat caricatural portraits behind *Mister Z* (1934, fig. 38), which marks one extremity of simplification, a man's features formed by the letter Z. In *Caligula* (1936), one little boot produced by a kind of scribbling justifies the title.

The last three and a half years proved extraordinarily rich: in 1937 Klee produced 264 works (including drawings), 489 in 1938, 1,253 in 1939. Even in the year of his death (he stopped working in May, 1940), he produced 366. This is not counting a few unsigned works which are listed as posthumous. Nor did Klee limit himself to just a few themes, or concentrate on a few pictorial conceptions. In his case, maturity took the form of a certain apodictic formulation, a handwriting consisting of bars, which reduced all he had learned to the essential. How he could nonetheless produce the most varied works is a mystery, for down to the last days he executed such attractive pictures as *Horse at Waldsee* (1940). There are even works in which we find an echo of Klee's philosophical humor, for instance, *Capriccio in February* (1938), only we cannot be perfectly sure whether this is really humor or tragedy. *Clown in Bed* (1937) is certainly anything but cheerful, but *Traveling Circus* and *Child and Aunt* (page 141) of the same year certainly are.

The pictures composed of bars of varying thickness make their appearance in 1937; in some of these, color asserts itself against a skeleton of bars. Klee now often employs paste colors, sometimes thick, sometimes thin, alone or in combination with oil or watercolor; often plaster is added to the ground. He occasionally paints on rough materials like wrapping paper or burlap, as well as on linen and wax-coated grounds. He also makes use of wash colors and sometimes employs colored pencils or pastels.

The bar pictures of 1937 and 1938 are hard to subdivide. *Comments on a Region* (1937, fig. 41) is still slightly lyrical, but one is not even sure that the theme is a landscape. The bridge between the visible and the invisible becomes progressively harder to find. *Sentry*

(1937) is rather menacing with its thick bars, but Klee could also be very gentle with the bars, even without the addition of intermediate lines, as we see in the brush drawing *Dear, Oh Dear!* (1937, fig. 83).

Must we then conclude that these bar strokes can mean different things? *Heroic Fiddling* (1938, page 145) unquestionably refers to bowing and musical dynamics, but what are we to make of *The Gray One and the Coastline*? The title is picturesque, but the schema is the same as in *Heroic Fiddling*. Making a minimum of changes—a figurative addition here and there—Klee shifts from one theme to another. The basic polyvalence of these emblematic signs is such that he can do this. When Klee puts areas of color around the bar strokes, as in *Park near L* (1938, fig. 42), the result is chromatic passages that almost make us forget the bar schema.

In 1938 Klee painted seven large horizontal formats (up to 69 inches wide), which in a very free way combine bars with other pictorial means, especially color. Among these are *Fruit on Blue Ground*, *Rich Harbor*, *Spring of Fire*, and *Insula Dulcamara*. In so far as allusions to objects can be made out, they are ciphers of maturity or transience, landscape, or the sea. There are also ciphers for ordinary things like a key, the eye, or fruit, and they change meaning in new contexts. What is meant by *Design* or by *Artist's Bequest*? Try to find out the meaning of the ciphers and how they are related to the picture as a whole. "That's all that remains," Klee said, standing in front of *Bequest*. *Insula Dulcamara* (page 147) seems a welling up from some great happiness, so springlike are the colors, the young plants, and the sea; and yet we know that Klee was quite ill when he executed it. One is reminded of Mozart, who in moments of distress composed chorales. For all these large oils Klee made preliminary drawings on newspaper, which he pasted on burlap, and these served as ground for the paintings. Bits of advertisements here and there are occasionally visible through the paint.

Among the last groups of pictures are the late pastels (1937) on white cotton or burlap, more rarely on paper. The chalks are for the most part applied on a wet ground and absorbed by it; the technique heightens their luminosity and intensity. Many oriental elements appear, in *Legend of the Nile* and *Oriental Garden* (page 143), for instance, but *Stage Landscape* has features from Mozart's *Magic Flute*. Klee tells his story in hier-

46. DEMONRY. 1939. Tempera and watercolor on blackened paper, 8 ¹/₈ × 13 ¹/₄". *Klee Foundation, Bern*

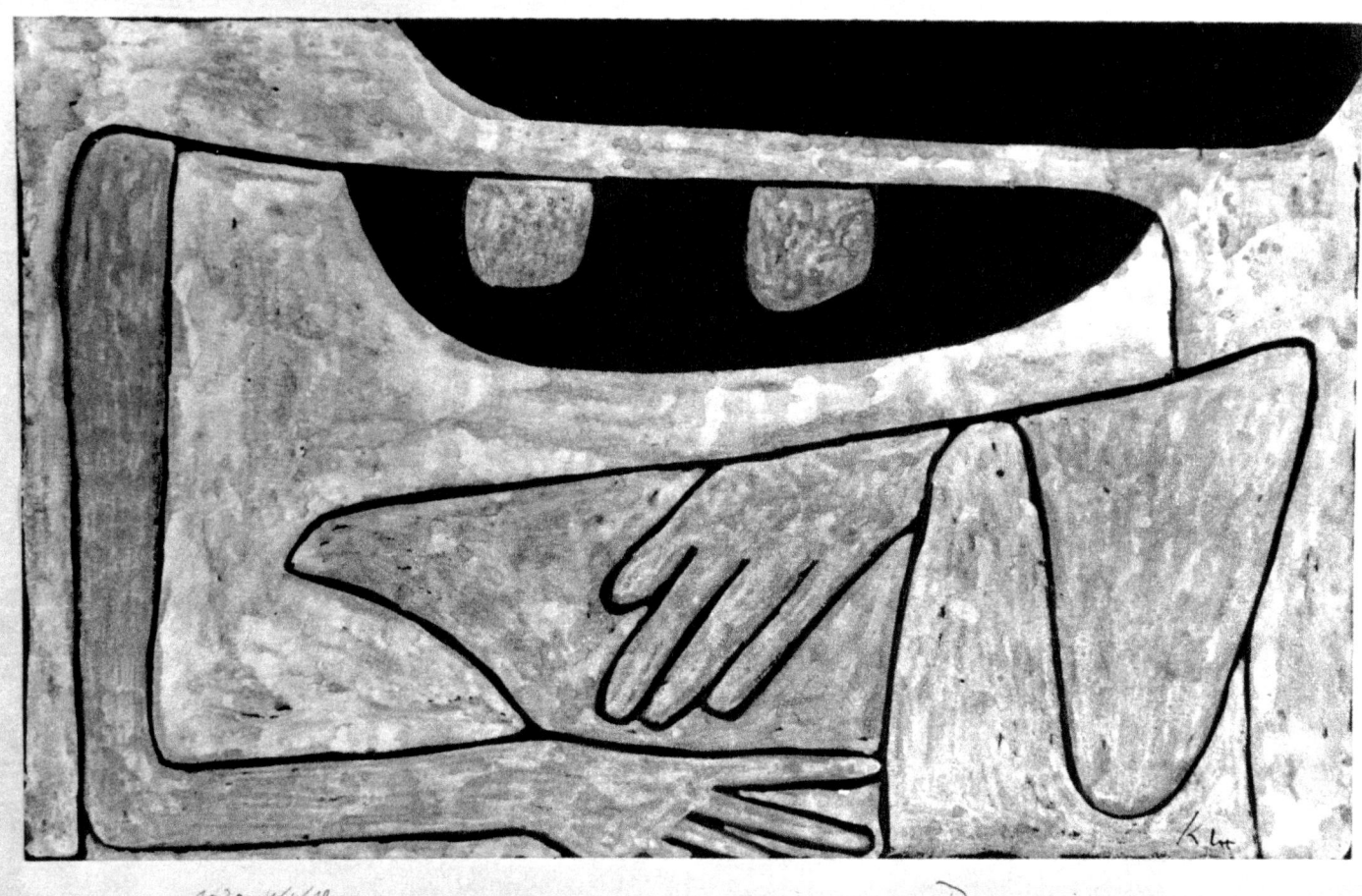

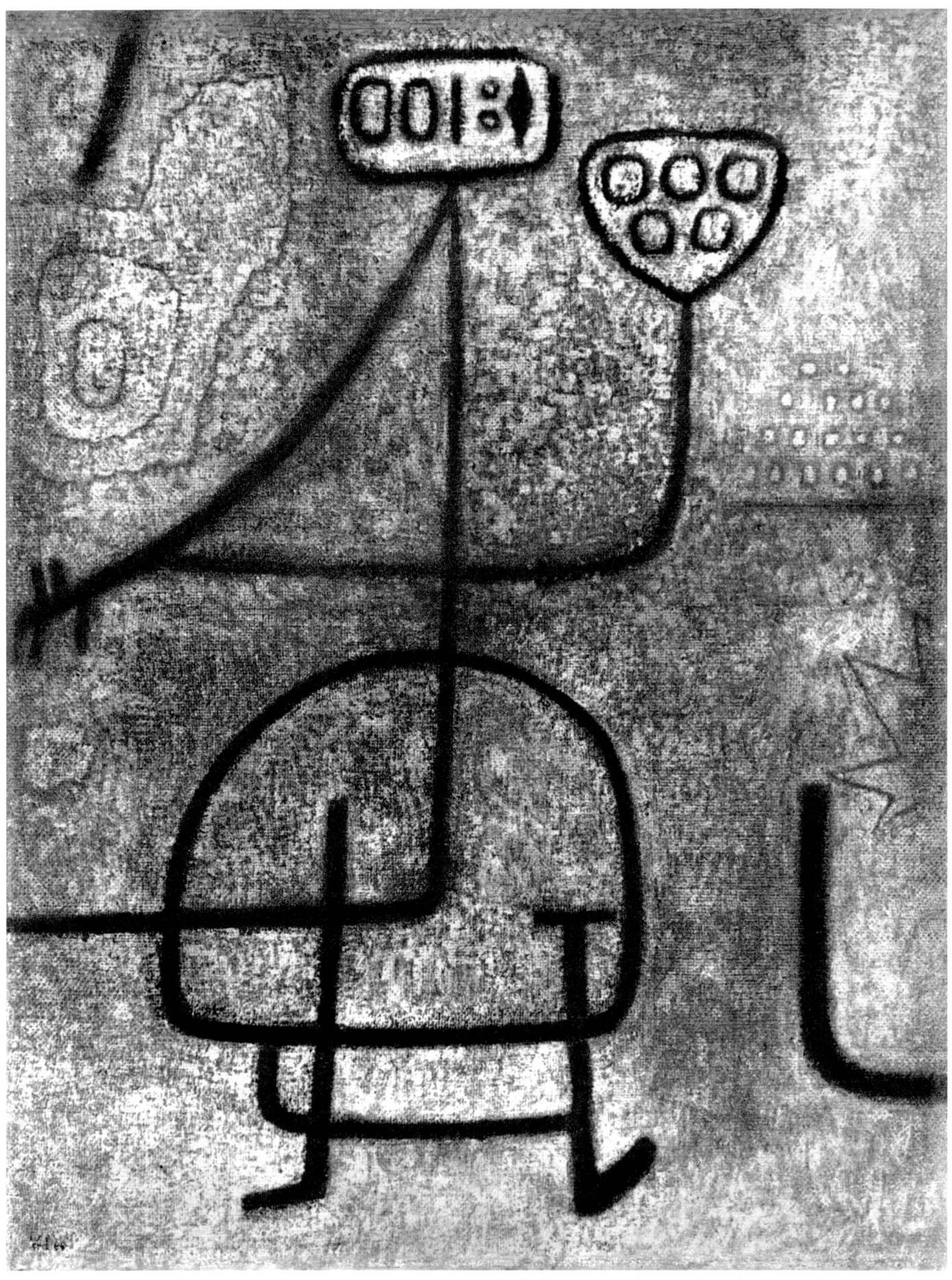

47. LA BELLE JARDINIÈRE (A BIEDERMEIER GHOST). 1939. Oil and tempera on burlap, mounted on panel, 37³/₄ × 28″. *Klee Foundation, Bern*

44

oglyphics on colored divisions of the surface and comes close to the sphere of poetic metaphor; *Blue Night* is a true hymn to night, like the one by Novalis. Often Klee merely listens inside himself, and then we get pictures with titles like *Green in Green* or *Yellow Signs*. Possibly to Klee these were similes or aspects of a world he saw in a state of euphoria. The colors here are more decisive than the signs—a rare case; they break down into a very few schemata: the "magic squares," those of the Divisionist or atmospheric sketches, and that of the pastels. In these, all we have to go on is the pictorial vocabulary: it is as though the meaning here transcends the colors, as in poems it may transcend the words. The patterns of the pastels go back to seeds that were planted more than twenty years before. *Green in Green* brings to mind Mallarmé's idea of writing a mute poem in white. *Poésie pure*.

We are now approaching the last period of Klee's life and work, pictures full of daemonic elements. Persons and acts are often fragmented and, seemingly fortuitously, reassembled. Color is more substantial than elsewhere, the signs look as though written in murky ooze. A picture like *La Belle Jardinière* (1939, fig. 47) is no less disquieting than *Park of Idols* (1939, page 151). *Mephistopheles as Pallas* smells of decay no less than *Love Song by the New Moon* (1939, page 155). Even the titles become unfathomable—in just what sense are we to think of Mephistopheles "as" Pallas? The German subtitle to the French "pretty gardener" work is "A Biedermeier Ghost." In so far as they are recognizable, the objects provide no enlightenment. The enigmatic element preponderates, as Klee speaks a language we can only grasp very indirectly. *Omphalo-Centric Lecture* (1939, fig. 44) might be a reference to Joyce's *Ulysses*. To Klee, too, the navel was the seat of divine light and prophetic inspiration, as well as symbol of birth and reincarnation. A painter is also a philosopher, Klee said, and as the end drew near he became ever more deeply caught up in the interplay of telluric forces or, alternatively, stepped over the boundary between this world and the Beyond.

Between these pictures and the Requiem he composed for himself (just like Mozart) come two sequences of drawings, the "Eidola" and the "Passion in Detail." Klee included among the "Eidola" (which means archetypes) *Warlord*, *Buffo Singer*, and *Knaueros, Former Kettledrummer* (1940, fig. 88). This last refers to

the drummer of the Dresden State Opera orchestra whose name was Knauer, and whom Klee admired at a symphony concert in that city. He re-surfaces in Klee's memory in 1940 as a hieroglyph of death (fig. 48). When executing these pictures, Klee said he felt so excited it was as though he were beating a drum. In the "Passion" sequence we find, next to *Old Maid*, a picture called *Dürer's Mother, Too* (1940, fig. 87). It is a tribute to the master whose drawing of his dying mother (1514) had deeply impressed Klee, but Klee gives her the features of Lily, his wife, whom he had met forty years earlier.

In 1939 Klee produced twenty-eight "Angels," and four more the year of his death; about twenty had already preceded these. They are not the angels of

48. KETTLEDRUMMER. 1940
Paste color on paper, mounted on board, $13^{1}/_{2} \times 8^{1}/_{2}$"
Klee Foundation, Bern

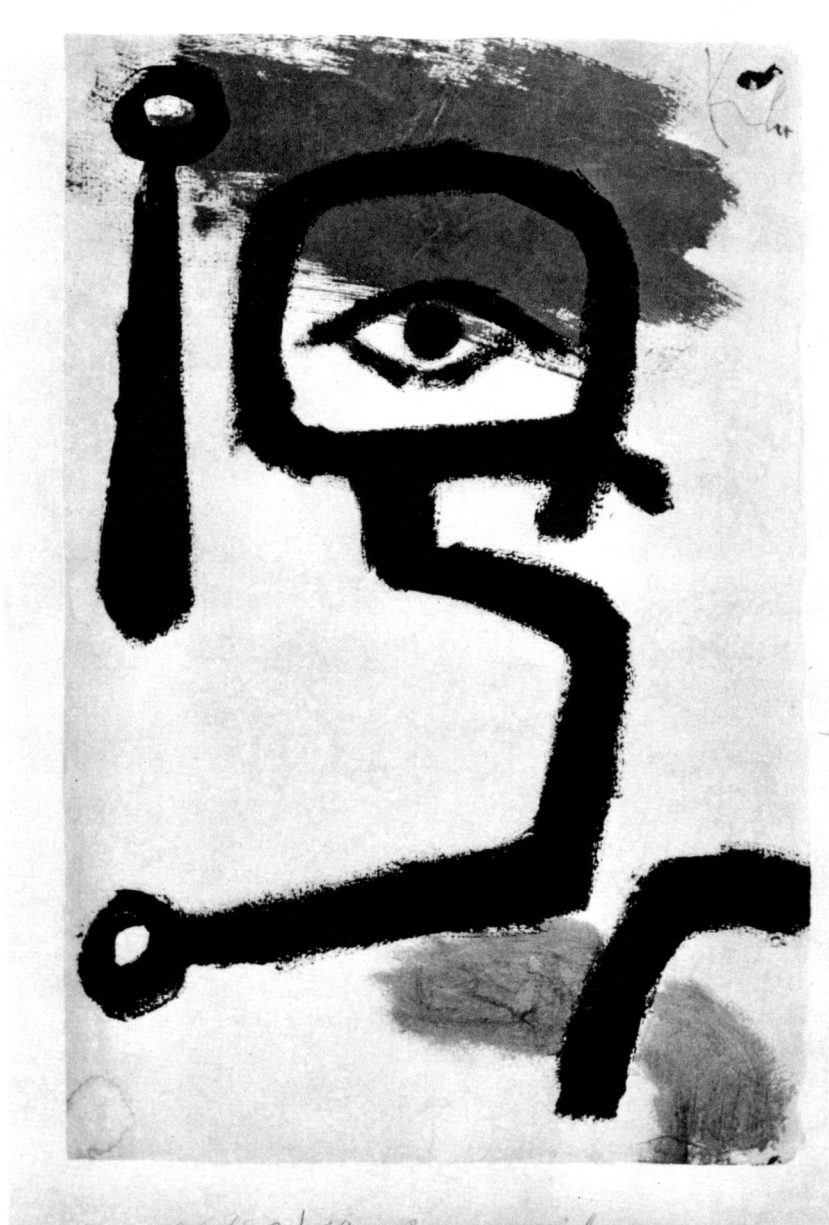

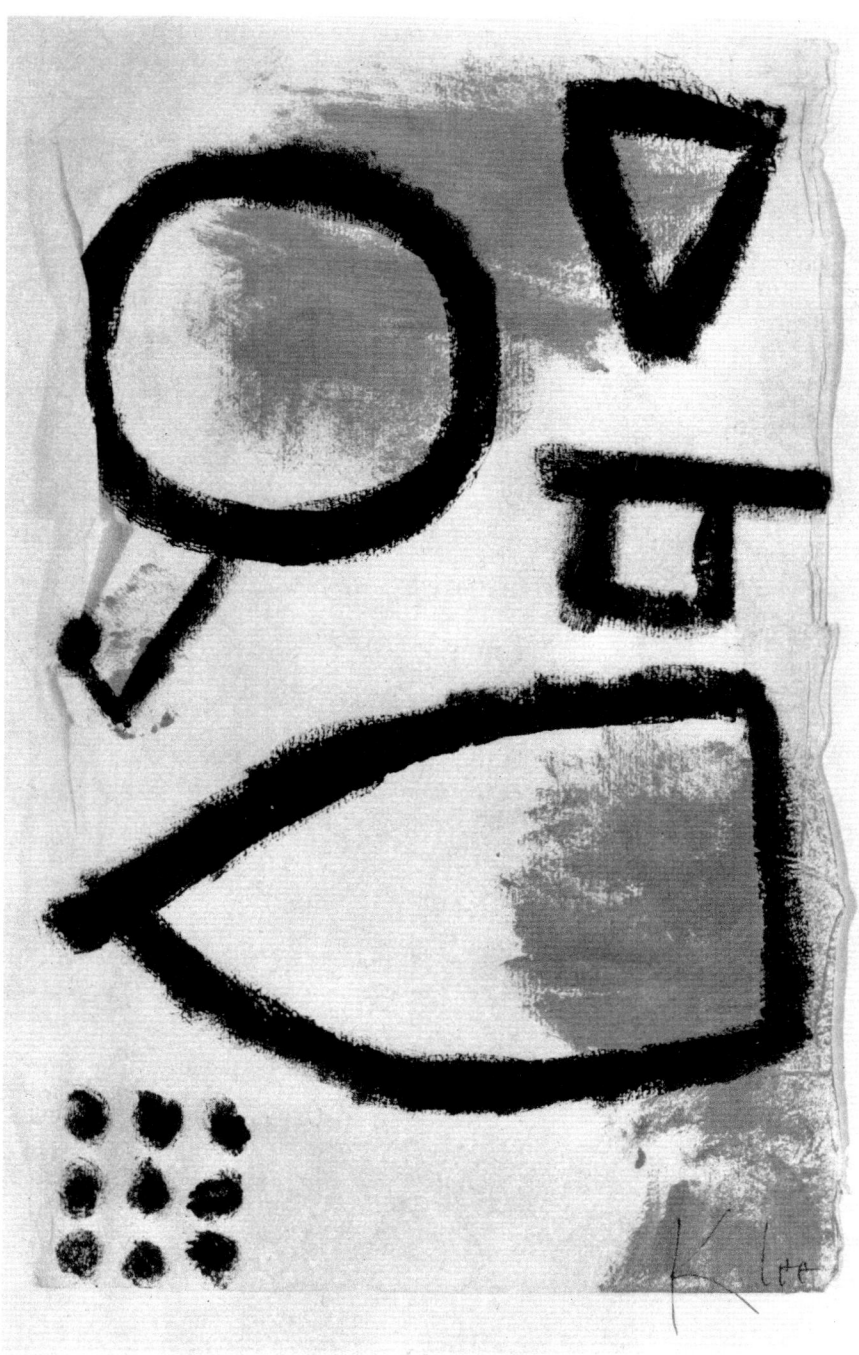

49. ALEA JACTA. 1940
Paste color on paper mounted on board, 13 ¹/₂ × 8 ¹/₂″
Collection F.C. Schang, New York

Rilke's *Duino Elegies*, higher beings ranging through life and death who have already transformed the visible into the invisible. Klee's angels also inhabit the great One that encompasses life and death, and in the invisible they perceive a higher kind of reality, but for Klee this was also true of man. In fact, the differences between angels and men are not great, for how otherwise could there be an *Unfinished Angel*, a *Forgetful Angel* (fig. 86), an angel who has *Not Yet Been Taught To Walk*, or a *Poor Angel* (1939, fig. 45)? Klee's angels are emblems of the last transformation, and his se-

quence must not be interpreted as an ascending hierarchical order, for the last one is the *Angelus Dubiosus*, not *Angel from a Star*. At the angelic level change is eschatological and points beyond itself. Thus it would be false to say that Klee changed his position in view of the end; he remains what he is—after all, had he not always felt "just as much at home among the dead as among the unborn"?

Klee knew that the end was approaching; did he still await a turn for the better? On January 2, 1940, he wrote the author after an attentive reading of the *Oresteia*: "Of course it is not by chance I got on the tragic track, many of my works point in that direction and say: The time has come." His works now revolve around the theme of the end, including *Gloomy Cruise* and *Charon*. The question of the questioner's existence gives meaning to artistic creation and reflects the tension between time and eternity. He was not afraid of death. As early as 1930, when he was at the peak of his life and work, he said apropos of death: "How can we say which is more important, life now or that which comes afterward?" He had always felt that death was merely a passage to the other side. Ever since Kairouan he viewed life as a continuous passing beyond, as a getting ahead of oneself. Now he had reached his goal, but the decline of physical energies mysteriously released superhuman creative energies, as though to him a new beginning lay hidden in passing away.

His last dated work is of May 10, but he left a few pictures unsigned. They revolve around the theme of death and transience, and fall into three groups. The first comprises such symbolic signs set down with a broad brush as *Alea Jacta* (fig. 49), *Hurt* (fig. 89), and *This Star Teaches Bending* (fig. 90). The terrestrial has been subjected here to a total process of artistic combustion, and all that remains is answers to calls the nature of which we can only guess at, answers set down with utter economy of means. These means had been anticipated in works such as *Hurry* (1938, fig. 43), *Pond with Swans* (1937, fig. 84), and *X-let* (1938), though here they are employed in more terrestrial senses. Klee is capable of using one and the same medium in very different ways; what changes in his hands are the direction of the expression and the kind of expression. *The Little One Has His Day Off* (1937, fig. 82) is one of the rare works based on personal experience, for it was inspired by fear concerning a

three-year-old runaway. The drawing might have become something entirely different, perhaps a landscape, but at the right moment the question of the little boy came up and gave the drawing its title.

The second group comprises the pictures with latticework, of which *Captive* (page 163) is an example, which transcend all boundaries between this world and the Beyond. The tragedy takes place in an intense blue, not in the hellish red of *Death and Fire*, the main work of the third group, with figures of Death and the ferryman. It is not easy to decide where to place the "Wood Louse" pictures: *Wood Louse* (fig. 50) and *Mud-Louse-Fish*. In figuration they belong among the latticework pictures, in color to the same group as *Death and Fire*. At all events they signify combustion, burning. Klee's language of images has become highly apodictic; in those last weeks not much else mattered to him. Requiem, not despair. Death, as Goethe put it, is "Nature's device for multiplying life."

One large *Still Life* on a black ground remains unsigned; it suggests no ebbing of energies, but only that the artist has confined himself to the indispensable.

At the left, Klee has stuck a piece of white paper into the frame, with the drawing of an angel gripped by two strong hands: Jacob wrestling with the angel. The still life, with its egg-yellow moon and the strawflowers on the tablecloth, makes a sort of ghostly nocturne. Klee was well aware that these were his very last pictures, but this did not prevent him from including a Hallelujah in his requiem, for how else are we to interpret *Glass Façade* (page 161)? A stained-glass window, if you will; the black contours supply the leading between the scarlet and green color areas. Because of the numinous effect one almost forgets that this work derives from the "magic squares" of the 1920s. It is idle to ask what Klee might have produced had it been granted him to live longer. He was ready; life and work, always inseparable in his case, remained so even in death and beyond death.

Klee had always held himself aloof from controversy, and nothing changed in this respect after his death. Unlike Kandinsky or Picasso, he never was attacked. He was admired, and no opportunity was missed to

50. WOOD LOUSE. 1940. Paste color, $11^{3}/_{8} \times 16^{1}/_{4}$". *Collection Rolf Bürgi, Bern*

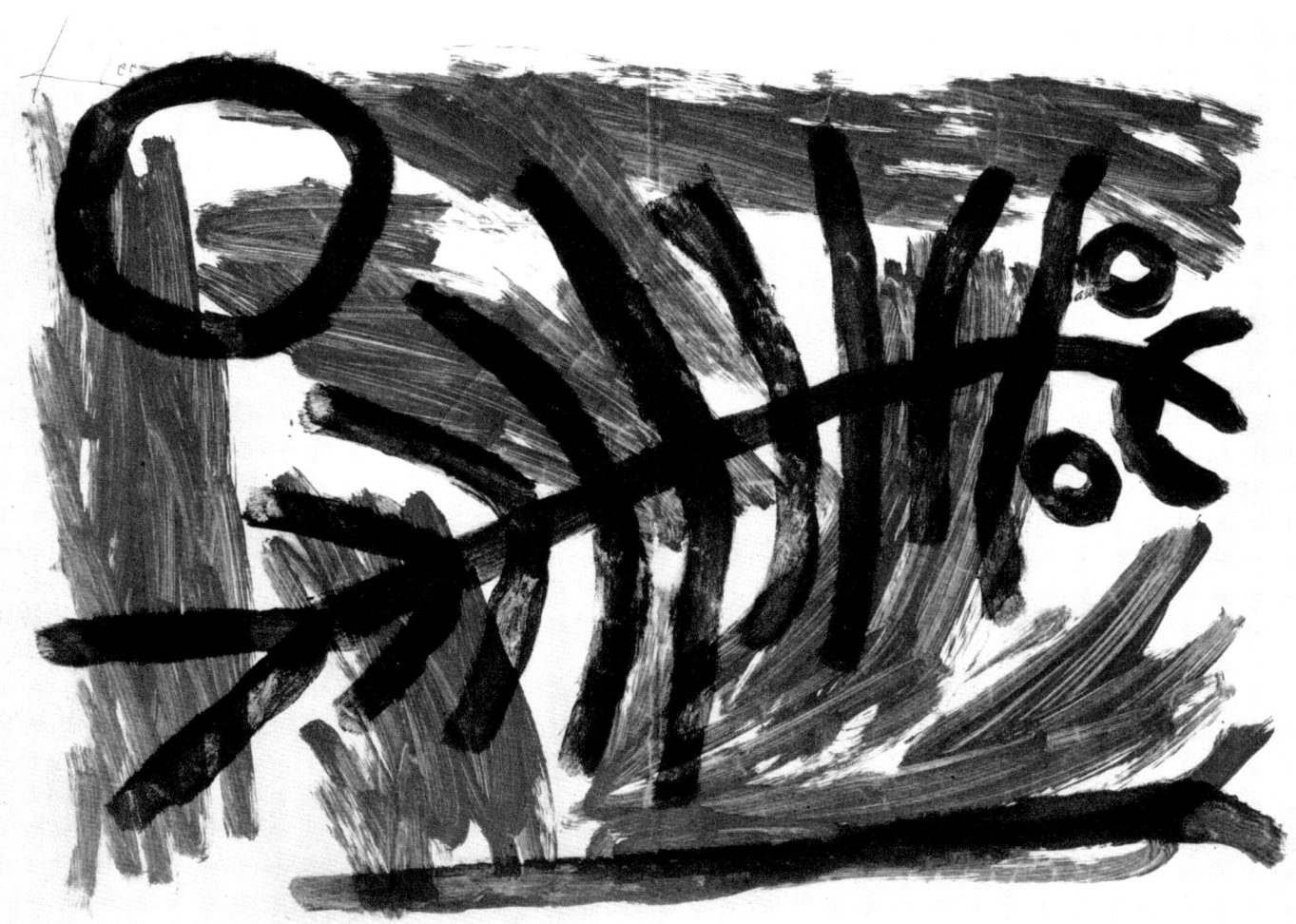

exhibit his works in Europe, in America, all over the world. There are perceptive collectors of Klee even in provincial cities of Japan. Though the age has moved on, what is eternal in Klee's work remains. Who today would claim he had not gained something from him?

A whole body of teachings might have been built up on the basis of Klee's thinking as outlined in his lectures and writings. That this has not been done is because it is impossible to make such a body of doctrine come to life without the force of Klee's personality to sustain it. Just what he was getting at in the course of a difficult analysis often dawned upon his listeners only because Klee was there to illustrate it with a single word or gesture. How could "the formal fuse with the world view" (Klee in 1917) if teacher and inventor were not the same man? Klee taught only so much of his art as could be learned, but this amounted to a good deal. "In art, too, there is plenty of room for exact research, and the door has been open to it for some time. What had been done for music before the end of the eighteenth century has been begun, at least, in the field of pictorial art." Nonetheless—and nobody knew this better than Klee—nothing can replace intuition. There is nothing a teacher can say about genius: "Genius is genius, a higher gift which has neither a beginning nor an end." Speaking conversationally during a lesson, Klee once formulated this provocative statement: "Genius is the error in the system." This is the reason why so many students, though they assimilate everything there is to be learned, nonetheless never reach the point of "creating."

It is hard to define Klee in a few words. After all, he was not merely a painter, but also a student of nature, a philosopher, a poet, and a musician. He lived in many worlds, including the world of the primeval, of the dark, and in all of these it was a matter of belonging, not of gradually establishing contact. He practiced music, composed poems; he painted *Fugue in Red* (1921)—and it *is* a fugue—painted *A Light and Dry Poem* (1938), and no one has written a better poem. Since Klee in every connection kept going back to the basic elements, it was natural for him to exploit the inner unity that links painting, poetry, and music. When Klee was in the Near East or conjured it up in his Tunisian and Egyptian pictures, the very spirit of the Near East was in him, the alliance between gaiety and seriousness, the love of metaphor. With all this, Klee aimed not only at the most comprehensive formula, but also at the most exact one. Only thus can we account for the way he labored over those thousands of drawings, until he had found exactly the right solution to a given problem. He was tireless and unshakable, always surpassing himself with new exploits. If, at the end, he skipped a phase or two, this was only in order to be entirely in harmony with death.

THE DRAWINGS

Of Klee's approximately nine thousand works, about five thousand are drawings. Klee was reluctant to part with these, for besides serving as preliminary studies they constituted his archives. Often enough, he executed a drawing only after he had already realized a conception in the form of a watercolor or a painting. Moreover, demand for his drawings was curiously small, and only a few found their way into private collections or museums before his death. The first dealer to appreciate them and urge them upon his clients was the late Curt Valentin in New York, but he only began to do this shortly before the artist's death.

Drawing meant something very different to Klee in the early years from what it meant to him later. For a long time, he suspected that he would have to make his living as an illustrator. Of course, as he eventually learned, this was not so, but it helps to explain why he worked so long and hard on his drawings for Voltaire's *Candide* (1911–12, fig. 55), which did not find a publisher until 1920. *Die Jugend* and *Simplizissimus* rejected all the drawings he sent them. So, in the course of the years, his drawings gradually came to be a proving ground to him for trying out variously "constructive," naturalistic, and impressionistic experiments. At times he felt that his hand was the "instrument of a higher power," at other times he merely worked away "making images from nature," or setting down "experiences that could translate themselves into line even in the dark of the night."

His production of drawings declined somewhat over the years. In 1914 for the first time he produced more watercolors and paintings than drawings. After the trip to Tunisia, Klee worked predominantly in color, but in the last years the ratio swung around again, to the point where Klee frequently would produce a whole series of drawings in a single evening. In 1939 he produced 962 drawings as against 291 works in color.

Down to the time he left Munich, his drawings are either abstract or, as he put it, "absolute" drawings such as *Drawing with Fermata*, or anecdotal drawings like *Scherzo with Ladder* (figs. 59, 60), both dating from 1918. After he moved to the Bauhaus in Weimar, the narrative element continues to predominate for a time,

as in *Dance of the Mourning Child* (1921, fig. 65) and *For Little Liese's Autograph Album* (1921, fig. 64). Such works may have been inspired by opera or ballet, but the feeling is definitely more musical than theatrical. In the following years this situation changes little, though new schemata make their appearance. *Dr. Bartolo* (1921, fig. 62) is a mixture of musical notation and construction. *Home of the Opera-Bouffe* (1925, fig. 66) is a lacy texture made up of stairs, windows, and sonorous S-curves.

51. CHRIST CHILD WITH YELLOW WINGS. 1885
Crayon, $3\,^1/_8 \times 2\,^1/_8$". *Klee Foundation, Bern*

52. COMEDIAN II. 1904. Etching, $5 \times 5^3/_8''$

The schemata Klee developed at the Bauhaus are on the whole those we find in his drawings *(Animals in Moonlight*, 1927, fig. 69). Only a few drawings fall outside the schemata—the "magic squares" and the "Divisionist" drawings. Many drawings, such as the "Beride" series *(Air-tsu-dni*, 1927, fig. 72), derive from an imaginary journey. A drawing like *Dreamlike* (1930, fig. 73) is simply not susceptible of painterly treatment. Figurations like *Shame* (1933, fig. 77) and *Figure Entering* (1935, fig. 79), the latter employing water-soluble colors, can be derived only from specific graphic ideas.

After 1935, when he fell ill, Klee often used pencil because it required less physical effort. From 1937 on we have, next to geometrically exact works and looser

brush drawings, the works in which bar strokes of varying thicknesses figure. One might suppose them unsuited to the expression of gentle feeling, but this is not so. They are extremely sensitive and display the charming humor which Klee preserved to the very last. These drawings are only surpassed, if at all, by the last symbolic ones, which are of incredible concentration *(Hurt*, fig. 89). Here the artist really condenses all his energies in a single sign comparable to a Chinese ideogram.

Besides these, in the last months we have the "Eidola" series including *Ex-Warlord*, and the series of the "Passion in Detail," including *Galley Slave*, drawings which, like the "Angels," mark the uttermost simplification

of line and expression. They are Klee's farewell to drawing, in which he sets down the end of his life and work.

Technically, Klee's drawings are as conscientious and painstaking as his works in color. To him, technique was never a tool to be applied mechanically, but presupposed a high degree of capacity for divination. He always knew whether he should work with pencil, pen, or charcoal, and he looked upon many of his drawings as training exercises. "Make sketches," he advised his students, "the more the hand is capable of writing, the more sensitive the signs become." Klee was so well trained that he was never disturbed if watched while drawing; his hand moved as though of its own accord.

In the early years he preferred the pencil, from 1908 on the pen, and he never abandoned the latter. In 1925 he added the brush, which was to play a more important role after 1933, and in 1927 the reed pen. At the close of the 1920s he occasionally employed crayon and

charcoal, and from 1932 on a broad-edged heavy pencil; at the very last the pencil comes to the fore again. When he needed an indirectly differentiated line, he used tracing paper which he prepared himself with black oil paint. Here, mysterious and quite unintentional stains produced on the white sheet by application of the hand are sometimes left in the final drawing.

The influence of Klee's drawings was nothing like so great as that of his work in color. Unquestionably they did influence a few younger artists, such as Max Ernst and Joan Miró, and this as early as the 1920s. Wols was the most striking instance of such influence, after World War II. When one keeps in mind that more than three thousand drawings are still in Bern (in the Klee Foundation and in the Felix Klee collection), and that the rest have been scattered among many private collections and print rooms since 1945, one understands why this greatest graphic œuvre of any twentieth-century master has remained relatively little known.

53. VIRGIN (DREAMING), titled VIRGIN IN A TREE. 1903. Etching, $9\,^1/_4 \times 11\,^3/_4''$

54. MY ROOM. 1896. Pen and wash, $4^3/_4 \times 7^1/_2$". *Klee Foundation, Bern*

55. IL LÈVE LE VOILE D'UNE MAIN TIMIDE (SHYLY, HE LIFTS THE VEIL). Illustration for Voltaire's *Candide*, chapter 7
1911. Tusche and pen, $6^1/_4 \times 9^1/_2$". *Klee Foundation, Bern*

56. MAIN RAILWAY STATION, MUNICH I. 1911. Tusche and pen, $5^3/_8 \times 10^3/_8''$. *Collection Dr. F. Trüssel, Bern*

57. A CLEARING IN THE FOREST. 1910. Tusche and pen, $4^1/_2 \times 6^1/_2''$. *Collection Rolf Bürgi, Bern*

58. HORSE RACE. 1911. *Whereabouts unknown*

59. DRAWING WITH FERMATA. 1918. Tusche and pen, $6^{1}/_{4} \times 9^{5}/_{8}''$. *Klee Foundation, Bern*

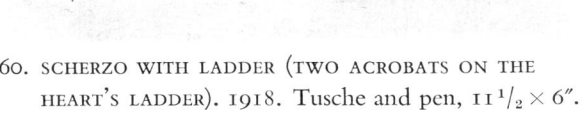

60. SCHERZO WITH LADDER (TWO ACROBATS ON THE HEART'S LADDER). 1918. Tusche and pen, 11 1/2 × 6″. *Formerly Collection Curt Valentin, New York*

61. DRAWING FOR "PERSPECTIVE OF A ROOM WITH OCCUPANTS." 1921. Pen and pencil, 13 1/4 × 9 7/8″. *Klee Foundation, Bern*

62. DRAWING FOR "DR. BARTOLO." 1921. Pen and violet ink, 7 3/8 × 11 1/8″. *Klee Foundation, Bern*

63. OF THE FATE OF TWO MAIDENS. 1921. Oil drawing, $8^5/_8 \times 11^1/_4$". *Collection Dr. Bernhard Sprengel, Hanover*

64. FOR LITTLE LIESE'S AUTOGRAPH ALBUM. 1921. Pen and violet ink, $9^1/_2 \times 11$". *Collection Dr. Theodore Leshner, New York*

65. DANCE OF THE MOURNING CHILD. 1921. Tusche and pen, $7^5/_8 \times 8^5/_8''$
Klee Foundation, Bern

66. HOME OF THE OPERA-BOUFFE. 1925. Brush drawing, watercolor on chalk-coated ground, $8^1/_2 \times 11''$. *Collection Mrs. Charlotte Purcell, Chicago*

67. AN ORIENTED PERSON. 1927. Tusche and pen,
$12^1/_4 \times 9^1/_4$". *Private Collection, U.S.A.*

68. RECOGNITION OF AN ANIMAL. 1925. Tusche and pen, $12^3/_4 \times 8^1/_2$"
Busch-Reisinger Museum, Cambridge, Massachusetts

69. ANIMALS IN MOONLIGHT. 1927
Black chalk, $8^3/_4 \times 7^1/_8$".
*Collection F. C. Schang,
New York*

70. RURAL CLOWN. 1925
Brush drawing, $10^1/_4 \times 4^1/_8$".
*Collection F. C. Schang,
New York*

71. THE GREAT DOME. 1927. Tusche and pen, 10¹/₂ × 11⁷/₈″. *Klee Foundation, Bern*

72. AIR-TSU-DNI. 1927. Tusche and pen, 11³/₄ × 11″. *Collection Dr. Hans Meyer, Bern*

73. DREAMLIKE. 1930. Tusche and pen, 10¹/₈ × 12″. *Klee Foundation, Bern*

74. ON THEIR WAY OUT. 1929. Tusche and reed pen, 12 × 18″. *Collection Nelson A. Rockefeller, New York*

75. MECHANICS OF A PART OF TOWN. 1928. Tusche and pen, $5\,^1/_4 \times 10\,^1/_4''$. *Private collection, U.S.A.*

76. OVERBRIDGED. 1931. Tusche, pen, and brush, $25 \times 16''$
Collection Mrs. Kay Hillman, New York

77. SHAME. 1933
Brush drawing,
$18^1/_2 \times 25''$
*Klee Foundation,
Bern*

78. DISAGREEMENT ABOUT THE HEAD. 1933
Watercolor, $17^3/_8 \times 11''$. *Private collection, U.S.A.*

79. FIGURE ENTERING. 1935. Watercolor, $21^1/_2 \times 11^3/_4''$
Formerly Collection Curt Valentin, New York

80. EMIGRATING. 1933. Pencil,
13 × 8¹/₄″. *Klee Foundation, Bern*

81. SCENE OF COMIC RIDERS. 1935
Pencil, 16⁷/₈ × 11¹/₂″. *Private collection, U.S.A.*

82. THE LITTLE ONE HAS A DAY OFF. 1937
Black paste color, $18^7/_8 \times 13''$. *Collection Max Bill, Zurich*

83. "DEAR, OH DEAR!" 1937. Black watercolor
and paste, $11^3/_8 \times 7^1/_8''$. *Collection Rolf Bürgi, Bern*

84. POND WITH SWANS. 1937. Black paste color, $19^1/_4 \times 16^3/_4''$
Collection Mrs. John D. Rockefeller III, New York

85. MONOLOGUE OF THE KITTEN. 1938
Pencil, $11^3/_4 \times 8^1/_2''$. *Collection Felix Klee, Bern*

86. FORGETFUL ANGEL. 1939
Pencil, $11^1/_2 \times 8^1/_4''$. *Klee Foundation, Bern*

87. DÜRER'S MOTHER, TOO (from "Passion in Detail" series). 1940
Pencil, $11^1/_2 \times 8^1/_4''$. *Klee Foundation, Bern*

88. KNAUEROS, FORMER KETTLEDRUMMER (from "Eidola" series)
1940. Pencil, $11^3/_4 \times 8^1/_4''$. *Klee Foundation, Bern*

89. HURT. 1940. Black paste color, $16^1/_2 \times 11^5/_8''$. *Klee Foundation, Bern*

90. THIS STAR TEACHES BENDING. 1940. Paste color mounted on board, $14^5/_8 \times 16^1/_8''$. *Collection Felix Klee, Bern*

COLORPLATES

Painted 1909

THE ARTIST AT THE WINDOW

Watercolor and colored chalk, 11 ³/₄ × 9 ¹/₄"

Collection Felix Klee, Bern

One of the many self-portraits from Klee's early period. Like others from 1899 on, it is still close enough to nature to be a resemblance, though the rapid, slanting brush strokes blur and distort it. Later self-portraits, such as *Lost in Thought* (1919, fig. 9) and *Specter of a Genius* (1922, fig. 8), are spiritual rather than physical portraits.

Here Klee is sitting on an old-fashioned chair, his back to the window and the light, with a drawing board on his knees. He is drawing with his right hand—this is unusual, for he was left-handed. It is true that he also was able to draw and paint with his right hand, or even with both hands at once. In the course of a lesson he once told his students: "Keep exercising your hand, best of all both hands, for the left writes differently. It is less skillful and, for this very reason, often more serviceable. The right hand writes more naturally, the left more hieroglyphically. Handwriting is not an exercise in neatness, but in expression—think of the Chinese—and with practice becomes more and more sensitive, intuitive, spiritual."

Klee employed black watercolor at this time, less sure of his mastery of color than after the trip to Tunisia. He was content to manipulate the "weights," as he called them, leaving mastery of the "qualities" for later. The blue dots of the curtains and the reddish-brown highlight on the head and coat must have been added with chalk while the watercolor was still wet. Precisely because the range of tones is so limited, the picture takes on an attractive colorfulness, the white becomes more radiant, the sepia brown warmer. Indeed, Klee used sepia, not black watercolor, here. Sunlight outlines the right shoulder and arm, endowing them with perceptible dynamism, and at the same time adds volume to the body and produces a contrast between it and the light-flooded space behind it.

Klee drew this self-portrait from memory. After moving to Munich he worked a great deal "pictorially, from nature"—landscapes, heads, nudes—purely training exercises, as it were. By 1908 nature had begun to bore him, he was becoming more and more interested in the pictorial means; for instance, in the proportion of light to dark in composition. But he wanted to keep as much as possible of the elements of the outer world, until he felt that in order to say more than nature (and what painter does not aspire to this?) one must do it with fewer, not with more, means. This is why Klee limits his possibilities of painting here, concentrates on a single gesture which at the same time determines the expression.

Painted 1913

IN THE QUARRY

Watercolor, 9 × 13³/₄″

Klee Foundation, Bern

This is one of the few perfect watercolors executed before Klee's trip to Kairouan in 1914. It is amazing with what sureness he selects and applies his colors here, and with how few indications of objects he constructs his landscape. It is complete and self-contained in every respect.

Presumably it was painted in the quarries at Ostermundigen near Bern, which belonged to friends of the Klee family. Klee was always attracted by them, evoking them at least once even after the trip to Tunisia *(Quarry,* 1915), though in the latter work the natural scene is treated in terms of the Kairouan square patterns.

In the watercolor shown here, nature and artistic conception are harmonized in Cézanne's sense—reality and invention are seen as reciprocal, the dependence on a law is not far removed from a pre-established harmony, and the sensitivity with which color plane is set against color plane comes very close to Cézanne. The lack of contours still troubles Klee a bit; he cannot dispense with them entirely, but he weakens their ties to color. His experience with black-and-white watercolor helps him find the correct tones; here he graduates pinks against dark greens as he formerly graduated grays against black and white.

There is also the influence of meeting Delaunay in Paris in 1912. Klee's concern here, however, is not in employing color "simultaneity" as a means of introducing space, time, even objects into the picture, but in the possibility of balancing quantities against qualities. Klee places the area of violet-pink against the deeper violet above it, the bright green at the center against the blue-green with leaflike contours at the right, and the carmine-red clumps against the pointed green forms at the left. All this reveals intuition, but also artistic good sense. Delaunay's insights will stay with him for a long time, helping him in his own development, as will Kandinsky's insights into the relationships between form and color.

The result, however, is wholly Klee. The theme has been pictorially so well prepared that it is exhaustively treated in every aspect: content, color, and form. The green plant shapes, the violet-pink gravel banks, and the sandstone-colored blocks of stone provide the foundation for the picture. Quarry architecture and conception are at one.

Klee
1913 135 Im Steinbruch

Painted 1914

HAMMAMET WITH MOSQUE

Watercolor, 8$^1/_8$ × 7$^1/_2$″

Collection Heinz Berggruen, Paris

In 1914 Klee traveled to Tunisia, and during his stay there painted *Steamship in the Harbor (Tunis)*, a work followed by a number of watercolors treating motifs of the trip: St. Germain, Kairouan, Hammamet, Arabs, and camels. Back in Munich he first finished a few sketches begun before his trip, but he did not forget Kairouan. On August 1, World War I broke out, and only with the painting shown here does the long series of watercolors done from memory begin. He kept working on these for the rest of the year. Time and again Klee went back to the schema he had invented in North Africa, frequently making new variations on it.

This is not a study from nature. The arrangement of the colored areas, not bounded by lines, in the lower half of the picture, their overlappings and their transparency, the modulations from carmine to rose-violet and from yellow to green, show at once that here Klee was consciously drawing upon lessons lately learned, in part from the examples of Cézanne and Delaunay. Accentuating the points where the geometric and the nongeometric planes intersect, he suggests a road running through sparse vegetation toward the tower, which can also be reached by a circuitous route on either side of it. As in *Southern Gardens* (1919, page 85), we see that Klee pasted a strip along the right edge of this picture, not to make the picture larger, but to complement the schema with a few narrow rectangles of the same colors as the rest, plus some blue which was missing among the complementary colors in the lower part of the picture.

As a rule, the Kairouan watercolors are based on a pattern of squares that is rhythmic in effect, whereas the sequence of the colors filling them is melodic. It is hard to say whether these squares derive from analytical Cubism or from Klee's own researches. Presumably he was still under the influence of Cubism and Orphism, which encouraged him to greater boldness. However, the lyrical element (an adjective preferable to "anecdotal") is entirely his own contribution. He evokes clumps of grass and bushes amid the geometric shapes. Sometimes it is a city, sometimes a group of camels that emerges from the pattern of little squares. In the work shown here, which is somewhat more "objective" than others, a mosque with two towers, surrounded by gardens, rises against a mat blue sky. All the details stand out clearly.

Presumably, what fascinated Klee was this very contrast with the rhythmic forms and the colors in the lower part of the picture. He was interested in the problem of combining the absolute with the object, to weld them into one, so that the city in the upper part of the picture would tower over the broad foundations in the lower part. The horizontal strip across the top does more than serve merely to link the abstract area at the right with the colored planes below it. It rounds off the work and unifies it.

Such unity between inventive freedom and the functional elements of form and color, between the incomparable and the demonstrable, was often achieved by Klee from 1914 on, and not only in the Tunisian series.

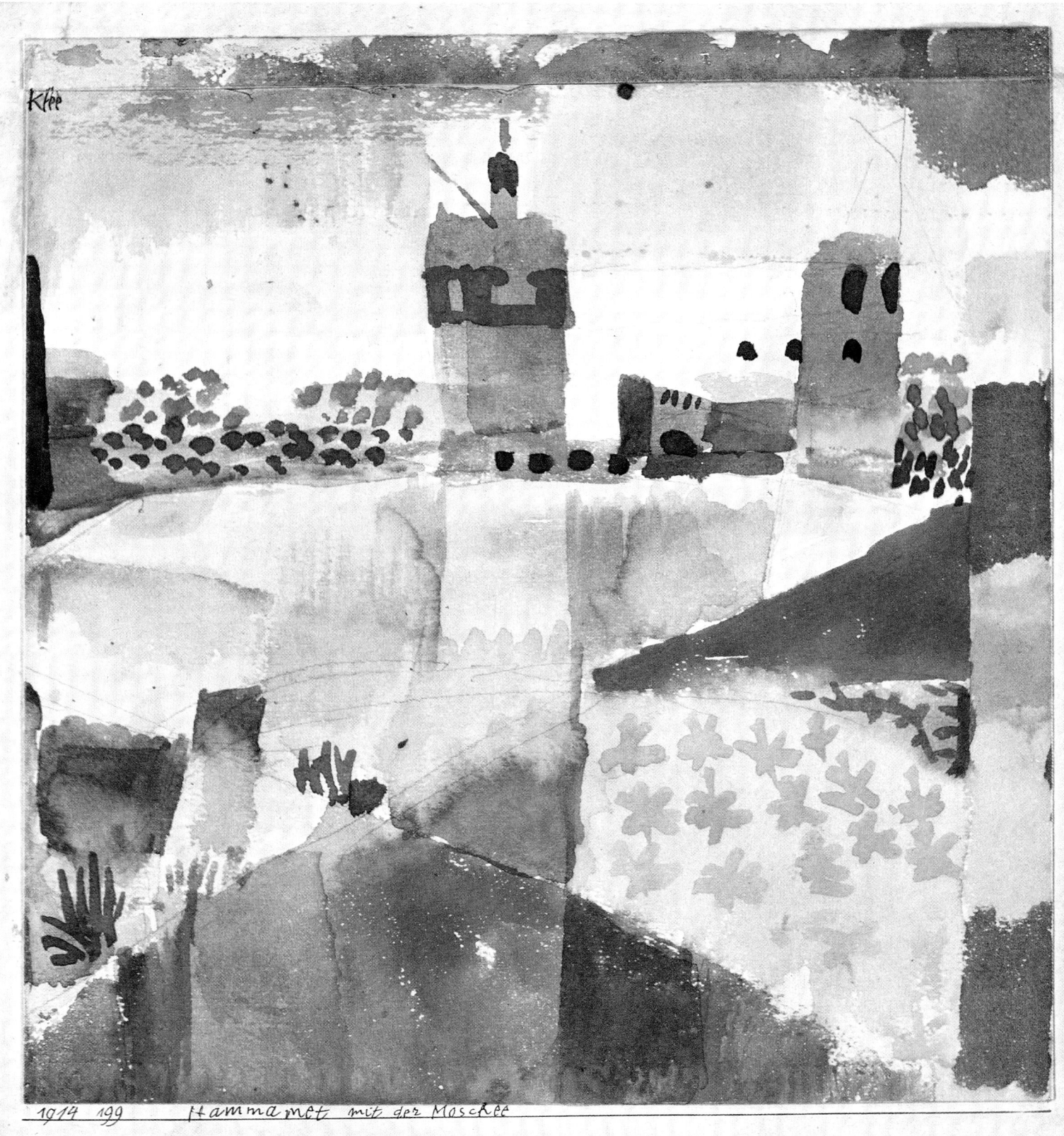

Painted 1915

SIDE PANELS FOR
"ANATOMY OF APHRODITE"

Two watercolors on chalk-coated ground, 9 × 7¹/₂″ overall

Collection Felix Klee, Bern

These are the side panels for the work titled *Anatomy of Aphrodite*. All three parts belong to the group of mysterious abstract pictures, more unfathomable even than *Movement of Gothic Halls* (1915) or *Lech River Landscape* (1917). Klee rather tossed these off, but occasionally a mention of them turns up in his *Diary* or in a letter, to the effect that he has just "painted a few watercolors that even I find deeply moving." He says it, for instance, of *Lech River Landscape*, which at the time was looked upon as "un-Kleean" for the flashes of lightning and stars composing it. His more "romantic" pictures were the ones admired in those years, not works like *Movement of Gothic Halls* or *Colored Circles with Colored Bands* (1914).

What sort of an Aphrodite did he have in mind here? Klee was so well versed in Greek mythology that we cannot assume such a title was arbitrarily chosen, like the titles some artists give their pictures today. And what does Aphrodite's "anatomy" mean here?

Klee himself would not have cared to be taken so literally. "We quit the here below and build beyond, toward the land of the Great Yes. Abstraction. The cool romanticism of this unrhetorical style is unprecedented." What does he mean? Actually, it was not abstraction he was seeking. Klee goes on to say: "The more terrifying this world (just as it is today), the more abstract art becomes. A happy world produces an art that celebrates the here and now" *(Diary*, 1915, 951). We may be a trifle surprised at this view; restless times produce an abstract art, untroubled times a more objective art. If the idea is sound, then those who attribute the abstractness of the earliest artistic expression to the fears of primitive man would be right.

The war was on, Klee was facing mobilization, his future uncertain. Invisible forces now asserted themselves in him, in the expressive movement of his hand, the hand as instrument of a remote will. "I must have friends there, dark ones as well as luminous ones, but I find in them all a great kindness." He was even able to sketch the *Feelings Aroused by a Girl Playing the Lyre*.

Anatomy? We are familiar with the anatomy of the female body; it would be absurd to try to read it into this picture, or to discover correspondences in minor allusions. Klee must have meant by anatomy in this case something altogether different, something like a diagram of the divine female rising from the sea foam, the eternal miracle of love, harmony—but also the pangs of love (Helen).

Just as in *Movement of Gothic Halls*, a myth is created here through the use of light and color; whether it has been realized in arching forms or some figure from Greek mythology is essentially a question of secondary importance. Klee's *Aphrodite* is like Delaunay's *Saint-Séverin*. Klee goes so particularly far in abstraction here in order to gain every conceivable freedom to apply the same schema to the treatment of two contrasting themes.

Klee

1915. 48.

Painted 1918

NIGHT FLOWERS (SUBMERGED LANDSCAPE ON BLUE GOUACHE)

Watercolor, $6^5/_8 \times 6^3/_4''$

Folkwang Museum, Essen

1918 was a romantic year. Klee's pictures, some of them watercolors on chalk- or plaster-coated grounds, were so popular that late in life Klee still owned only one or two of them, and could only hold on to these with difficulty. German collectors and amateurs caught on almost at once to the fairytale charm of *Kingdom of Birds*, *Descent of the Dove*, *Myth of the Flowers*, and *Hermitage*. But 1918 was also marked by aggressive works such as *The Moon Was Waning and Showed Me the Ugly Face of an Englishman, an Infamous Lord*.

Submerged Landscape on Blue Gouache (it was given the title *Night Flowers* by the Folkwang Museum) may well bring to mind Novalis' "Blue Flower." Like *Ad Marginem* (1930), this picture can be read from all four sides. The flower resembling a helianthemum is growing down from the upper edge. The red tower is rising from the bottom edge. From the left, starworts are growing out toward the center. At the upper left a dark triangle protrudes—is it a mountain or a formal expedient?

There is a lot going on in such phantasmagorias and in most of them there is also a human form somewhere among the different plants: the green fir trees and palmlike growths, vegetation both familiar and exotic. The landscape must surely be inhabited, for one window in the red tower is open, and at the left stands an inviting pavilion. Is it a submerged landscape? Vineta? Is the blue the color of the sea, does "submerged" denote more than embedded in blue gouache?

At the left the silver moon Klee encountered at Kairouan is shining. "Like a muffled mirror image, many a blond Northern moonrise will whisper memories to me, again and again. It will be my bride, my alter ego. An incitement to find myself. But I myself am the Southern moonrise" (Easter Sunday, 1914, at Saint-Germain near Tunis).

Under the crescent moon, the black sun. Black suns often turn up in Klee's pictures next to rising stars. Is the black circle over the "submerged" landscape a kind of foothold that prevents us from sinking deeper, an emblem of Fate, or intended merely to strengthen the loose structure of a picture knit together from all sides out of so many different elements? Actually, it is not so loose as all that—turned upside down, it is still right, but the circle does help keep things balanced.

Klee's development is marked by a continual alternation—breathing in, breathing out. 1918 is a relatively terrestrial year. By contrast, the *Ab Ovo* and *Dynamic of a Lech River Landscape* of 1917 are worlds deriving from formal considerations or spheres of "cosmic community." In 1919, a great year for oil paintings, these are still being explored, alongside experiments that still recognize the claims of optical appearance.

Painted 1919

LITTLE TREE AMID SHRUBBERY

Oil on paper, 12 × 9"

Collection Nika Hulton, London

This work is one of the long series of oil paintings that mark the year 1919. It is noteworthy for the fact that, at the time, Klee had rarely made so exclusive a use of color. There are no contours, unless you take the little tree in the middle for an outlined form. Moreover, the better known paintings from that year, like *Villa R* or *Picture with Cock and Grenadier*, have associative elements, references to the familiar and to human fate, whereas the work shown here looks like a color chart. The colors pass into one another, forming eddies and currents, and are governed not so much by the familiar laws of color theory as by Klee's desire to compose music with color. In the upper part he does this in sonata form, in the lower part contrapuntally, in a way not unlike the colored squares of the Tunisian water-colors, although the paint on the shrubbery at the bottom is thick and fuzzy at the edges. There are green bushes next to violet-red and blue ones; that is, no question of likeness to nature, however clear everything seems at first sight. Even so, the "terrestrial" element is not eclipsed by the "cosmic" element to quite the same extent as usual.

Are the color sequences in the upper part to be interpreted as the atmosphere? Probably not; the picture as a whole is a free sketch, the little tree purely secondary. What is essential is not the "program," but Klee's way of composing music with color. Klee is anticipating himself here, for only much later did he compose color music so boldly. In his last years, however, such compositions express disintegration rather than growth and *joie de vivre*, as here.

FULL MOON

Oil on paper, mounted on cardboard, 19 $^1/_4$ × 14 $^5/_8$"
Otto Stangl Gallery, Munich

This is one of the most famous oils of 1919, a work characteristic of Klee's development at that time. Bolder than his watercolors, which were often improvisations, it is a more solid, museumlike achievement, incorporating earlier discoveries. Oil painting compelled Klee to build up his work slowly and persistently, to aim at static construction and sonorous expression.

We have here four or five areas within which Klee sets down his world of colored forms. At the lower edge, the pointed triangles refer to nothing objective; above them we see squares and rectangles with a window below the diagonal. At middle right, we see architectural forms and hieroglyphs of trees, at left a window and above it a spherical tree. At top center the yellow moon holds the picture together and dominates it. Such a heterogeneous collection sounds very dreary, nor do the red moons (or circles) and the crescent make it more animated—they neither belong to the landscape, nor are they really heavenly bodies.

Is there depth, a horizon? Hardly; everything is taking place in a flat space which is not truly measurable, but can be felt. The irregular, interlacing, colored forms are juxtaposed contrapuntally but yield no canon; where architectonic allusions enter in, the motifs crystallize into themes such as a church or a city. The windows bespeak a peaceful evening—the dark one as well as the lighted one. The full moon is shining upon a landscape without people, but one feels that there may be people hidden away in the harmony between rocks and trees, house and windows, the outside and the inside, in the simultaneity of the events.

Nowhere is there a beginning or an end; the picture should probably be read starting from the lower left diagonally across to the upper right; nor should we forget the irregular rectangles extending over the moon across the picture to the spherical tree. But the moon stands in splendid isolation apart from all this—it is the key to the whole and gives it its name. In other words, nature and art, and "the Self at the very core" (Klee). As the forms crowd in upon the painter, he defines them in turn as tower, lighted window, etc., and in this way gradually produces a well-shaped whole. What is so moving in pictures such as this one is that in the end they develop a theme completely before our eyes, the various elements and structures successively bringing it to life. One of Beethoven's sonatas has been called "The Moonlight Sonata," a nickname which suggests a content much more "human, all too human" than is actually the case. Still, it points to a content, and the same applies to Klee. This was why he gave his works, no matter how abstract, evocative titles, rather than relying on the public to do this.

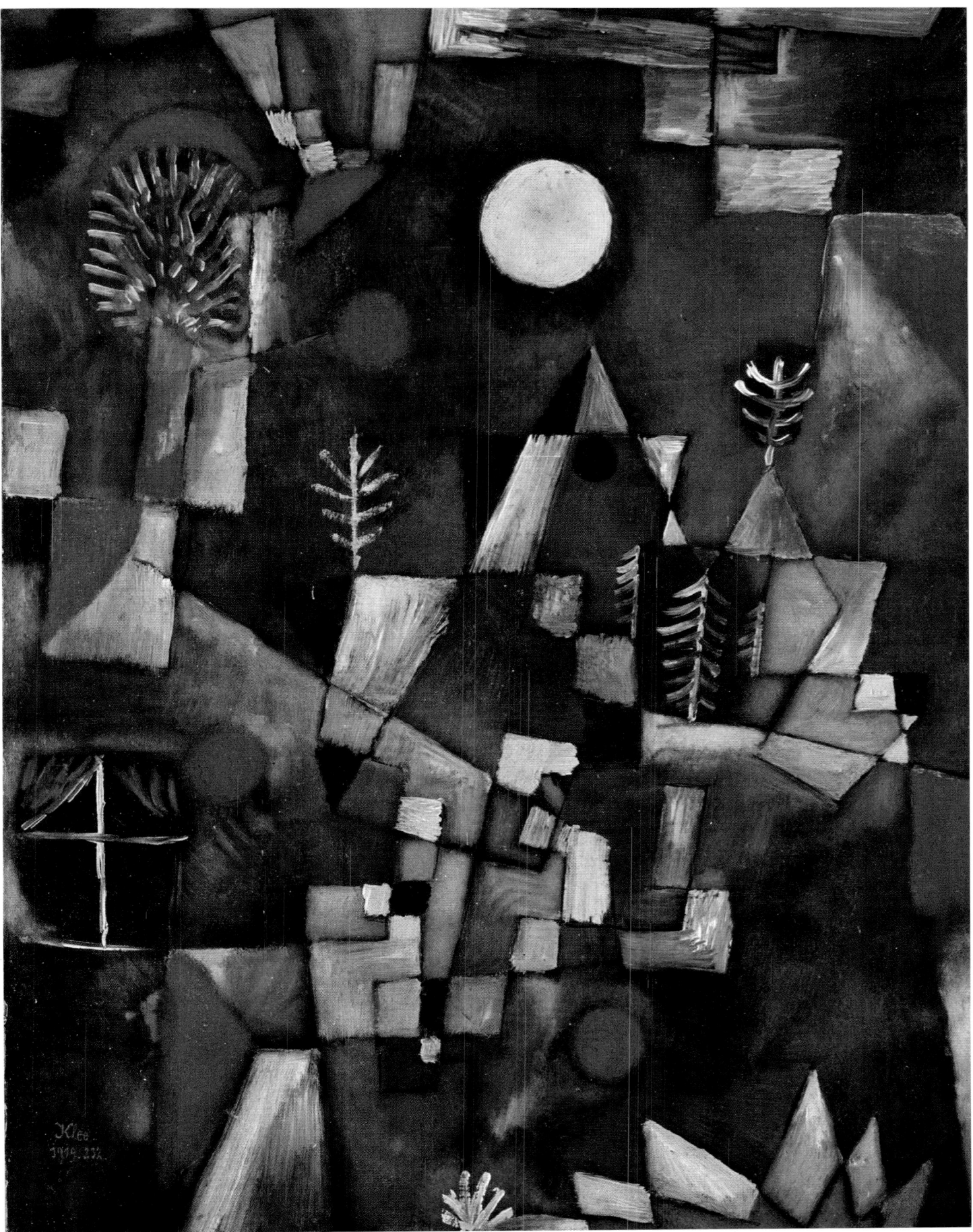

Painted 1919

SOUTHERN (TUNISIAN) GARDENS

Watercolor, $9^{1}/_{2} \times 7^{1}/_{2}''$

Collection Heinz Berggruen, Paris

Klee sometimes gets ahead of himself, sometimes turns back. *Southern Gardens*, which he calls *Tunisian Gardens* in his own catalogue (such changes of title are not at all infrequent), is so named because he did not wish to relate it too obviously to his Kairouan pictures (from 1914 on). The schema is the same, a tapestry of colored squares and rectangles, with a few triangles at the top of the picture suggesting roofs or towers. At the right edge a strip has been added, perhaps because this produces a more balanced format or in order not to press too closely together the smaller forms on the right. At two places Klee inserts plantlike forms—he had not yet arrived at his "magic squares," which require no such lyrical additions and are based exclusively on rhythm and relationships between colors.

In this work Klee's only link with the things of this world was via reminiscences going back five years—for he had not visited the South since 1914. But Tunisia influenced him to the very last, and he also never forgot Delaunay's "window pictures." What he is concerned with here is rendering objects and forms with light and color, visual rhythm, poetic feeling. Delaunay's trail had been blazed by Cézanne, by the latter's discovery that color is the place where our brain and the universe come together and meet. Of course, nature had a hand in this, but Klee was scarcely trying here to depict a pattern of planted fields, save in the arrangement of the colors.

These are warm, southern colors, with a great deal of red, orange, ocher, and yellow, the succulent green of the palms, the violet of the earth, and the blue of the sea. A few patches of black break up the colored rectangles along the diagonal running from top left to bottom right, and at the same time make the colors look brighter. Did Klee so much as remember planted fields and gardens when making this picture? Only relatively; he saw through things, but his friends maintained he had no eye at all. Here he was probably visualizing phenomena of light, the way light relates things to one another, thereby remaining interdependent on the space-time plane. This is why the two plant forms give us so very strong an illusion of nature, a truer image of it than any imitation could have achieved.

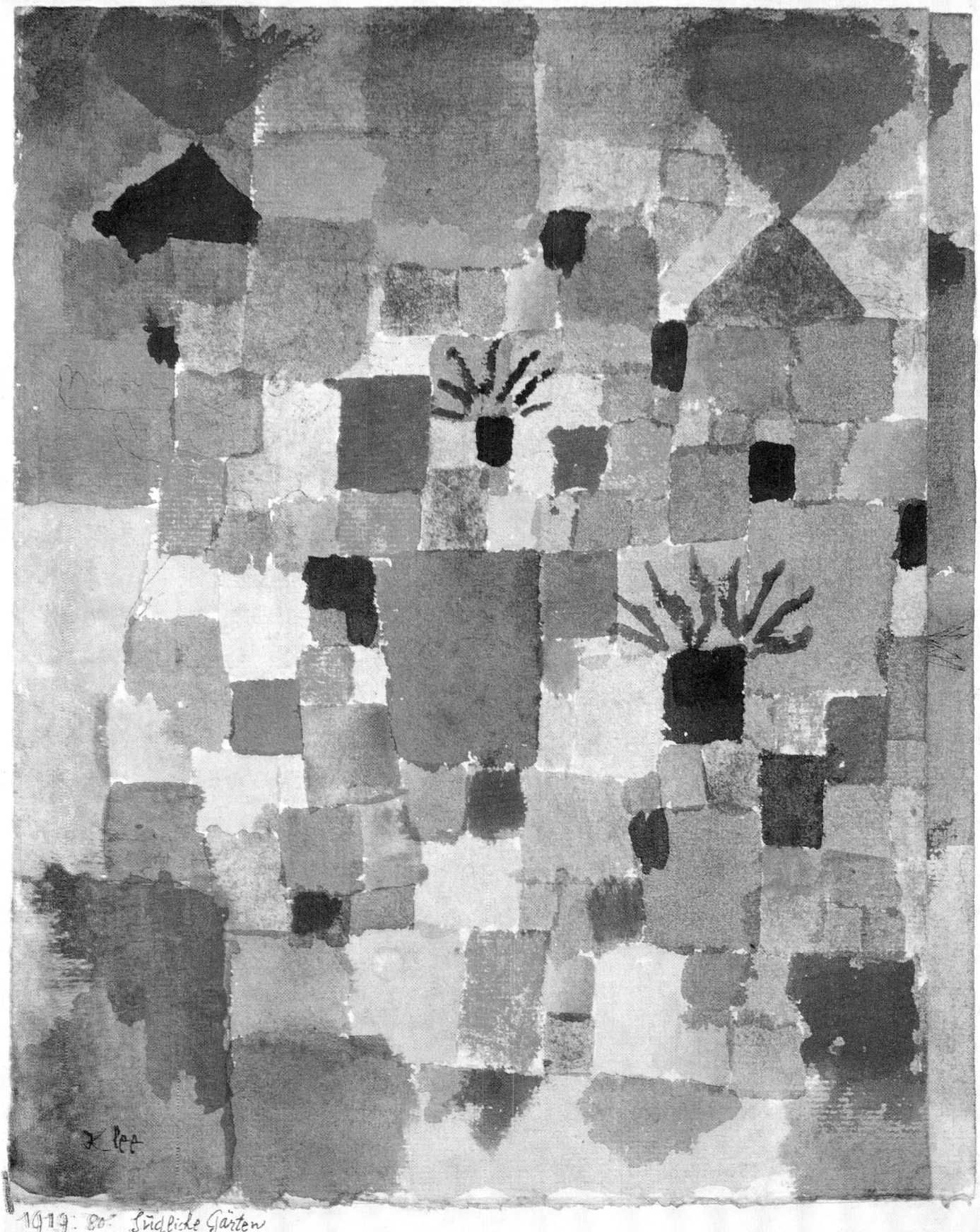

Klee

1919: 80: Südliche Gärten

Painted 1919

COSMIC COMPOSITION

Oil on cardboard, mounted on wood, 18⁷/₈ × 16¹/₈″

North Rhine–Westphalia State Collection, Düsseldorf

Like *Kiosk* of 1920, *Cosmic Composition* presents the essential part of the theme in sparkling, nearly linear forms contrasting with the dark ground. At the top the moon is rising and there are two hexagonal stars; below these there are smaller stars and the sun in all its effulgence. There are houses and trees in the upper part of the picture, and one spherical tree lower down which looks like a dandelion. Close to the lower edge of the picture there is a garden hedge which goes well with the kiosklike little houses, and we are again led upward to the right by pavilions with stairs and fan-shaped trees. At the lower left corner there is a thick arrow which does not, however, overly assert itself as a direction pointer.

The whole is like a picture book full of mysterious things, but where are the people? We notice that no living beings appear on the stage. For the work surely suggests a stage, not the suburbs. The title of the play being presented might be something like "Room to Let," a game similar to puss in the corner, which children and young people like to play. Its object is to find a comfortable place to settle down in when the signal to move is given. But here the players have not yet appeared, the game has not begun. The whole conception is the more attractive because night has already fallen, visibility is poor. Here and there we see a glimmer of light—yellow three times and red several times; also, certain houses are lit from within. The game can begin.

The actors enter from the lower left—the arrow. First they come upon the most brightly lighted house, then scatter. It's a good thing that there are those lighted windows; they help you find your way between the inside and the outside. If you so choose, you may use the stairs—this will bring you soonest to the upper right. There is a big hall. The moon and the stars don't give much light; the sun, as so often in Klee, is more an idea than a phenomenon, scarcely a heavenly body let alone a shining light. It is no brighter than the houses. Or could it be the source of the light that in many bright contours helps us to find our way? Yet the ground, the earth (for that matter) could be the source of light here. All Klee cares about is the pictorial facts, nothing else. At all events, the scenario is not about this world—the title, after all, is *Cosmic Landscape*. Klee once said: "On other stars things may look different," but here everything looks pretty familiar, save that the absolute aspect is rather more brought out. The gravity of prose is not to be found here—house rhymes with star and tree with moon.

86

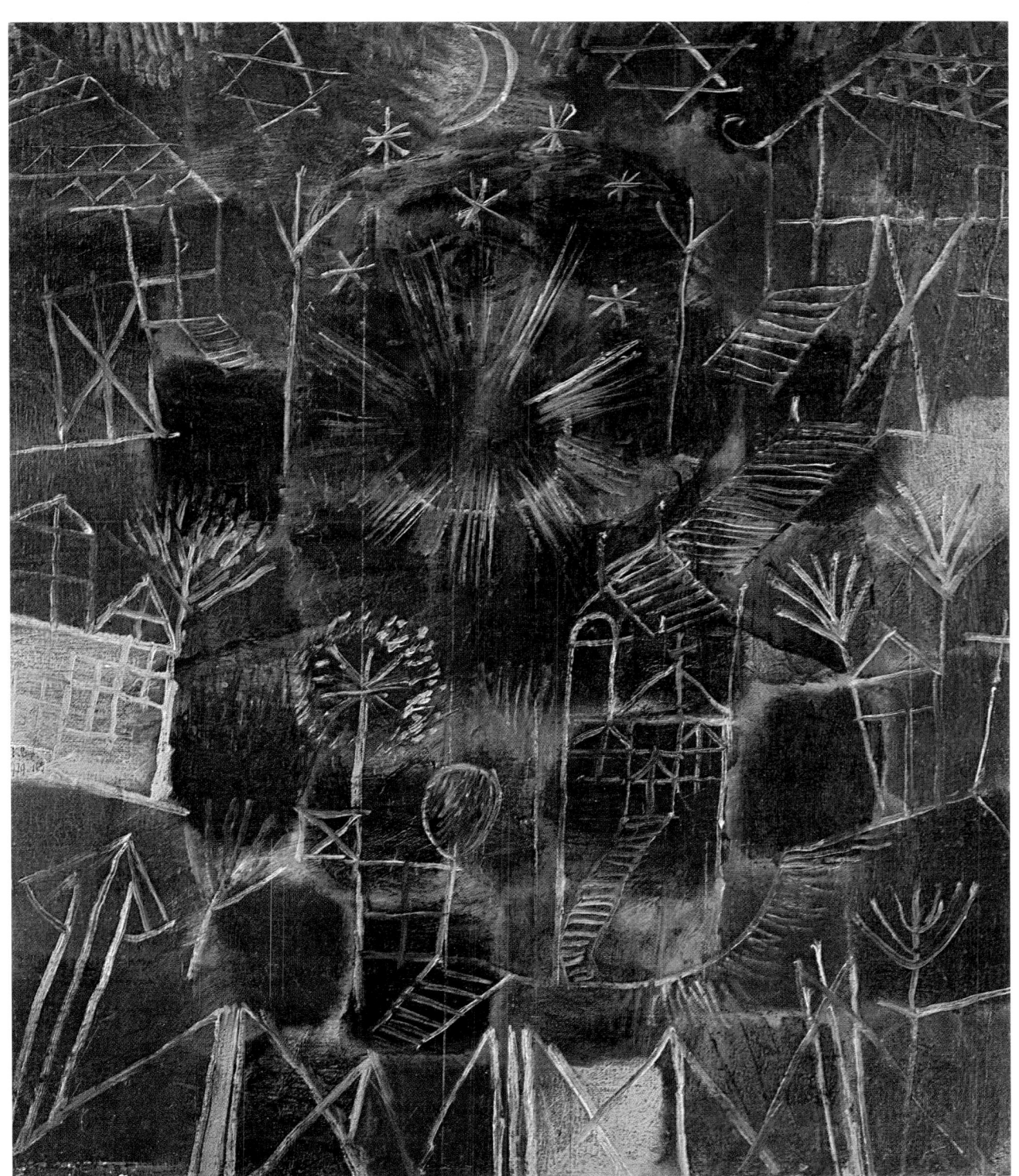

Painted 1921

DREAM CITY

Watercolor and oil, 18⁷/₈ × 12¹/₄"

Private collection, Turin

Klee's contribution to the art of the fugue—and not his only one. *Fugue in Red* and *Hanging Fruit* (1921) make use of the same schema. He would not have needed the influence of the Bauhaus to strengthen the rational principle in him. He had been familiar with the fugue since his schooldays, and the erotic principle, which permeates other pictures of this period, is not in true opposition during these years.

Here Klee consistently applies the principle of imitation and polyphony, the subjective element is pushed far back, and every square centimeter of the picture is an integral part of the overall musical/pictorial conception. Music encouraged Klee in a direction he was not reluctant to follow. Should we see the main forms (oval, triangle, square, rectangle) as theme and countertheme, the changing forms as changing musical keys, the development of color (from blue-green to pink-violet) as the progressing theme? This would be going too far, no doubt; musical terminology is after all too different from pictorial terminology to be interchangeable, and every modification in music has other consequences than in painting. For instance, every change in the triangles may be looked on as a device of repetition, as well as a change in key. Nonetheless, we find such a title as *Fugue in Red* perfectly apt, and in other pictures, such as this one, we speak of "fugue" because the formal process is a related one. This work conveys as well a feeling of mounting rhythm, a musical sort of sequence in a minor key, and though the sequence has a beginning and an end, it nonetheless gives an impression of permanence, of eternity. And what can the patches of black be but pauses within the polyphonic movement? But all these are questions rather than answers.

Klee calls the picture *Dream City*, and actually the modulations ranging from white through pink to green and black do evoke something ethereal, although one and another form may be read as a house, a tower, or as vegetation. Yet is it altogether out of the question that something like this may actually exist somewhere, perhaps even on our planet, in some faraway, unfamiliar corner of Southeast Asia, perhaps? Dreams being the free play of the imagination, recollections are not excluded, and an external stimulus may set memory zones in motion which suddenly bring the dream closer to reality.

Klee's creative powers went far beyond the natural, and yet they remain comprehensible to others, for he hated nothing so much as surrender to the uncontrollable, anthroposophy, occultism. What is true, he believed, need not be wrapped in obscurity; even the supernatural can be made clear. *Dream City* is a dreamlike improvisation, of course, but it derives from the musical imitation of color and form. In 1913 Kandinsky painted one that became famous, and in 1921 Klee painted another one, which comes close to Bruno Taut's utopian glass architecture.

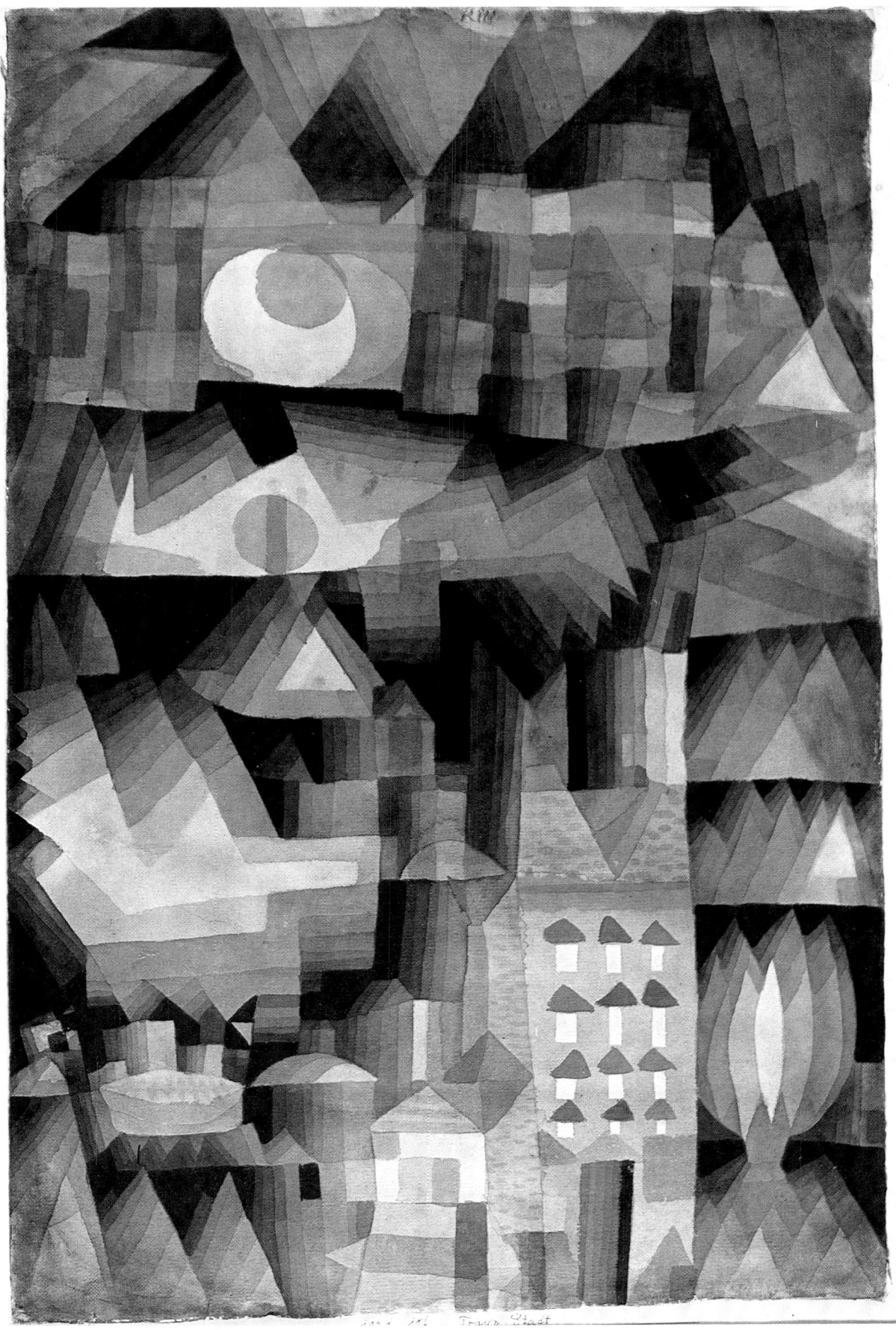

CITY PICTURE
WITH RED AND GREEN ACCENTS

Oil, plaster-coated gauze on cardboard, $19^1/_2 \times 17^3/_8''$

Collection Dr. J. Steegmann, Cologne

A utopian city which has nothing in common with Kairouan or the "magic squares." The city is built upward from predominantly small squares—only four of them are large enough to provide footholds. There are gabled houses even at the bottom, so this is not a perspective view, but a complex of tall buildings which terminate all the way up, near the horizon, with triangles. Some of these look like turrets, others like chimney pots. The dark-blue rectangles and the even darker "sky" form gullies between the quite cheerful, mostly red houses and the areas of green. On this assumption, the larger squares would be apartment houses or parks. One might also make a purely formal interpretation and, despite the title, speak of geometric colored forms, of triangular and pyramidal forms, blue-black rectangles, and of chromatisms inlaid with white fermata signs that have been assembled and integrated. Black ones too? But the blue-black ones are supposed to indicate sky and gaps in the buildings. They may perform a double function, of course. Are we to make anything of the similarity to a checkerboard pattern? Klee liked to combine his forms in ever more all-embracing complexes, within which his overall theme—here, the city—nevertheless emerges.

A city with red and green accents, a Northern city. Did he ever lay eyes on such a city? Perhaps during the war when, as a corporal in a transportation unit, duty took him to Cambrai, Cologne, and Cuxhaven. He also knew the brick construction common along the North Sea coast, where sonorous colors range from brick-red to green and whose violet and gray intermediate tones accelerated the passage into the unreal. Looked at in this way, the city suddenly turns into a highly differentiated color chart, self-sufficient as such and framed by the dark areas at top and at bottom, setting off a magnificent piece of chamber music.

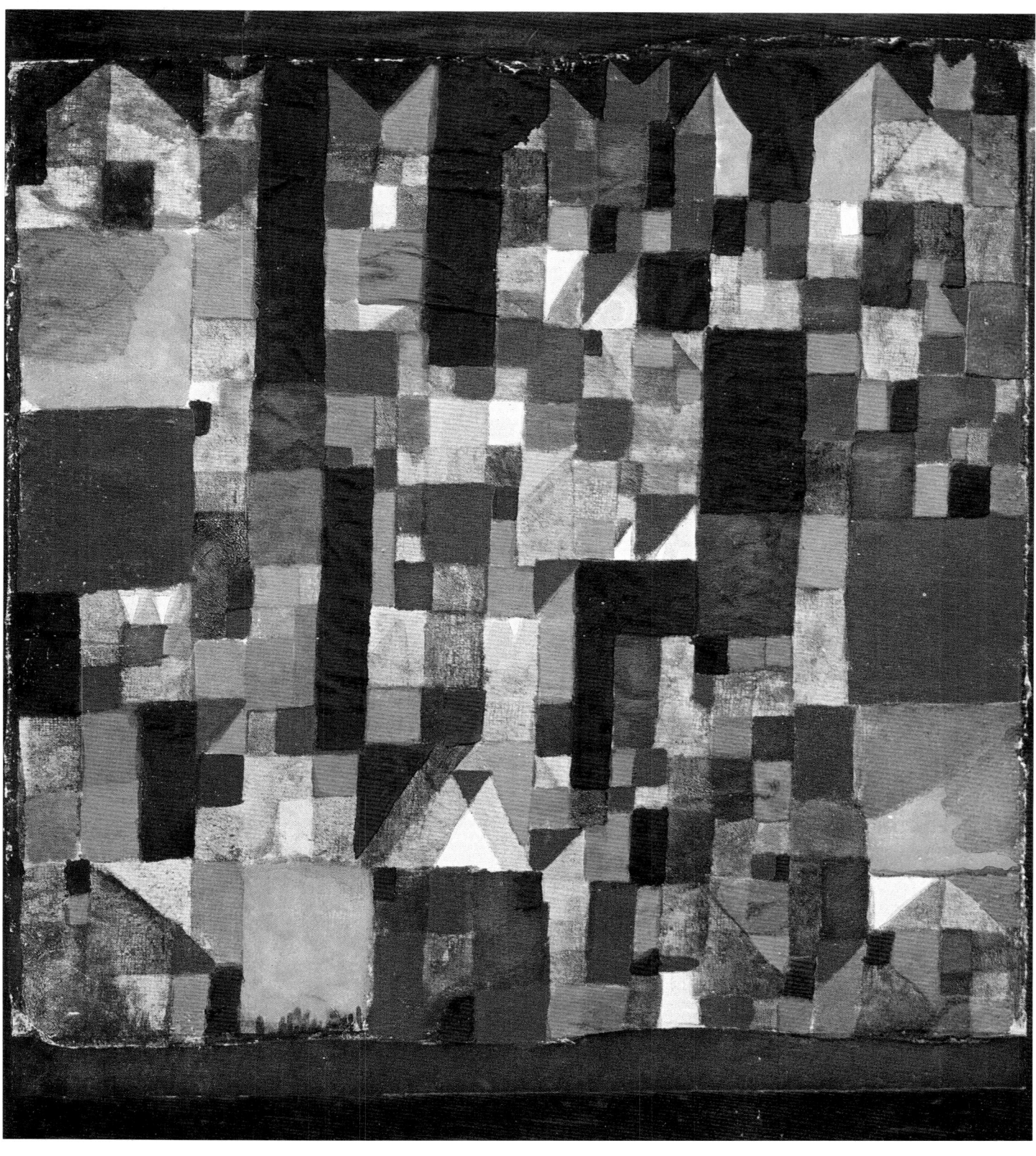

WOMEN'S PAVILION

Oil on cardboard, $15^3/_4 \times 20^1/_8''$

Collection Mr. and Mrs. Ralph F. Colin, New York

This is not a theater picture, but it does have an inner relationship to *Stage Landscape* (1922). Like the latter, it is built up of colorfully phosphorescent curtains and hangings, and additional appliqué work reminiscent of Klee's tree landscapes with their musical notation lines and trees like notes of music. On top of these there are even the tops of towers. Are they part of the pavilion or not? The architecture, too, brings to mind a stage in that we see the curtains and a door center back; the curtain is up, the actors can make their entrance, but, as in *Stage Landscape*, no human figures are to be seen. The play has not yet started. Klee enjoys keeping the viewer waiting—it builds up the suspense.

Copper, green, blue and red are dominant. The very decorative little red trees at either side contribute to the total effect as much as the perforated curtains. In form they differ little from the other trees. Klee leaves it an open question whether the "pavilion" of his title is only the middle part of the picture, the rest its surroundings, or whether the latter form part of the pavilion, as might be inferred from the wavy parallel lines (reminiscent of musical scoring) that run across the whole picture from left to right. This is also suggested by the changing tones of the colors, which range down to bleached Italian blue and old rose.

A precious picture, painted with love during a year marked by many inspiring achievements. Everything to do with the theater—and *Women's Pavilion* could easily serve as decor for a Mozart opera—comes to the fore during Klee's residence in Weimar. Klee missed Munich as soon as he left it. There he had been surrounded by opera and concerts in golden abundance, and here he enjoys remembering it. This explains why he made so many pictures recalling stage sets and stage scenes. After a while the number of such works declines, but they still turn up now and again. In 1937 he produced a *Stage Landscape* in pastel. What attracts him to opera is the elemental character of its subjects, heroes who are symbols of good and evil, beauty and ugliness, and the way the one tilts over into the other without loss of unity because the contradictions are fused into an ensemble. A fictitious world that, like his own schemata, veils the indescribable.

If we look again now at *Women's Pavilion*, the contradiction between inside and outside strikes us as quite natural, and we see that the lines and trees between them compose a musical score. We can only wonder what opera Klee had in mind—perhaps *The Magic Flute* would go better with this picture than the more dramatic, tragic *Don Giovanni*.

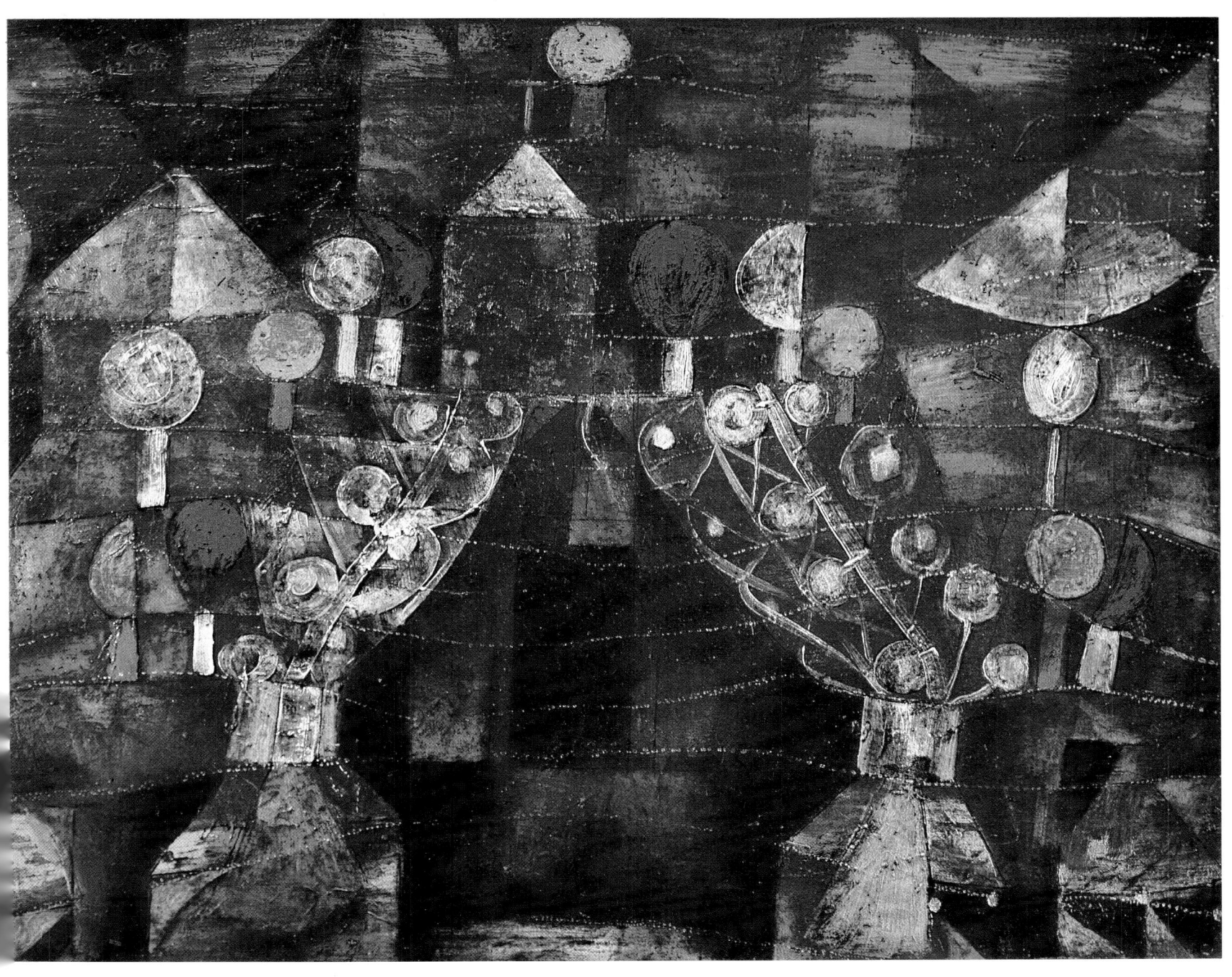

ANALYSIS OF VARIOUS PERVERSITIES

Pen and watercolor, $12^{1}/_{4} \times 9^{1}/_{2}''$

Collection Heinz Berggruen, Paris

Nothing was alien to Klee, he was even interested, though not overly so, in sexual problems. To the extent that he saw them from outside, he did not think the love life of human beings very different from that of other living beings; to the extent that he was involved personally, he often felt he was neutral. He wondered whether, in the end, people would believe he had taken too little account of such matters. His attitude to the erotic was something else; no one will maintain, surely, that he lacked Eros, but Klee himself often doubted that he had given it its proper place in his work as a whole.

Here, in *Analysis of Various Perversities*, the medical and experimental are brought to the fore, presenting us with a kind of laboratory with much apparatus, a twittering bird, and a magician "P" whose arms end in instruments. The grid of irregular planes nearly constitute a picture in themselves, so completely are the geometric elements interlocked with the predominating mauves and pinks.

The colors give us the key to the development of the action. They range from pink to blue to violet and black. The black is not just there to serve as a border (at this time Klee was fond of putting a colored border around his drawings), it obtrudes from inside the picture as space, abyss, menace.

The doctor is at work. He is one of Klee's childishly drawn figures ("Children can do it, too, and there is wisdom in the fact that they can"). Were he to look more human, he would be still more puzzling. As it is, room is left for the dignified expression on the magician's face and for his limbs to be treated just like the other pieces of apparatus. These are all Klee's own inventions, though the glass with red beads at the top suggests a retort. The bird appears interested in this, as though the beads were insects. It is perched oddly on the edge of a glass bell and its droppings are falling into an ornamented goblet. Actually, there is one insect in the picture (letter i) making spiral-like movements. At the bottom is a fish that seems to be coming out of some sort of a fish trap. But where do the horizontal legs come from? They seem to extend into the fish trap. Or is the whole horizontal complex with legs a bewitched human body which is serving the witch doctor in his experiments? The arrow pointing up may supply a link with the rest of the apparatus, and the arrow at the upper right a link with the outside world and human tragedy. "The more distant the voyage, the more we feel the tragedy.... Where there is a beginning there is never infinity."

But the bird, the fish, the letters "P" and "R"—who can interpret them in detail? What is important are the many cross sections recalling anatomy and physiology books; we also find them in Klee's plant pictures. "Various Perversities"—we are probably to consider them in birds and fish as well as in man, for in many domains they are governed by the same laws, particularly when a magician is presiding.

Klee must have attached unusual value to this work, for he designates it S Cl (*Sonderklasse* — "special class"), to be sold only after oral or written agreement.

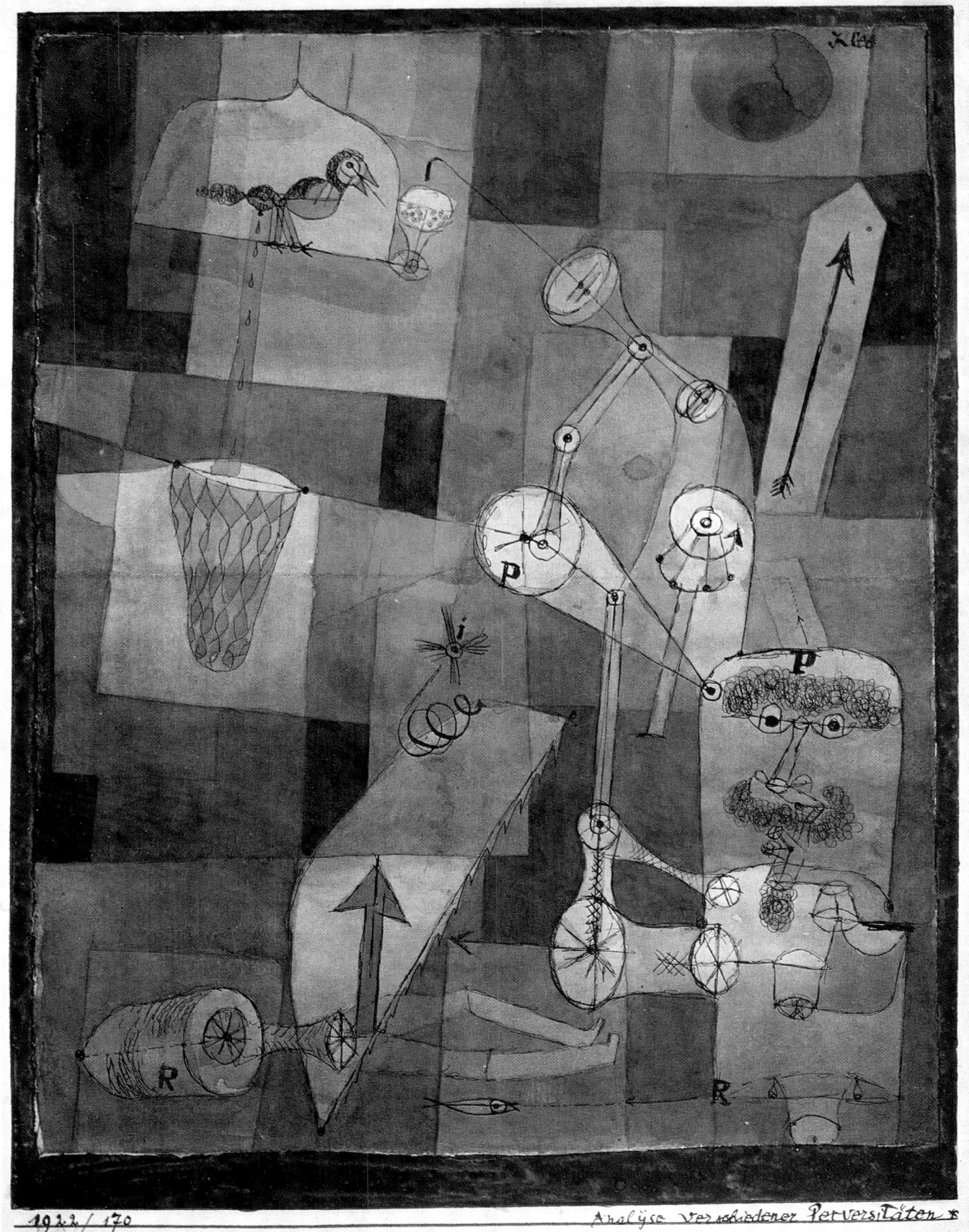

1922 / 170
Analyse verschiedener Perversitäten

Painted 1923

THE SINGER L. AS FIORDILIGI

Oil and watercolor on chalk-coated ground, $19^5/_8 \times 13''$

Collection Norman Granz, Geneva

One of Klee's most famous theatrical figures, which turns up in two other works of his as *Singer in a Comic Opera*. L. was a much-admired soprano whom Klee had often heard, and whose memory he perpetuates here in the role of Fiordiligi. His conception of the singer as an almost marionettelike "neutral creature" is entirely in line with Goethe's notion of opera. The upper part of the body and the arms are hinged like a doll's, with head, hair, and hat fitted exactly to the body. The abdomen consists of musical formulas, and the body stops at the abdomen. Proportions and symmetry are operatic. The ceramic colors have no accents, in keeping with the singer's superior calm. Everything here is elegance, music, arabesque.

Note how closely Klee comes to musical elements with his pictorial technique, how the motifs are transformed into themes, how the melody develops rhythmically and harmonically with relatively few embellishments. Does he refer to some specific aria in *Così fan Tutte?* If so, it is probably to Fiordiligi's aria, "Firm as a rock," though the artistically arranged orange curls, the snail-shaped hat, the spiral breasts, and the winding line of the hips suggest anything but a rock. Painting is not nature, however; what matters here is the ambivalence of the figurations, the unrealistic gestures, expression, and colors, which are anything but descriptive. The background is scarcely operatic, with no suggestion of stage props, merely a scale of inexplicit tones ranging from gray to pink-gray and ocher, plus a bit of brown at the edges—all this is left very tentative. Fiordiligi, however, rises from this ambiance like Aphrodite from the sea foam; she is here, she alone, and nothing else matters.

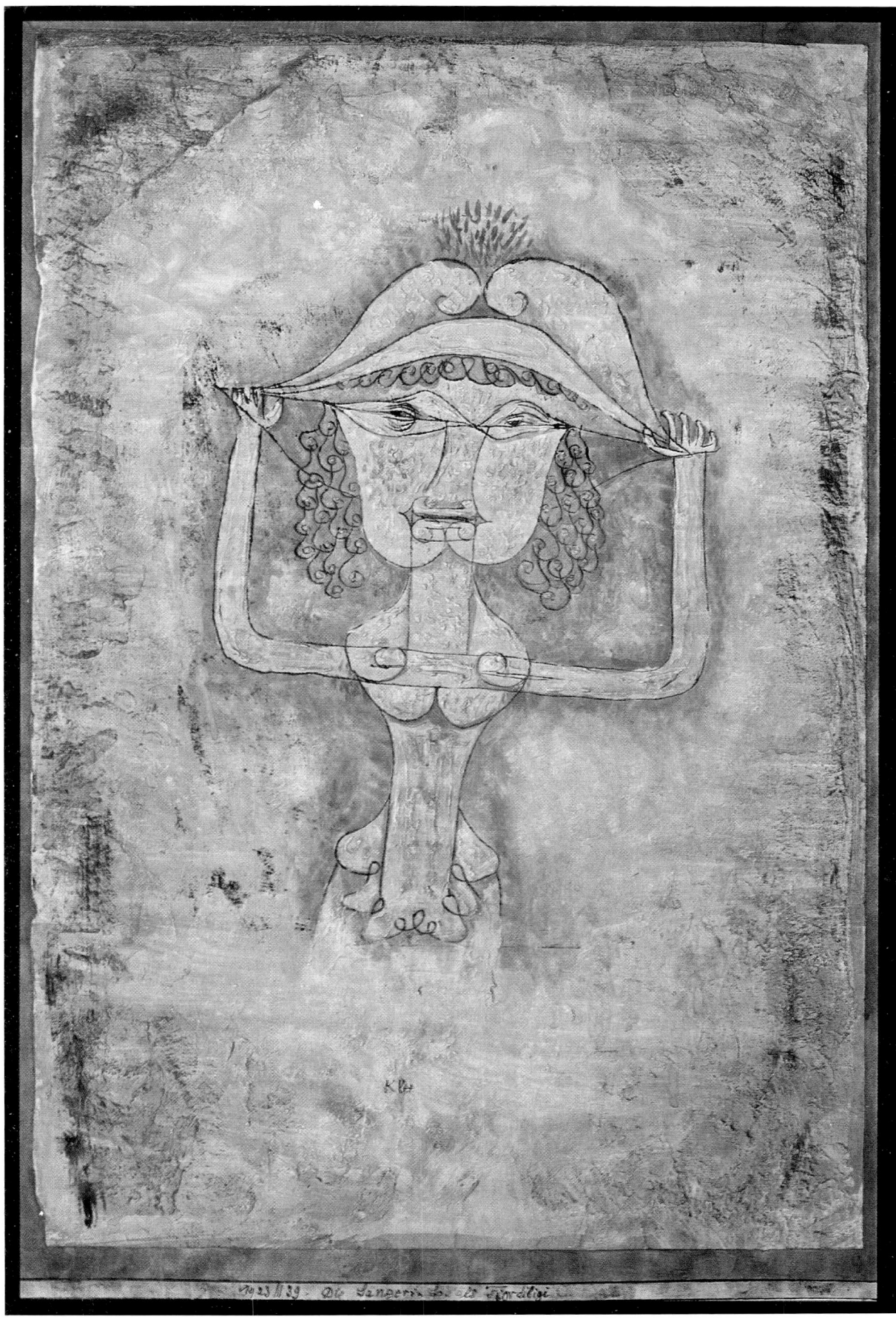

Painted 1923

LANDSCAPE AT SUNSET

Oil on canvas, mounted on cardboard, $11^5/_8 \times 16''$

Marlborough Gallery, London

An enchanting little oil, a landscape with houses and trees (the green patches), the last rays of daylight (the yellow accents) drowned out in the red of the setting sun. There is a faint echo of the Kairouan schema in the squares and triangles, also in the pictorial organization of recognizable forms. It was in 1923, the year this picture was painted, that the first of the "magic squares" was produced; these are compositions in checkerboard pattern, and Klee continued to produce them to the end of his life.

The little house with three windows and gabled roof, the tower with the pointed top, and the other structures, roofs, and windows are the subject. Klee dispenses entirely with anecdotal elements, such as are found in other works produced during his first years at the Bauhaus. This landscape is one of his more "constructed" works; another one is *Chorale and Landscape* (1921), in which overlapping geometric forms dominate and the scene is only softened here and there with a little tree.

The poetic element here is the red of the sun suffusing the whole, enhanced by carmines and violets and the contrasting yellow and green. The last rays of light are gliding over the landscape, the atmosphere is beginning to flicker, in a moment night will have fallen. The transitory character of the event is so graphically rendered that it is almost tangible.

Tangible to Klee, certainly, for whom color was an element as immediate as line or space. He was disappointed with the island of Elba because the colors there did not stimulate him, but a year later, on Corsica, he could hardly work fast enough, the color harmonies were so fresh and inspiring every day. It is as though colors lived a life of their own in Klee, occasionally egging him on to works that would never otherwise have occurred to him. Here he enhances their effect with somewhat darker areas around the edges of the picture—this is the twilight standing in the wings. Night is about to close in; the landscape is flaring up in one last burst of glory, about to vanish like a mirage.

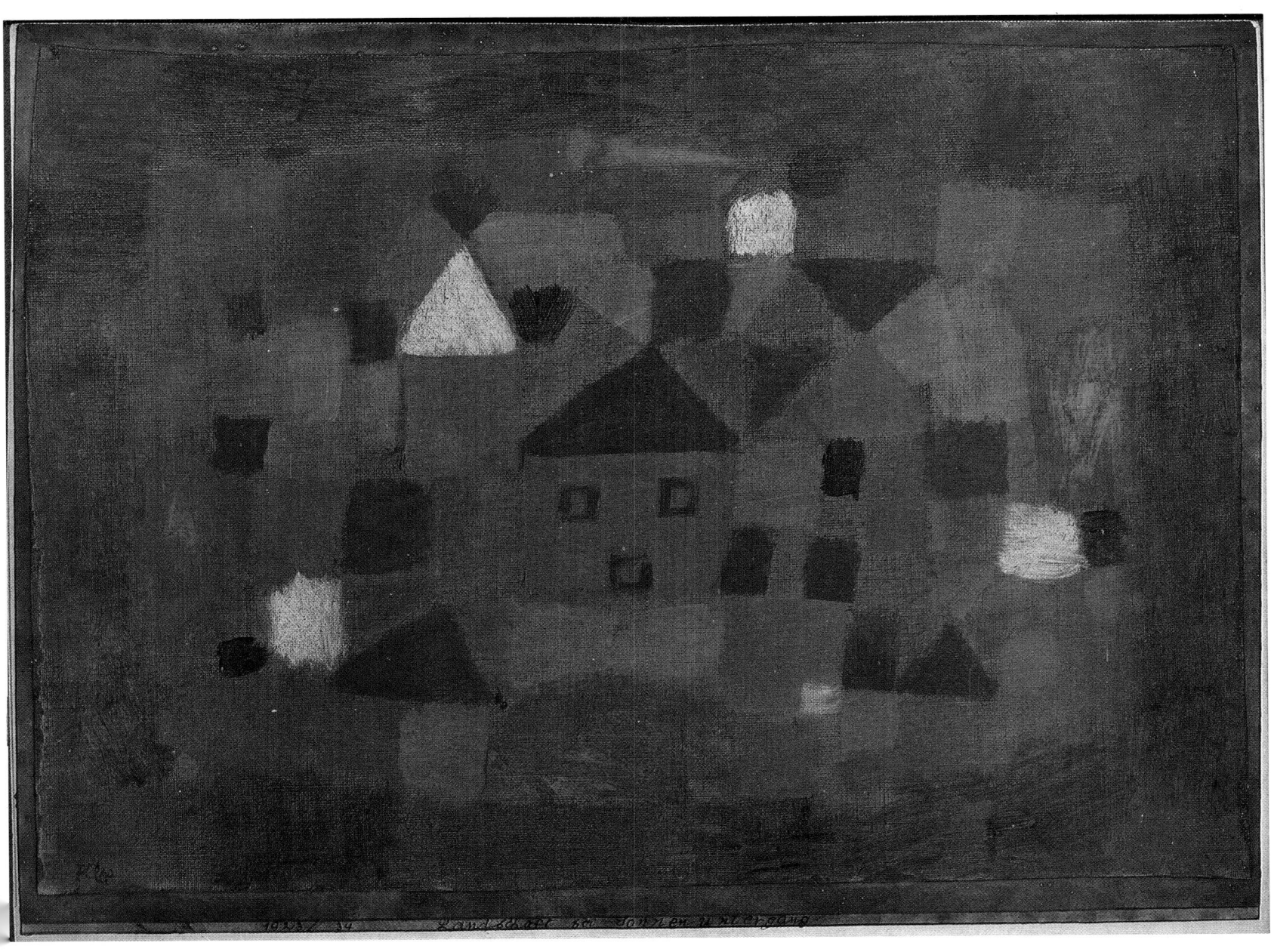

Painted 1923

LANDSCAPE WITH YELLOW BIRDS

Watercolor on blackened ground, 14 × 17³/₈″

Private collection, Switzerland

"A picture may also be regarded as a dream" (Klee), and this work can be classified as a dream picture in this sense, like the *Fish Magic* of 1925. This watercolor is one of his most admired pictures, unique for the way it combines fairytale fantasy with precision of treatment. In style, the plants especially bring to mind Indo-Iranian art, and the metallically brilliant chrome-yellow birds are comparable to Sassanid works in metal. Like the whitish-blue lianas they stand out against the deep black ground at the center, which is divided into several areas by the plants and tree trunks. The blue and violet plants with the birds in the lower part of the picture are not very far removed from the plant ornamentation Matisse devised late in life.

The birds are scattered around as on an oriental rug, though the upper edge of the scene is overcast by clouds and the lower edge by the moss-covered realm of earth. Only the fir trees are familiar to us, and they stand on mounds. One of the birds is perched upside down on a cloud, enhancing the impression of the dreamlike and the oriental. Suddenly the balance of the structure shifts to the imaginary, the forest of plants turns into a magic garden, and its forms defy all comparison. Only the firs keep their closeness to nature, a sort of North European enclave in this oriental kingdom.

But what about the tiny, scrawny bird at the bottom? It is trying to get through the space to the right of the tree that divides the picture, reaching up to the clouds. Are we to say that to the right of it is morning (the white sun), and to the left, evening? But the violet circle on the left side is a flower, not a star. There are always many riddles in Klee, and more in the dream pictures than elsewhere. At first glimpse the world of the yellow birds looks quite simple, we appreciate the clarity of the forms, the clear color contrasts, the consistent way nature has been approached. On closer scrutiny, however, we discover deliberate contradictions, more and more gives occasion for puzzlement. Why milky blue clouds in an oriental scene, how could there be firs in a tropical forest (the decorative red-brown plant life at either side), what is the meaning of the whitish lianas which give such firm scansion to the picture? A dream landscape is not to be explained down to the smallest detail; we must content ourselves with the truth *in* the phenomena, not look for it behind them.

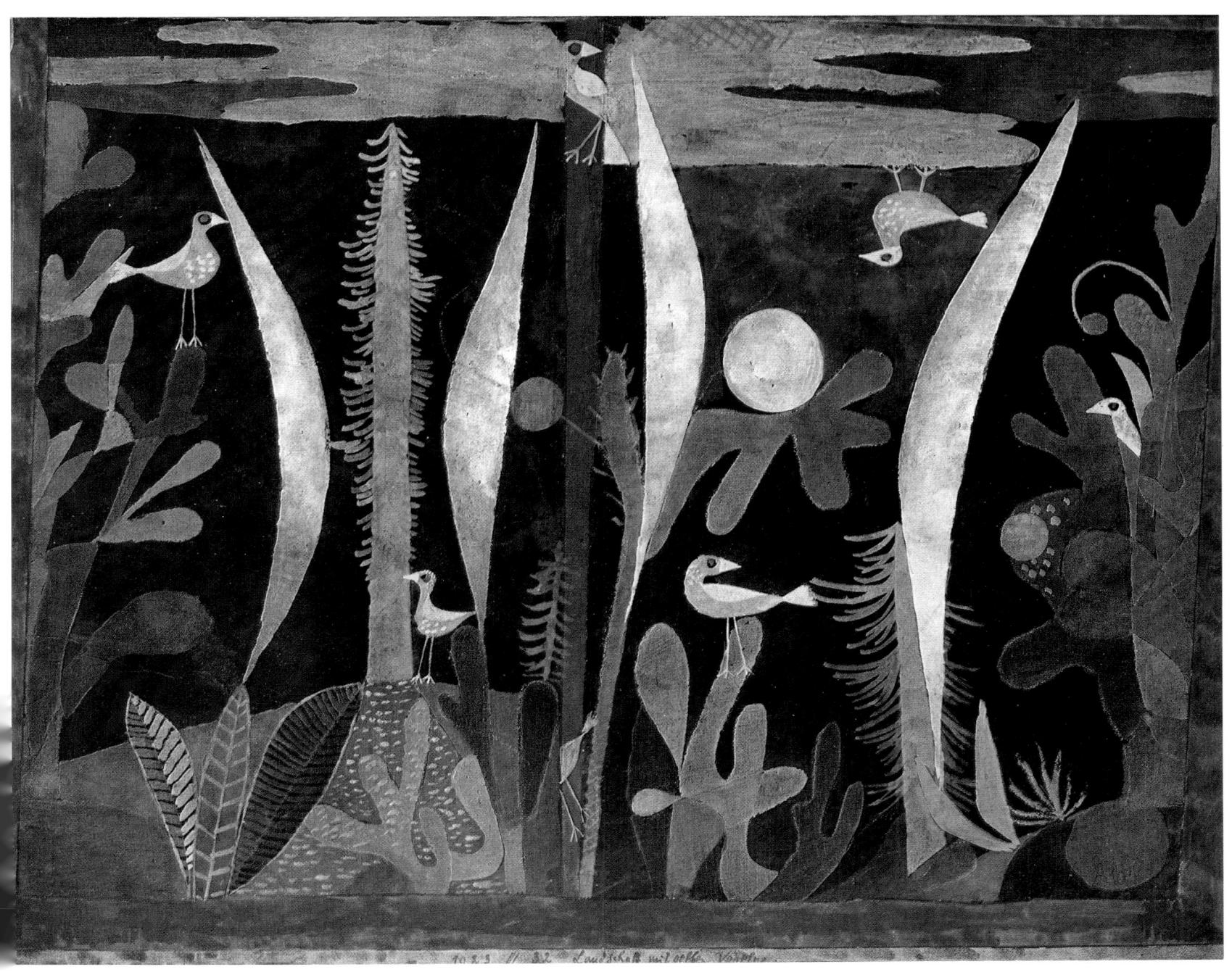

ANCIENT SOUND, ABSTRACT ON BLACK

Oil on cardboard, 15 × 15"

Kunstsammlung, Basel

A rhythmic structure of squares and rectangles, assembled in a single musical movement in accordance with some invisible law. There is neither beginning nor end here; the theme of the rectangles caught up in this rhythm obviously comes from pure meditation and cannot be illustrated with reference to anything previously known. Novalis speaks of a "germ of self-forming life." The artist, he says, is the organ of a higher power, and nature is animated by artistic instinct.

The separation between the world and the self has here been transcended. This is a magical invocation of the absolute, "art in the highest circle. Behind the ambiguity lies an ultimate mystery, and the light of the intellect is snuffed out" (1918). The titles Klee gave his "magic square" pictures are characteristic: *Harmony in Blue and Orange, Abstract Color Harmony, Harmony, Architecture: Cubes Graded from Yellow to Purple*. The affinity with music is obvious, not only on the score of rhythm, but also in the chromaticism of the colors and the phrasing. Klee here deals with things hard to formulate in words; besides mathematics, there is a reference to magic. Among Klee's papers I found a diagram for one of these pictures. Numbers were inscribed in the squares to form different arithmetic series, probably so he could get a better overall view of the dynamic relationships. When these numbers are added along the horizontals and the verticals, the totals are equal, as in the well-known "magic square." They bring to mind Arnold Schönberg's twelve-tone harmonic system, developed about the same time as these pictures. In Klee's case, too, one may speak of a basic "series" from which the work derives. Conformity with law, reason, magic.

The squares and rectangles are arranged in twelve rows horizontally and vertically. They are more or less equal in size here, though in others of these pictures they get smaller toward the middle, as though in a hurry to get there. These are more luminous, perhaps also warmer, at the center—yet aren't the peripheral brown and green squares warm rather than cold?

The term "ancient" in the title suggests patina—the colors are magenta, faded violet, Naples yellow, reseda green, and countless shades of brown and gray. The subtitle, *Abstract on Black*, reminds us that all the works of this type are painted on a black ground, and, according to Klee, chromatic values are particularly hard to balance on black. But then black is always unfathomable to Klee. According to him, it is the primal ground. The Incomparable dwells in its depths.

What does it mean? In some pictures, Klee says, one or another element points to the archetypal, which is usually veiled by the man-made, and the latter produces the effect of an alien body. But, he goes on to say, the self is always present and sees to it that the thread leading to the archetypal is never broken, even where no connection can be observed. Often, he says, the link-up with the archetypal can be made only by way of hallucination, and what emerges in that case will be recognizable. It may lie far back, but it may also lie in the future (from his lectures at the Bauhaus).

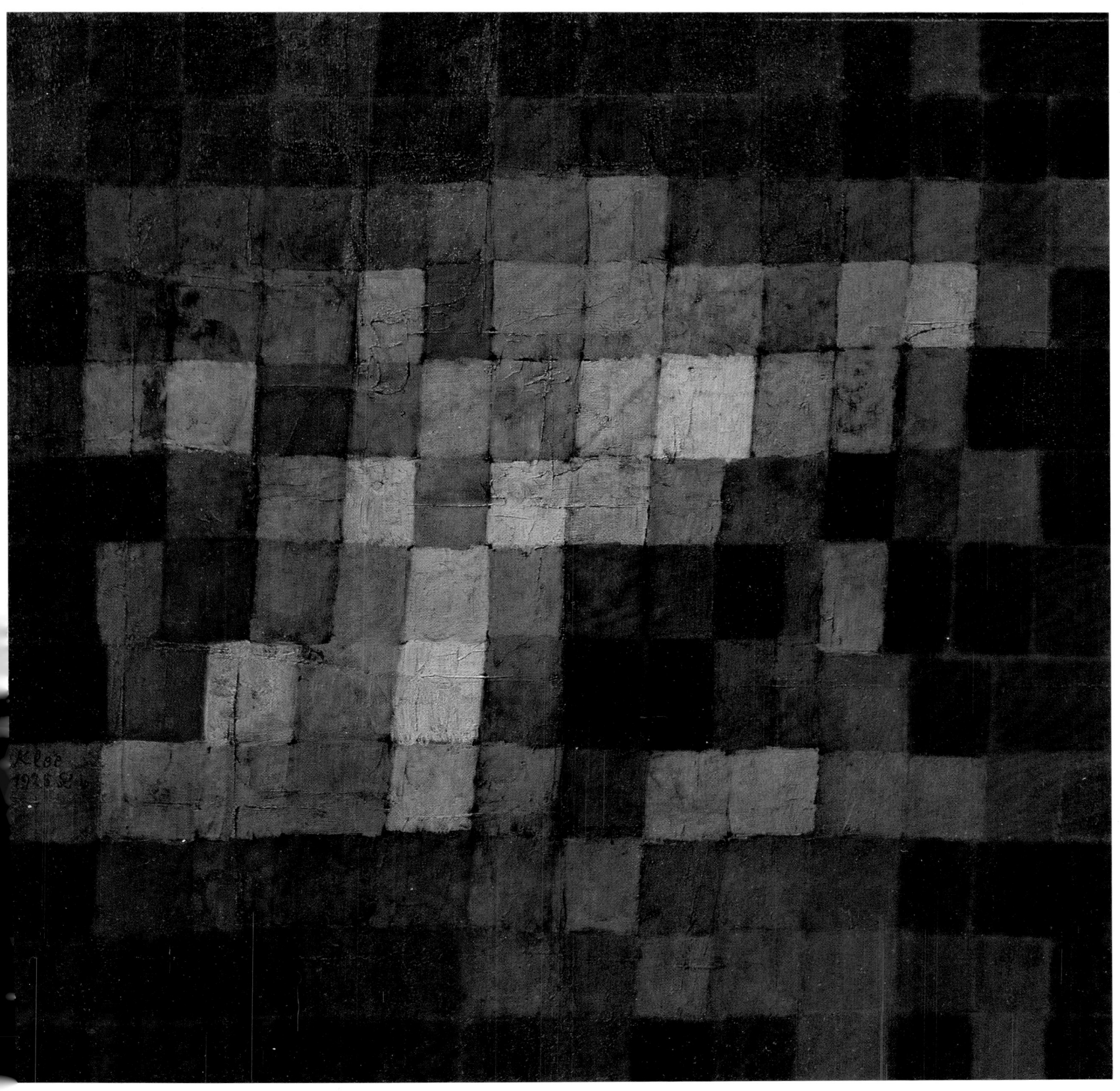

Painted 1925

THE GOLDFISH

Oil and watercolor on paper, mounted on cardboard, 19 ¹/₈ × 27″

Kunsthalle, Hamburg

Klee's attitude to animals was a matter of surprise to his contemporaries. From childhood on he kept a cat, and, as this was known, nobody was surprised at his many variations on this theme. But he also painted a *Trilling Nightingale* (fig. 18, celebrated by Theodor Däubler), a *Migratory Bird*, and many other feathered friends. What no one would have expected him to produce was a long sequence of fish pictures. They turn up in round goldfish bowls and among coral reefs, as actors in a dream kingdom *(Fish Magic*, 1925), and even as a plain edible dinner course, on a platter with sliced lemon and symbolic signs such as a cross and arrow *(Around the Fish*, 1926). The last-mentioned work hung in the Dresden State Art Gallery until, following the Nazi campaign against "degenerate" art, it found its way to the Museum of Modern Art in New York. *The Goldfish*, formerly in the National Gallery, Berlin, was acquired by Curt Valentin and is now in the Hamburg Kunsthalle.

This wondrous goldfish is in deep blue water, other little red and purple fishes rather keeping out of his majesty's way. There are tiny ripples in the water all around, and from the lower edge rise some light blue plants of simple form, such as are found in meadows and near ponds. The goldfish is giving off an inner light, and actually should light up the water, but the water remains dark. The goldfish glows alone with its improbable color. The cinnabar red fins and the red eye heighten the brilliance of the scales, which look as though embroidered upon the fish.

Is it moving? Presumably it is, for the seven other fish seem to be running away from it. Calm as a god, it divides the blue element, which is deepest and darkest at the middle, where there is no trace of vegetation. Surely there is no reference here to stars or signs of the zodiac, or to other symbols—the goldfish is miraculous in itself, its size and its beauty. Everything is subordinate to it, everything else is present purely for its sake.

"Dialogue with nature as a *conditio sine qua non*," certainly, but was there any point of departure in nature here? Klee must have had other reasons for painting so many pictures of fish. Like his bird pictures *(Landscape with Yellow Birds*, page 101, for example), they rise to the higher spheres of art. If the landscape just mentioned resembles an oriental rug, which can be viewed from all sides, here we have a dream picture in golden yellow, deep blue, and ultramarine. The shapes of the grasses and the leaves, the waves and the scales, are assimilated to our ordinary notions of such things, however. So here we have another metaphor of the world explored poetically and pictorially by the artist.

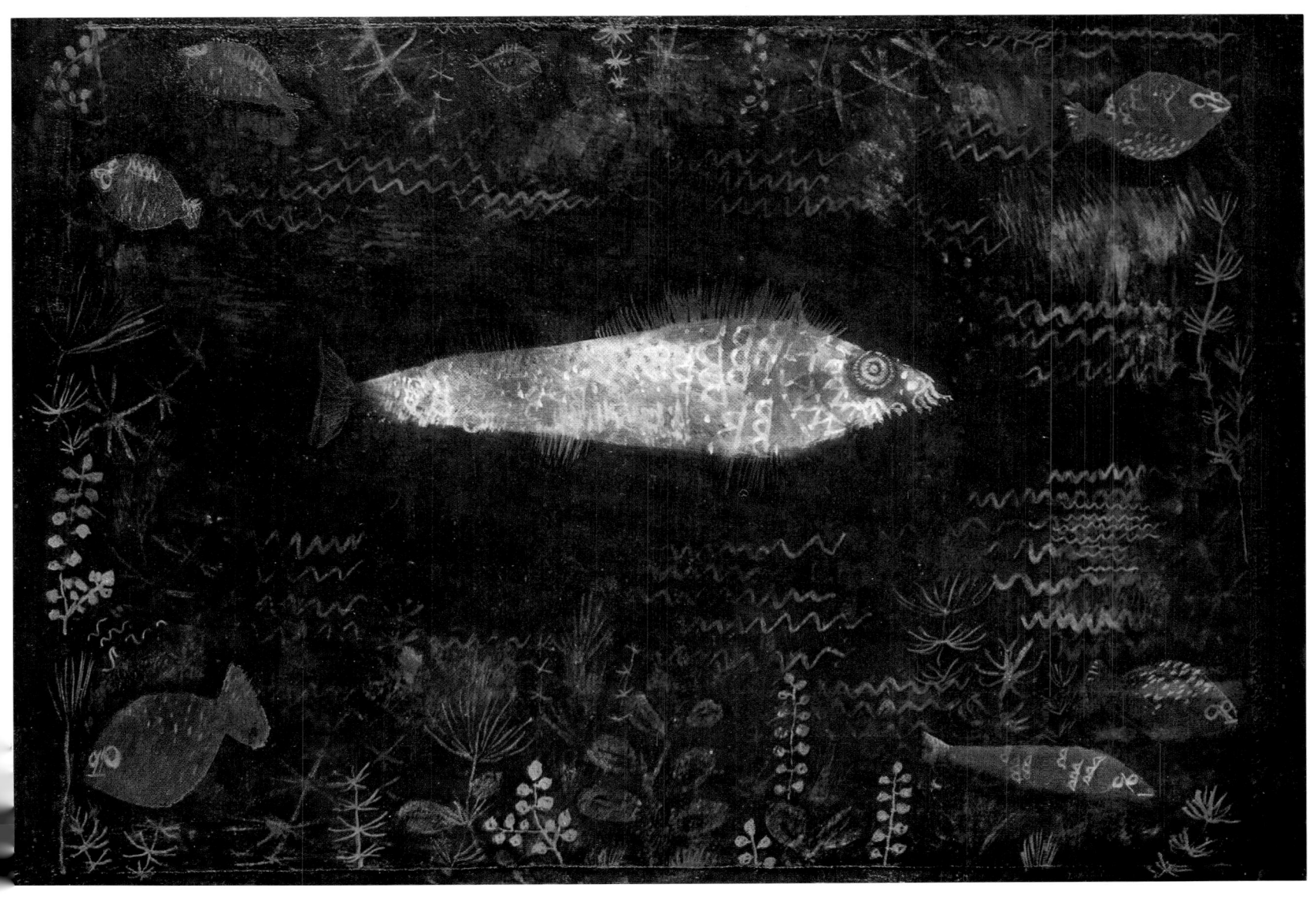

Painted 1927

BLACK PRINCE

Oil on canvas coated with white tempera, mounted on wood, 13 × 11 ³/₈"

North Rhine–Westphalia State Collection, Düsseldorf

A somber picture, not without parallels, although works executed about the same time, such as *Portrait of the Artist*, are more nearly studies in balance. *Black Prince* gives off awesome forces. Is this an African king looking at the world with his emerald-green eyes, as dangerous as a predatory beast? His energy is stressed by the ocher hook of the nose and the two ruthless lines of the mouth, perhaps also by the raised right hand which is opened aggressively in front of the lemonlike form. Is this his gold, which he is protecting? The body is massive, heavy, and almost merges with the brown background. At top left we see a lemon-yellow coat-of-arms with four rows of simple ornamentation; the figure's crown and the braid on his garment are richer in their articulations and color gradations. These ornamental forms bring to mind the calligraphy in *Mural* (1924), the schema of which is an invention of Klee's based on lace weaving, and in *A Leaf from the Book of Cities* (1928) where the texture is transformed into a kind of musical notation.

There are several other "black" pictures dating from 1927: *Spirit at Drink and Play*, which was owned by Hermann Lange, the Krefeld silk manufacturer and collector, *Fool of the Deep*, and *Singer in a Comic Opera*. Like *Black Prince*, they treat of the sphere of the nocturnal, but none of the other dark figures is as "African" and daemonic, at once fascinating and fearsome. The green eyes under the circular crown keep pursuing us, although they are completely unreal, altogether void of human expression, more like precious stones than eyes. A peculiar mixture of cruelty and magnetic attraction, of exoticism and European sensibility. It is not unique in Klee's œuvre, but in expressive force it is as exceptional as *Negro Glance* (1933).

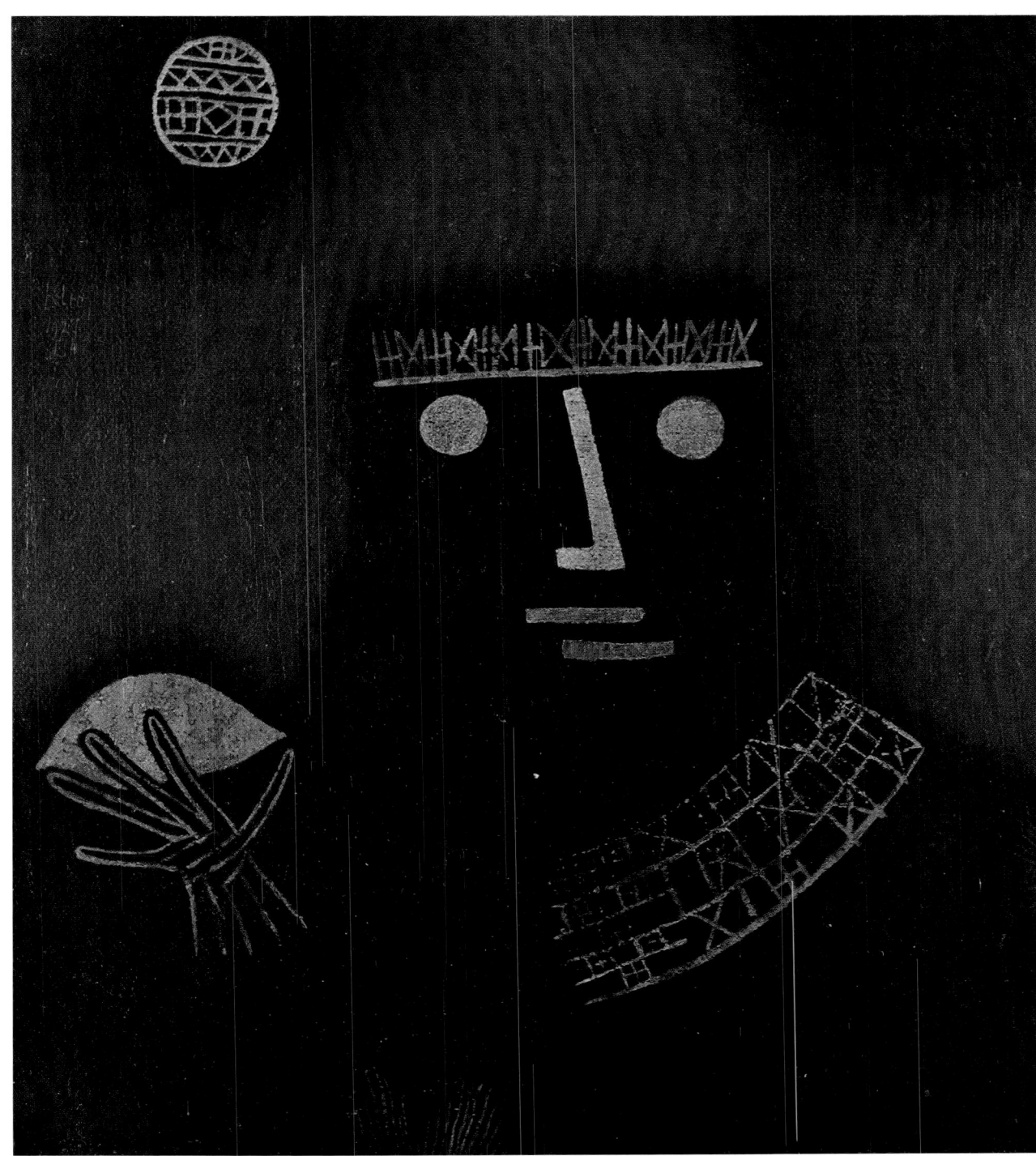

Painted 1927

CHOSEN SITE

Watercolor and pen, 18¹/₈ × 12″
Private collection, Munich

Chosen? Does the heavenly body represent the silvery moon of Kairouan, which, Klee said, accompanied him ever after, once color opened a new epoch for him? Klee had many favorite sites, not necessarily well-known spots; occasionally one as out-of-the-way as the village of Gela, where Aeschylus lies buried. Is this Gela? Probably this "site" is no identifiable place, but a place important to Klee in some other sense entirely. The synthesis between urban and pictorial architecture, which he conceived as early as 1914, here becomes a reality, and not for the first time. Since then Klee created many cities in which schema and picture come together, in which method and work form a single whole. This was achieved sometimes with plastic-cubic elements *(Castle Hill,* 1929), sometimes with checkerboard patterns *(City Castle,* 1932), sometimes with squares and rectangles and straight lines intersecting at the corners (as in the work shown here). The vertical forms are elongated as in *Arab Town* (1922, fig. 21), although in that work the intersecting lines are essentially intertwining meanderings. Imitation and parallelism contribute to the theme.

Chosen Site is very free in the employment of means. The diagonals introduce movement, and tension is produced between the broad base and the stressed verticals, which identifies the place as a village with a tall castle. Does the blue strip at the bottom indicate that the place is on the sea? At the top, however, red holds sway, a peculiarly tropical red, made even more tropical by the broad expanse of green sky. The sky is so green only in Africa or Southeast Asia. To Klee, however, who after all creates a nature of his own, this is neither a Tunisian nor any other geographical setting.

Assuming it is his own, everything becomes more comprehensible—the architecture and its effect, the giant heavenly body with the same network of lines as the multitowered town, and the same luminous, silvery purple, the earthy brown-red under the city corresponding to the carmine red at the top, and the intense green of the sky which, between the two reds, points to distant worlds—to Troy, perhaps. With Klee one can never tell. Could the moon, for instance, be Achilles' shield?

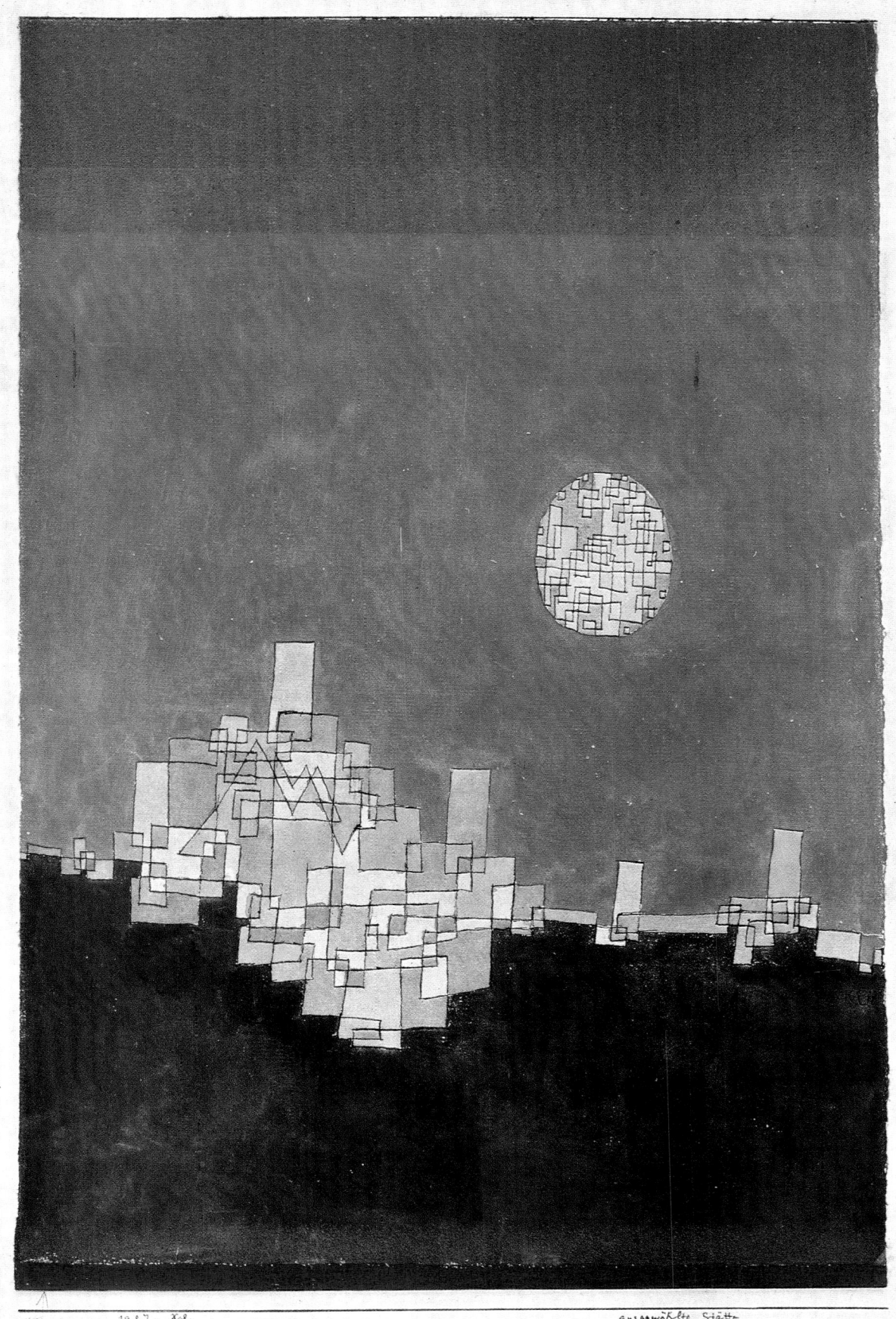

1927 X.8 ausgewählte Stätte

Painted 1927

PASTORAL (RHYTHMS)

Oil on canvas, mounted on cardboard, 27 1/8 × 20 1/2″

The Museum of Modern Art, New York. Nelson A. Rockefeller Fund

This work belongs to a series of about twenty-five panels of the highest quality, dating from 1926–27, which includes *Black Prince* (page 107), *Spirit at Drink and Play*, and *Singer in a Comic Opera*. It even includes another "rhythmic" picture, *Young Garden*, related to the one shown here.

Like *A Leaf from the Book of Cities* (fig. 30), this is a page of text, or perhaps of a musical score, for it is hard to say whether what we have here is script or musical notation. The signs are signs, not letters, but they stand for letters. We may recall what Klee said about one of his "letter" pictures: "It was all developed from these few signs." At the same time, like hieroglyphs or Chinese ideograms, these surely refer to remembered forms, nature obviously remains the *conditio sine qua non;* it is only that the "crown of the tree" (the work) differs from its "root" (the source of Being).

In the uppermost line are the stars and planets, next come young trees, then arches (architecture), then again little trees, followed by candelabralike trees, etc. In between the lines are garden hedges in the form of Xs. Farther down the *Pastoral* becomes somewhat more decorative, like a book of patterns such as children follow when learning to embroider. One might also think of fabrics— lace or embroidered cloth. The color is light green with a bit of sky blue at the top, and the border is brownish. In *A Leaf from the Book of Cities* the pattern is more complicated; the signs actually suggest the wall of a city, rows of pavilions with pennons, and, farther down, rounded arches with stars on them. On the whole, we are dealing with the same invention here. Presumably, works like *Pastoral* were a substitute for music for Klee; he treated them as scores, and when he wrote them down he may have felt like Haydn writing *The Seasons*. The word "Rhythms" which he added to the title confirms that it was a musical conception he had in mind.

Painted 1927

CÔTE DE PROVENCE 6

Watercolor on colored paper, 9 × 12¹/₄″

Collection F. C. Schang, New York, N. Y.

Klee was fond of the South, the whole Mediterranean coast, Sicily, North Africa. Every time he went there he was stimulated. Not that he brought back lots of sketches, as most artists do—he never worked much while traveling. Rather, he would bring back the completed version of some previously conceived schema, or ideas for a new one, as here in *Côte de Provence*. This work shows that he was preoccupied with three-dimensionality as early as 1927; it anticipates *Surfaces in Tension* (1930), from which *Sailing City* and *Cabins* derived. Here the schema is simpler, consisting of superimposed rectangles and triangles with thick strokes of color. These are not as yet confined to the corners, but they are already drawn in such a way as to suggest sailboats (at the top), bathing cabins, and a beach with occasional tufts of grass (the rows of colored dots and short brush strokes). At all events, the picture is not built up on the basis of intersecting lines (as in *Arab Town*, 1922, fig. 21), but on overlapping rectangles of various sizes. The sails are readily recognized, but one must be somewhat familiar with Klee's method to recognize the little cabins. With the help of the title, we realize these are on a beach, and finally we see that they must be dressing cabins for bathers. The colors are those of the French tricolor (red, white, and blue dominate, not yellow and orange), and of themselves help to place the scene in France. The warmer tones are at the bottom, the cooler ones in the upper part, and at the top the yellow tones of the sun predominate.

Pictures inspired by the beaches of southern France mark a preliminary stage toward the working out of such schemata as the flying cities, the dragons, and the collapsible boxes which begin around 1930, and which derive from *Surfaces in Tension*. In these, the problem of three-dimensionality is transposed to the realm of air, the motifs being those of floating, hovering, and flying. The rising or flying effect is suggested by colored lines linking the colored, partly transparent rectangles at the corners, so that they seem to be in front of the picture surface. They look like extremely light volumes that will go on revolving forever in cosmic space. The work shown here is the first step toward such a new and fruitful schema.

1927 ∄.4 Côte de Provence 6

Painted 1929

BEFORE THE SNOW

Watercolor on colored paper, $13^{1}/_{2} \times 15^{3}/_{8}''$

Collection Allenbach, Bern

Klee was not even daunted by the challenge of meteorological processes. He painted *Unsettled Weather*, an *Air Hunting Scene*, and (since references to human destiny are never absent from his work) also a *Wandering Soul*—all in the fall of 1929, like the watercolor shown here. Such atmospherical pictures—a small group—date from shortly before *Surfaces in Tension* and the "flying cities." Like the latter, they deal with problems of space, only in this case the approach is not "constructed," but in terms of irregular, translucent planes. They look sometimes like clouds, sometimes like birds sailing through colorful cosmic expanses; they open vistas upon ever vaster, deeper layers of space. These works are "constructed" only in so far as the translucent surfaces break up space into definite arrangements with definite intervals before surrendering it to infinity. Thus, even the realm of air is ordered by Klee—he had always intended (unlike Ingres) to order movement.

The fact that this work brings to mind ghosts and demons or the transitory nature of human existence is almost inevitable. "We only pass by, like a passing breath of air," Rilke says in a poem; consequently, inner cosmic space in the poet's sense, the inner and outer processes, correspond to each other, and the tree in our picture is not outside us: "O, I who would grow, I look outside, and it is within me that the tree is growing."

One is surely reminded of late autumn when viewing this picture, clouds bringing snow above the tree, the earth turned brown-red and gray below it. The two clouds with their peripheral colors come close to touching tree and earth, planes overlapping without touching. By contrast, the colored planes of the tree intersect, but the compartments are filled with one color only, pink at the center, reseda green and light violet next, a darker violet and a violet-gray at the edges. The space is black-brown and black-green.

Will the tree survive? Its colors are reassuring, suggesting fall and spring at the same time: Indian summer. The snow will cover it and keep it warm until the buds and the pointed tips of the leaves are allowed to unfold.

SHARES 1000

COMMON STOCK
$6,000,000
6,000,000 SHARES

NUMBER B6120

PREFERRED STOCK
$4,000,000
4,000,000 SHARES

PALMER UNION OIL COMPANY

INCORPORATED UNDER THE LAWS OF THE STATE OF CALIFORNIA

This is to Certify that O. D. Nahn & Co.

is the owner of

One Thousand shares of Common Capital Stock of

PALMER UNION OIL COMPANY, a corporation organized under the laws of the State of California, transferable on the books of the Company by the said owner in person or by duly authorized attorney upon surrender of this certificate properly endorsed. This certificate is issued and is to be held subject to and with all the rights, privileges and restrictions of the holders and owners thereof, the By-Laws of the Company and first meeting of Fifty in each year to be held at the office of the Company, shall become...

The preferred stock may be redeemed at any time at the option of the Company at...

191_, at the rate of $1.00 per share... the par value of said stock shall become...

In Witness Whereof, the said corporation has caused this certificate to be signed by its duly authorized officers and its seal to be hereunto affixed this _____ day of January A.D. 1917

SECRETARY. John M. Williamson PRESIDENT.

CAPITAL STOCK
$10,000,000.

10,000,000 SHARES
SHARES $1.00 EACH

THE UNION LITHO CO. S.F.

For Value Received _____ hereby sell, assign and transfer unto _____ Shares of the Capital Stock represented by the within Certificate together with the interest or dividends now due thereon or hereafter earned and do hereby irrevocably constitute and appoint _____

to transfer the said Stock on the books of the within named Corporation with full power of substitution in the premises. Dated FEB 28 1917 191___

C. D. Kahn & Co.

In Presence of
C. M. Busby,

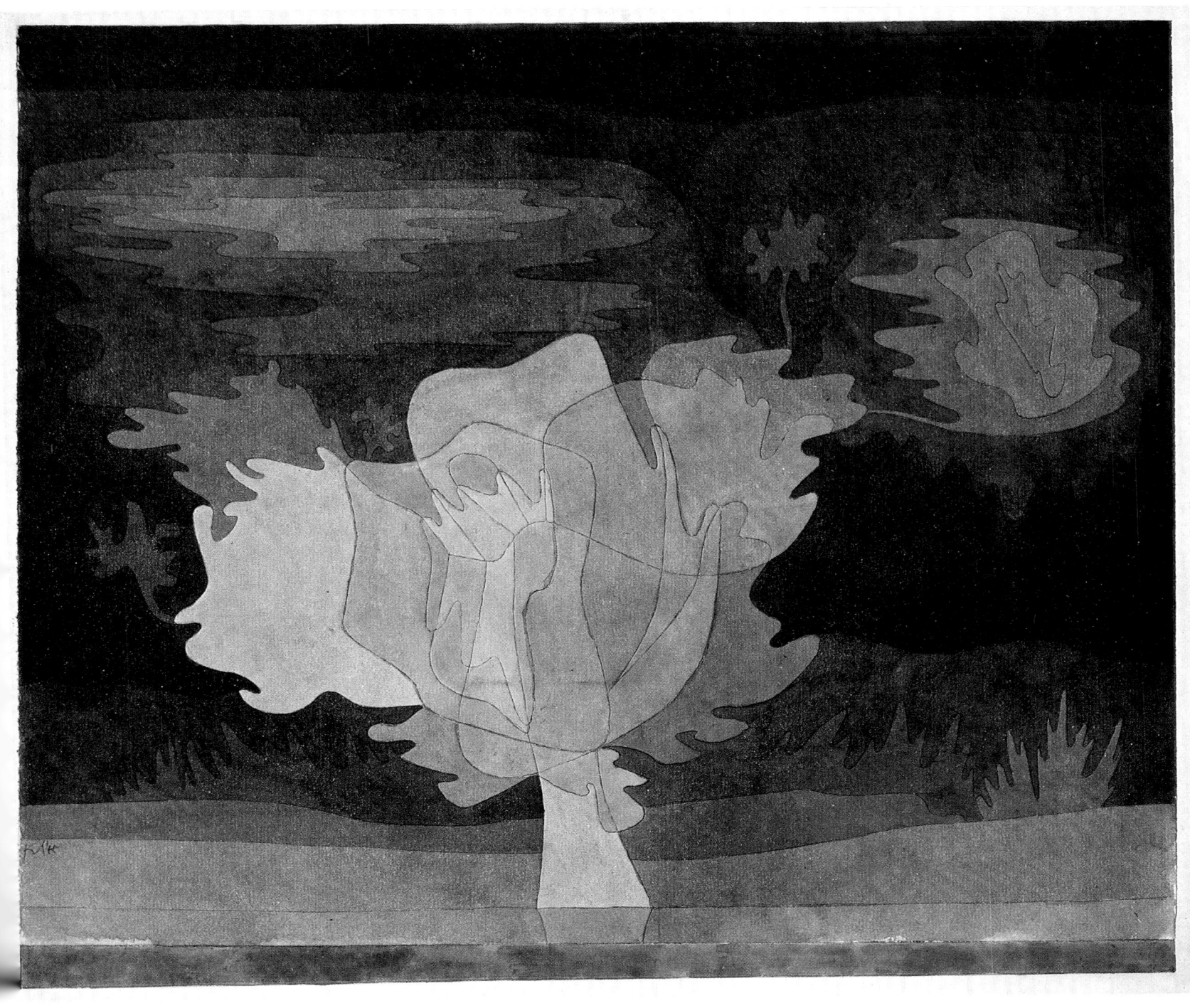

Painted 1930

ERROR ON GREEN

Watercolor on cotton, 16 × 15 1/$_4$″

Galerie Beyeler, Basel

A moon figure—one perfect circle with the appended segment of a circle, two tiny circles in the face, two rods supporting the segment—this is the construction titled *Error on Green*. But the title conveys more than the solution of a mathematical problem—"on green" is clear enough, but "error"? Inside one of the girl's round eyes is a crescent moon, inside the other eye a black sun from which rays are directed backward. Next to this eye are two overlapping rectangles, the one in front with a black teardrop. Tears turn up frequently in Klee, in the Divisionist *Sunset* of 1930, for example. "When the sun goes down, people are sad." Is there sadness here, too? About what? A failed acrobatic exercise, hinted at by the carmine red leg on the yellow card table? Or is it the ladder which doesn't quite achieve its purpose? It bends at the point where it touches the moon face, and stops short. Nor is the thin, severe mouth exactly cheerful.

Strangely enough, the moon disk cannot possibly be supported by the blue-green segment with the hands; it should fall forward. Is the ladder supplying the countervailing force? In any case, there is an "error" of balance—and "error" as well in the implied acrobatic anecdote. But would this suffice to bring tears? Perhaps the sadness comes from some remoter cause. Note that the lines of the nose terminate in antennae, the red line at the right disappearing in space, the black one at the left racing to infinity in a sweeping curve. This looks like some sort of remote control and brings to mind cosmic unity. The spirits that live beyond our planet are not all good spirits; have evil ones brought about the "error" which wrings a tear from the moon face?

Here everything proceeds according to law, i.e., the structure and articulation are governed by self-decreed rules. This is why the nose is shifted left of center, to make room for the rectangles at the right.

There are not many pictures of this type in Klee's œuvre. We may include among them *Senecio* of 1922, executed in Basel, which also shows a round form, a moon face with circular eyes, Divisionist and Surrealist references. Similarly, *Scholar* of 1933 has circular eyes and antennae for eyebrows, nose, and mouth; here, too, the oval head rests upon the segment of a circle. These are figurations that stand between man and the stars, between human fate and the universe. To Klee, such a sense of connection was perfectly natural; his formal cosmos is always in the end very much like the creation as a whole, and is a metaphor of it.

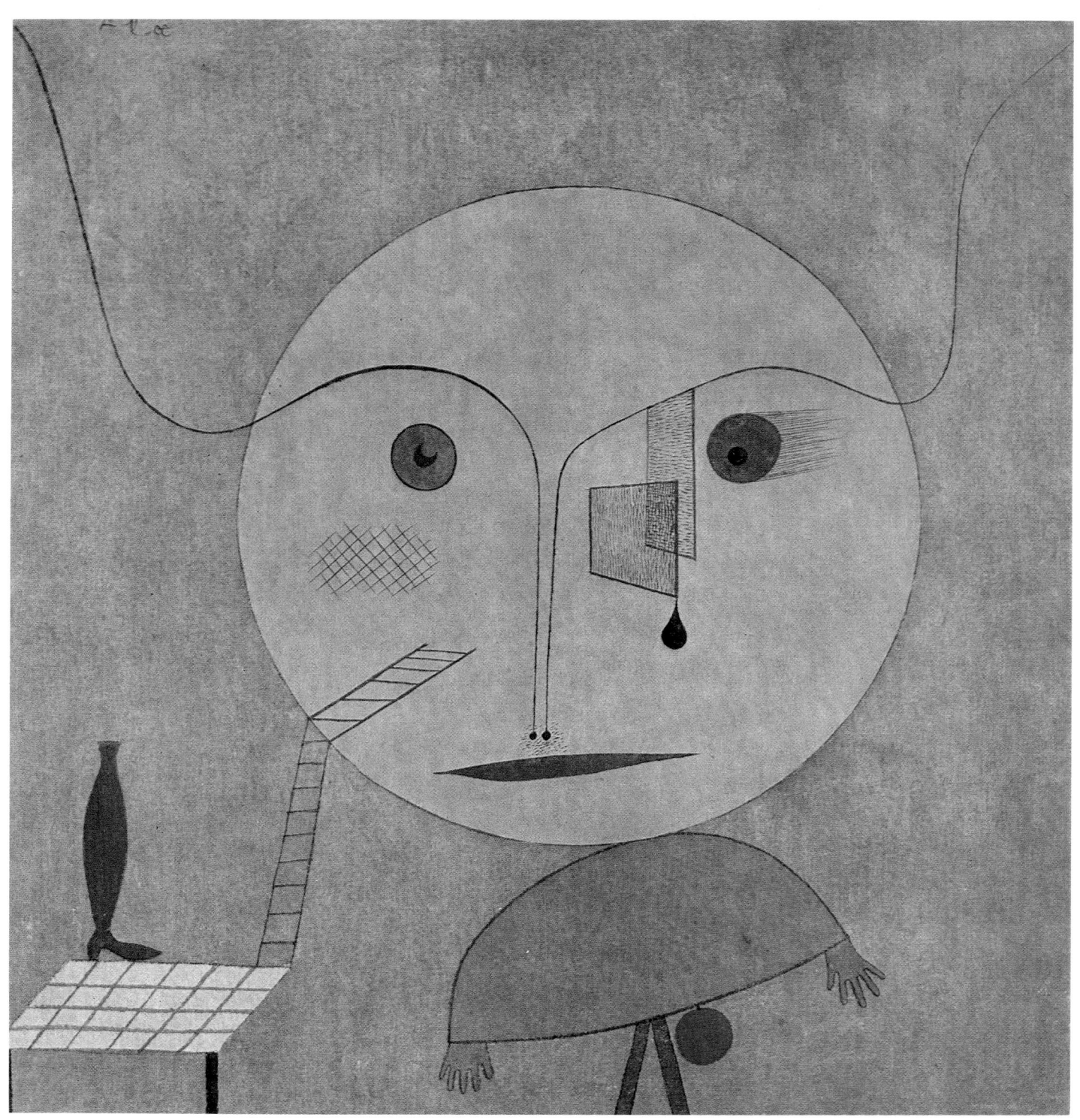

Painted 1930

OPEN BOOK

Oil and watercolor on canvas, 17⁷/₈ × 16³/₄″

The Solomon R. Guggenheim Museum, New York

This monumental structure brings to mind an Egyptian tomb rather than a book, although it would be hard to name the exact tomb, or to justify as an entrance the black-and-blue area partly covered by misleading superimposed flat forms. The planes, including the one that is folded back, might very well be parts of stone rooms, but the picture is titled *Open Book*, and in fact can be interpreted as such, a folio volume opened to an illustration. It is not possible to make out what sort of a book it is, for who can interpret the mathematical sign at the lower left, and the red drop: teardrop or heart? It may be the key to the picture.

The book looks yellow with age, mildewed, and there are fuzzy crosshatchings accompanying the contours. These turn up for the first time in 1923, and strengthen the impression that we are dealing with an object in an antique shop, although their primary function is spatial. It may not matter whether this is a book or a tomb, in either case the antiquity is made clear. Anyway, Klee never took objects as his point of departure; rather, he arrives at them once he has got down all the pictorial elements in the right order. Here the order is indicated by the position of the pages (or walls of a tomb) in relation to one another, in their problematical but pictorially right combination, by the way the parts interlock, how the brown spots of mildew are distributed over the entire surface, the deep blue accent of the linear-perspective vanishing point—the opening! It is impossible to explain rationally what the book (or tomb) signifies here.

Klee lets things come into being, his method of transvaluation extending over all life's many domains; the ambiguity and multidimensionality of his works are accounted for by the way the various realms of nature interpenetrate. He likes to deviate from the normal: "If you take the normal too literally, you wind up in a wasteland." He remains constructive, but never didactic, for the very fact that the picture poses a riddle invites the viewer's imaginative collaboration with the artist. This book remains a book with seven seals.

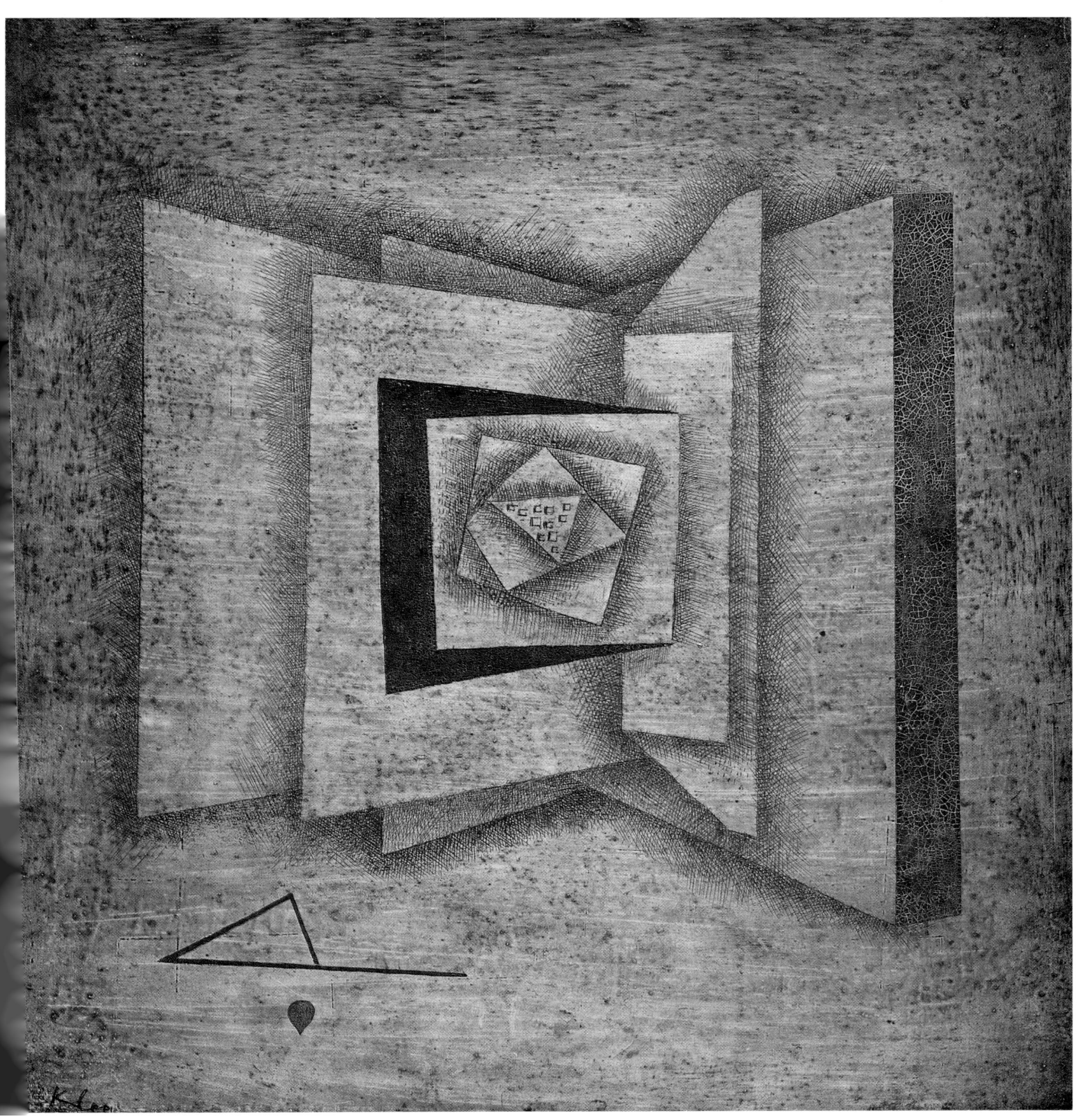

Painted 1930

TEMPO OF THREE, QUARTERED

Paste colors, cut paper, and cardboard, $17^3/_8 \times 24''$

Private collection, Germany

In 1930 Klee painted three closely related pictures: this one, *Rhythms*, and *Rhythms More Rigorous and Free*. The first two are black, white, and gray, the third is black, brown, gray, and blue. Shown here is the first version of the theme, which Klee believed to be the best. He was sorry to have sold it, and may have painted the other two versions to make up for the loss. The black, white, and gray squares and rectangles form rhythmic horizontal, vertical, and diagonal arrangements, so that no matter what color we choose to follow, the result is always a clear rhythmic arrangement wherever the eye leads.

Presumably this motif was inspired by the checkerboard pattern, but "its regularity lacks the charm of growing bigger or smaller. . . . The result is unproductive despite the multiplication of forms." Movement produces higher unities, quantities become qualities, the "three-part measure" dissolves the checkerboard pattern and turns the picture into a musical happening. The irregularity of the fields—the black have clear-cut boundaries, between the gray and the blue are blurred—produces a space-time continuum sonorous in effect, inviting associations with polyphonic music. Did Klee have Bach in mind? We know that he played Bach in the mornings as a sort of warm-up for work. Undeniably this work has a fuguelike quality, and we may even imagine a theme in the way the black, gray, and white rectangles of various sizes succeed one another. The broad brown border gives this passionate picture greater intimacy and warmth.

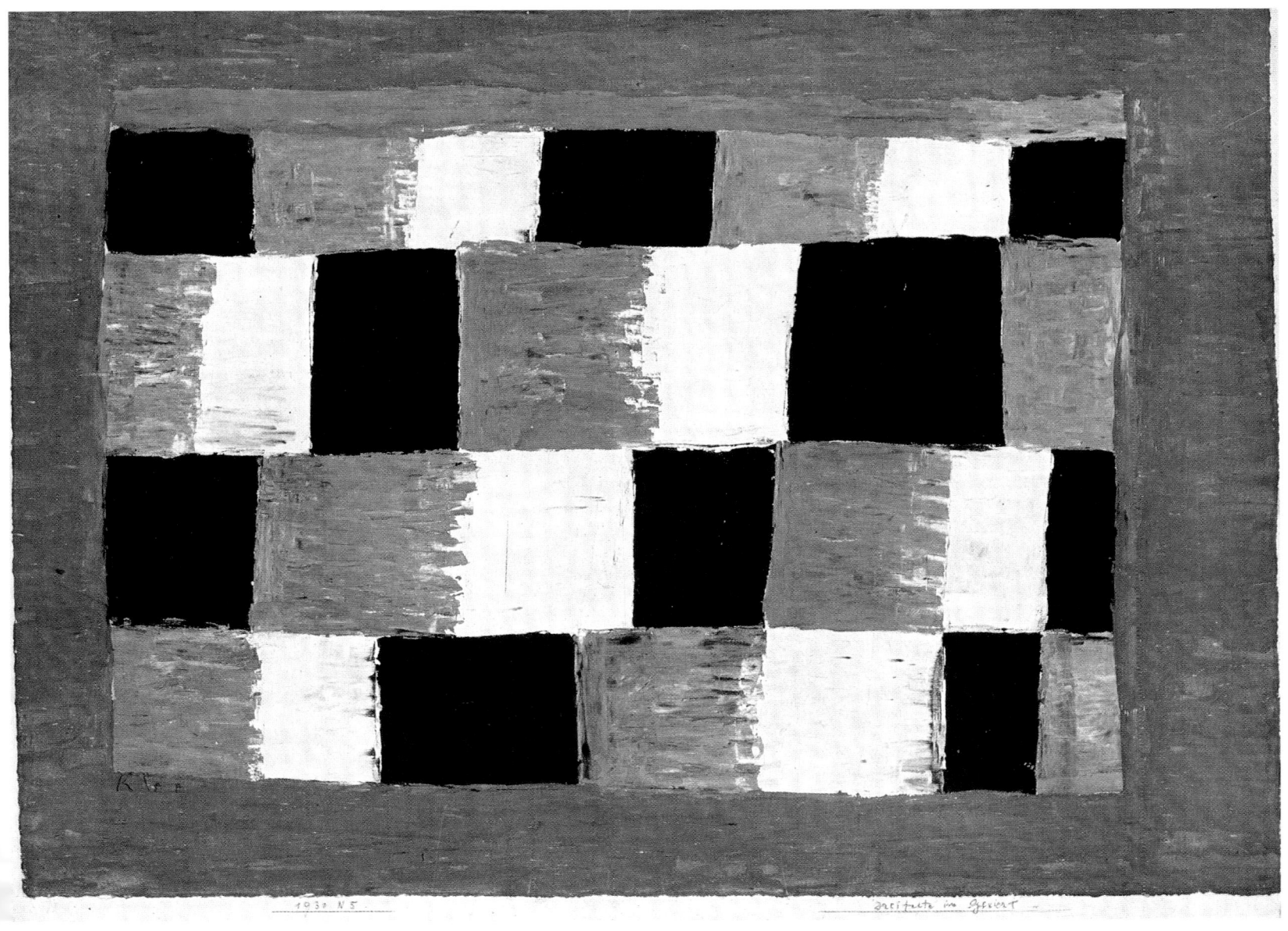

Painted 1931

STILL LIFE WITH DOVE

Oil and crayon on cardboard, 21 ¹/₂ × 27 ¹/₄″

Collection Dr. and Mrs. Howard D. Sirak, Columbus, Ohio

The dove is the protagonist of this picture and of one earlier gouache, *The Descent of the Dove* (1918). In the earlier work, it was the dove of peace flying toward Mount Ararat from a dream land, with the olive branch in its beak. Here it is part of a still life, more accurately an assemblage of objects: a tall goblet, a folded letter, the mortar and pestle on the right, and the head shape at the left. The dove looks numinous rather than terrestrial. Even the pink curtains drawn back on either side do not change the supranatural impression. The arrow at the top is pointing to the goblet with fruit or the mortar and pestle, perhaps past them to something outside the picture. The dove's head is also turned to the right. Does the solution to the riddle lie in that direction? Is the right side the East, is the East the destination of the dove and the letter? In Klee, a still life is more than a still life, never a *nature morte*. There are similar thrusts into transcendent realms in *Colorful Repast* (1928, fig. 29) and *Still Life on Leap Day* (1940), also to be grasped on the basis of their pictorial features rather than on the basis of the objects represented.

We see round and pointed forms, forms referring to objects, and free, flat three-dimensional forms, forms stressed by hatchings, both direct ones such as the arrow, and indirect ones such as the head (if it is a head). But these forms do not intrude into the space, if only because the relationships are undetermined (for instance, we do not know whether the wing shapes at the right of the dove belong to the dove or not) and because the colors do away with every kind of substantiality—the light pink of the curtains, the light blue of the dove, the green of the mortar and the tablecloth, the light brown of the fruits and the hatchings. And then there is the white. What sonorities! Many elements have been taken over from earlier conceptions (the curtains, the magnificently weathered surface of the paint), but the whole suggests the spirituality of the last period rather than the earlier, more richly varied ensembles.

THE LIGHT AND SO MUCH ELSE

Watercolor and oil lacquer on canvas, 39 $^1/_4$ × 38 $^5/_8$ "

Private collection, Germany

One of Klee's most radiant pictures, from a series that deals with colored light, which begins in 1930 and ends in 1932 (plus one addition in 1933). Thus it falls in the same period as the collapsible boxes of the "flying cities," and the "stripe" pictures based on the trip to Egypt. Klee had so completely mastered the most varied schemata that he could produce works falling into three different types at the same time. In most cases the first work of a new series contains some echoes of the preceding one (here, the Egyptian), but at this time the aerial space pictures and the aerial dream pictures were produced concurrently for more than two years.

Klee called pictures like the one shown here "Divisionist," so that what he called his "crop of dots" would not be confused with Seurat's Neo-Impressionism. His aim is not to make color and light, pigment and spectral color coincide, nor to make colors mix in the viewer's eye, nor to harmonize contrasts or construct space. It is to create light-filled space. On a slightly differentiated, cloudy ground Klee places dots of various colors and intensities in close alignment, in such a way that the blues and pinks, the greens and blues form distinct groups—in other words, so that they remain separate in the viewer's eye. Nor is the effect entirely dependent upon the color groups and the intervals between the dots. The breaking up of the Divisionist surface is determined by structural verticals and horizontals, which for the most part intersect at right angles, as well as by heavenly bodies (a dominant red sun and a half-moon), a flag shape, and an obelisk. Could we be looking here at a Mediterranean harbor? This is suggested by the lower part of the picture, which is "abstract with recollection." Klee's pictures always contain some clue pointing to some element of humanity or fate.

Preliminary stages of this treatment turn up as early as 1925, so this particular invention was slow to mature. It was only after structural patterns began to attract him for their "stimulation of the mind" that Klee began to create pictures which are nothing but colored luminous space, where the colors are the "actions and passions of light"—pictures that are "acts of the universe" (Novalis). There is no outside and no inside; the Divisionist schema does not presuppose a phenomenal world. The signs in this picture, to begin with, are comparable to numbers in an equation with many unknowns. For all that, the title could also be "The Divine Eye of Day" (Sophocles).

Not all pictures of this type are luminous. *North Room* (1932) is rather dark, and *Landscape Uol* (1932) looks like an airport at nightfall, the last glimmer of daylight caught on a plane and a landing strip. *Uol* is one of the more "communicative" works in this group. Like *Fermata* and *Polyphony*, *Light and So Much Else* is an absolute work. As always, the schema is not a limitation imposed upon the possibilities, but a device for intensifying them; everything is subordinated to it, the inner and outer eye in perfect harmony.

Painted 1932

AD PARNASSUM

Oil and casein on canvas, 39³/₈ × 49⁵/₈″

Kunstmuseum, Bern

Like *Light and So Much Else* (page 125), this is a major work of the Divisionist group, somewhat more "objective" than the other, with its golden-yellow morning sun and the divine mountain with the remnants of a temple at its foot. This time the dots are recognizable tiny rectangles—white, yellow, orange, blue, and green—but, unlike the preceding picture, here the planes are clearly delimited and superimposed on the ground—the light blue dots on dark blue, the light green ones on darker green, the white ones on gray. Here and there colored dots mingle with white ones, and orange ones with bluish ones.

The colors are fairly changeable, so that the viewer experiences the transformation of light from dawn to noon. The long narrow triangle above the sun signifies dawn, the pointed white wedge above the temple is noon—nowhere has Klee shown the phenomenon of time so clearly as here. The title, *Ad Parnassum*, is an invitation to ascend the mythical mountain in full daylight, not just to admire it from a distance. The temple portal at the bottom may mark the beginning of the ascent; the golden-orange triangle standing on its point may be an indication of more ruins. Did not the gorges of Parnassus contain the Delphic oracle and the Castalian spring? Might not the ruins refer to them, too, for instance? The light illumines a site dedicated to the Muses from the beginning of time.

The contours of the mountains and the ruins are so clear-cut that it seems as though Klee intended to merge them in a single whole; possibly he had in mind a second picture inside the picture of fluctuating luminous space, a solidly built picture including the pointed wedge of white dots, which forms a kind of platform. The second picture is all the more solid because the mountain confronts us as a vertical plane extending to the upper edge.

Inside the pyramidal form the light is brighter than outside. Was Klee thinking of a snow-capped peak and a forest farther down? Maybe, but if so he only thought of it afterward, for the primary element is the schema which, applied to different elements in each picture, provokes different associations and identifications.

The pictures of this type bring to mind the mosaics Klee admired in Venice, Ravenna, and Palermo. In his Divisionist period he actually painted mosaics: *Mosaic from Prhun* (1931, fig. 35), for instance.

126

Painted 1933

SMALL ROOM IN VENICE

Pastel on colored paper, 8¹/₄ × 12″

Kunstmuseum, Basel

Venice? Easy, melodious lines intersecting to form flat surfaces: windows, curtains, sky, sea. Only the year before, Klee had painted *City on a Lagoon*, which was inspired by *Highway and Byways* (frontispiece) as well as by the parallel figurations. Clearly, this is not Venice—it is Paul Klee's Venice. He could have painted it on the basis of the name alone. It is his idea of Venice, and had be seen it only later, his presentiments of it in color tones and formal development would have been confirmed, memories reaching deep down brought to life—memories not to be found in books.

A dreamy picture in luminous pastel chalks, applied on a sheet of absorbent blue paper which, as ground, shows through everywhere. The colors are various shades of blue, green, and pink: purple-blue, blue-green, purple-pink, with some intermediate tones in addition, just how many the viewer can hardly say. He perceives the fascinating pink and the deep royal blue in between, without asking whence or what for. Almost fortuitously he discovers curtains in the triangular areas, windows opening out onto a view in the blue between them, and eyes in the two circles. Are they looking in or out? Is the light coming from inside, or is the evening sun still falling on the sea outside? The cross at the upper right and the moon at the upper left are city and firmament, the tapering dome shapes are remote reminiscences of San Marco, the areas formed by intersections may be lagoons, but they look different from those in *City on a Lagoon*.

"Small Room" is a poetic paraphrase for a much deeper event, for the interchangeability between outside and inside, for cosmic inner space. Probably Klee never framed all this in so many words, but he lived on a spiritual plane where inside was scarcely to be distinguished from outside. Are we outside where the intersecting lines form pink triangles—which might be curtains? Is the light falling on them from inside or from outside? There is a picture titled *Angel in the Making* with a cross and a circle like the ones here; but there the signs presumably denote the place where the angel is coming into being. Here, are they references to the city of San Marco? Surely they are not meaningless, even though the greater mystery of this picture lies in the magic of its colors.

1933 H 7 ein Stübchen in Venedig

Painted 1933

FIRE AT FULL MOON

Watercolor, wax coated, on canvas, $19^5/_8 \times 25^5/_8''$

Folkwang Museum, Essen

This work falls somewhere between the picturesque flat city views *(Castle and Sun,* 1928) and the cubic castles and houses *(Castle Hill,* 1929). Distorted checkerboard patterns meet with stairlike formations coming toward the viewer; just to the right of the full moon a structural part is projecting forward. The lemon-yellow moon inside a dull violet rectangle at top left casts a pale light on the green, blue, and browns around it. At the right, in the alarming cinnabar red of the fire, a few accents flare up within the whitish violet, the pale and the darker greens, and the warmer brown. The sharp red is as exciting as a real fire at night; presumably Klee had watched one at some time or other and discovered a whole new range of color tones. He may have observed how the fire's reflections throw portions of the scene forward, whereas the yellow of the moon flattens out other portions. Thus, the left part of the picture brings to mind the "squares" (from 1923 on), and the right part Klee's attempts to render the third dimension, although in his opinion it has no place in painting. If it asserts itself, it does so in the manner of Picasso's pre-Cubist works, which Klee admired at an early date in Hermann Rupf's collection in Bern.

The cold disk of the moon and the cross of the fire determine the picture; the yellow circle draws everything it illumines into the melancholy-nocturnal, while the flaming red arouses echoes of uncertainty. The black strips and polygonal forms do not connect up but break apart. They are like fermata signs interrupting the rhythms of a stately funeral march.

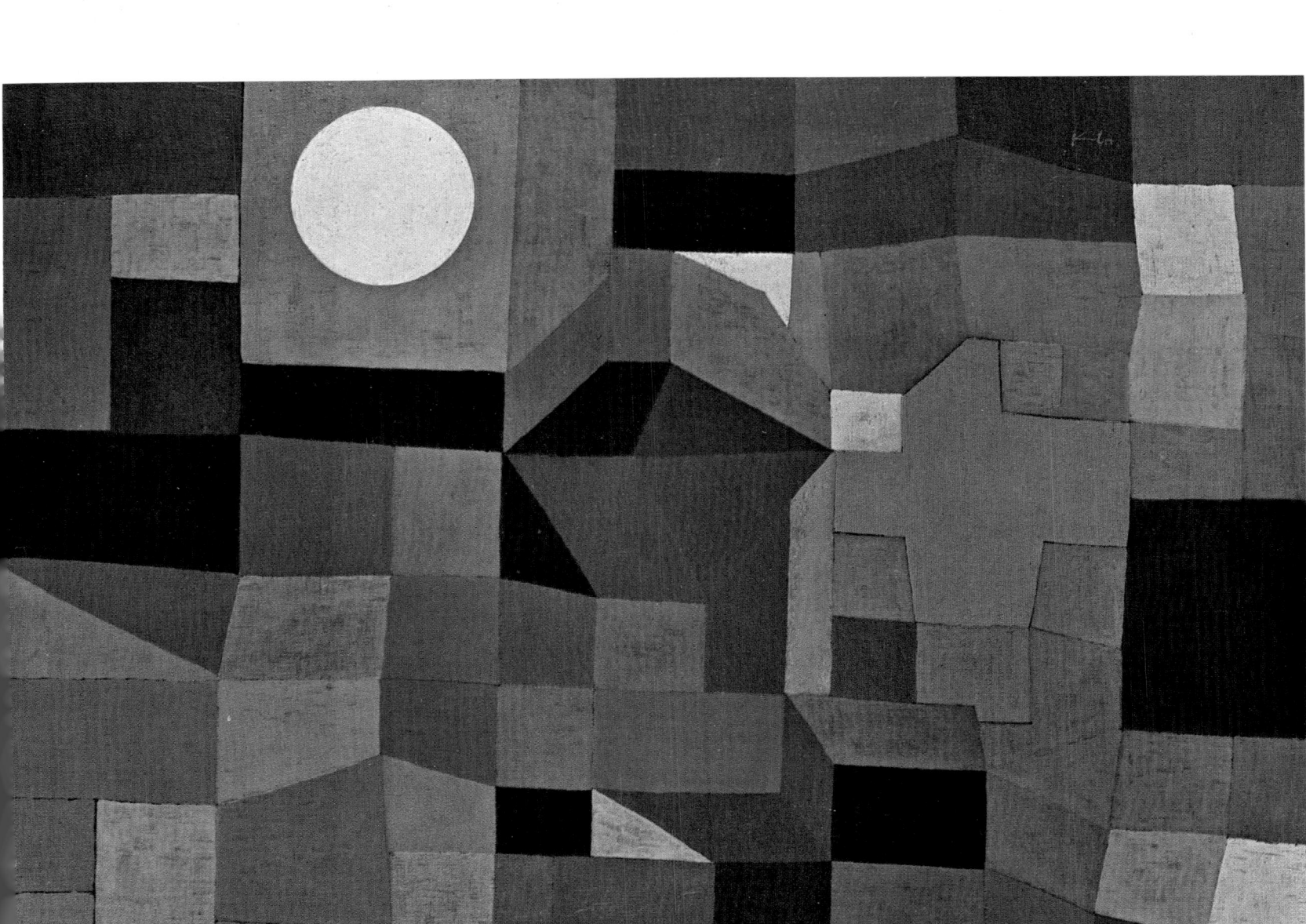

RAVAGED LAND

Pastel, watercolor, and oil on cotton, damask and silk, mounted on cardboard, 15 × 12¹/₄"

Galerie Beyeler, Basel

This, too, was within Klee's extraordinary range. *A Ragged Community* (1932) was a fairly orderly watercolor on a piece of burlap, but here Klee anticipates the painter Burri, pasting a scrap of damask on a piece of cotton, then both of these on a piece of silk, and finally the whole thing on a piece of cardboard. We can hardly speak of a schema here—the message has been so skillfully encoded, no one can break it. We are reminded of weathered walls, the study of which Leonardo found so stimulating, and of hidden abysses. The treatment actually is related to Burri's, but the feeling given off is more friendly than terrifying. The raggedness of the frayed bluish silk cloth is controlled by the paint. Klee has inscribed a cross on the square of damask and attached two legs to it, so that it resembles a skier holding a snow sail. At the same time, strangely enough, it remains a piece of cloth, a new form of confrontation between the I and the Thou. For all the seediness of the materials, this is a noble painting with springlike greens and spots and strokes of red. A garden? In any case, there is a window at the right in which a landscape is reflected, and the skier is not held up by a cable but moves along a path. The brown lines at right may be the contours of a house, the red strokes may be roof tiles, and the two upper corners flower beds. We are now inside this picture, but Klee wants his landscape to have legs, for the row of Xs at the bottom can hardly be a garden hedge. With Klee many things are possible and plausible.

He calls it "ravaged land." Is this the aftermath of a storm, or is the violence accounted for merely by the artist's impetus, once he has made up his mind to do something with the ragged kerchief? There are few conceptions by Klee as abstruse as this one; to some extent we may relate it to *Scarecrow* (1935, fig. 39), but the latter is at least normally placed on a rectangular ground. No, *Ravaged Land* is unique, perhaps even an accident—though if so, one of those accidents that happen only to artists as imaginative and inventive as Klee. It would be wrong to think of this as a vision of impending disaster, upon which the painter has hung the cloak of "Hope" to reassure himself.

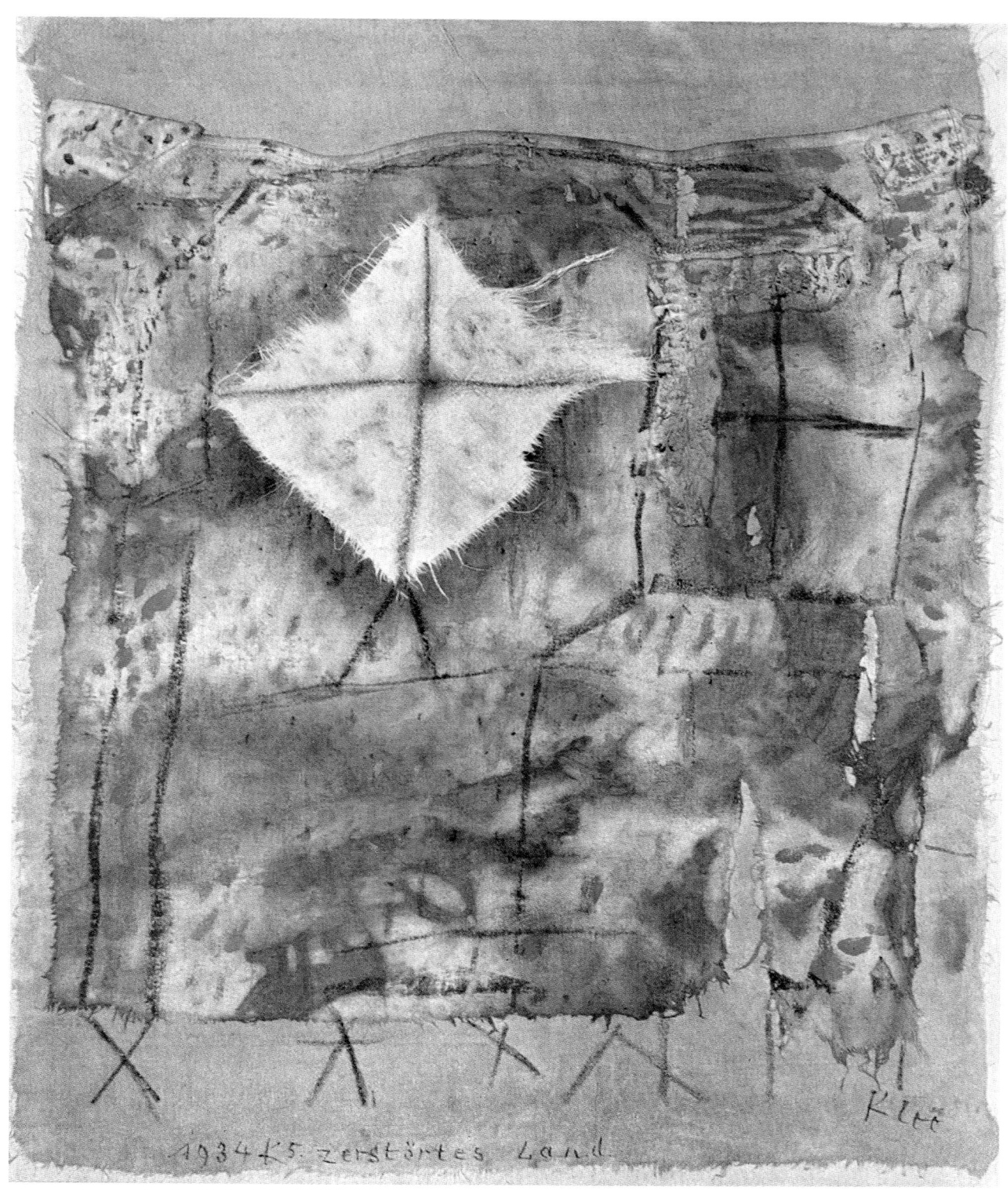

Painted 1934

COMING TO BLOOM

Pastel on paper, mounted on cardboard, $8^1/_8 \times 12^7/_8''$

Galerie Beyeler, Basel

Executed the same year as *Blossoming* (the famous Zurich picture which is a variant on the "magic squares"), *Coming to Bloom* is spring, a blossoming tree emerging from the schema of squares (their size decreases as we get closer to the center), a tree almost more credible as such than Claude Monet's sun-drenched trees in blossom.

The Zurich work is a big one, carefully worked out down to the last detail; this pastel is a sketch on black paper. The ground shows through, and the squares look like the rough-hewn stones of some Cyclopean wall. The colors are differentiated at the darker end of the chromatic scale, though carmine pink scampers forward in two places, and orange at the right. What a masterly gradation, at the left, from blue and violet-blue to violet, with a furtive green in between! The colors have all been chosen with the greatest sensitivity, including the various browns: red-brown, fawn, umber, and gray-brown, which at right brighten to ocher and orange. A chart of nuances such as turns up rarely even in Klee. As in the case of the rhythmic pictures (*Tempo of Three, Quartered*, 1930, page 121), the squares can be read vertically, horizontally, or diagonally. The composition is rhythmic in every direction, and in the right portion of the picture the small squares even supply pauses and interruptions.

One must not leave out of account the sketchlike character of the work and the pastel colors, which have the peculiarity of supplying sudden rises and falls in intensity. Moreover, all color is very different on black than on white—it leads a more imaginary life. The places where the black shows through are irregular in shape, now narrow and now broad; at one place the black gapes like a hole in the wall of colored blocks. Nevertheless, the picture essentially remains a color chart. Here the outlines of the squares result from the pastel strokes, most of which are horizontal, so that there are no sharp boundaries.

We do not know why Klee failed to include this work in his catalogue. Sometimes he would let a work lie around for years, neglecting to record it until urged to do so by a friend. *Penitent* of 1937–38 had to wait a long time before being signed and catalogued. Only when Klee was perfectly satisfied was this done. Surely this pastel deserved that happy fate?

Painted 1934

MOUNTAIN VILLAGE (AUTUMNAL)

Oil on white-coated plywood, $27^3/_4 \times 21^1/_4''$

Galerie Rosengart, Lucerne

The last half of Klee's first year back in Bern was rich in unusual panels: *Fear, Angel in the Making, Sphinx at Rest.* The work shown here is one of Klee's frequent translations of a three-dimensional theme into flat polygonal forms, interlocking like the pieces of a jigsaw puzzle and suggesting houses and town squares in colors that evoke autumn leaves. They range from orange through cinnabar red and carmine to blue and violet. The rough-textured brown areas interrupt this chromatic arrangement, like fields scattered here and there within an otherwise inhabited landscape. The late sun brings out the colors so that they are brilliant without being loud, the closeness of the tones to one another removing all danger of stridency. Where contrasting tones do emerge, the transitions are taken care of.

Where did this schema originate? As in *Small Town among the Rocks* (1932), with its many overlapping polygons, the trail leads back to the early experiments with Cubism. The illusion of three-dimensionality is eliminated, the volumes are projected onto the flat surface, and the colors reduced to a limited number of tones. What is affecting is the rhythm of the forms and the melody of the colors, recalling Delaunay rather than Picasso. It is a mounting rhythm, the larger forms at the bottom, the smaller and more animated ones on top (triangles and pointed forms). In the field at top center is one little tree—in other words, this is the way out of the village, which is constructed from bottom to top—more exactly, in the direction of the arrow upper center. It is not by accident that the arrow crystallizes from the rough-textured brown areas.

The melody is a cheerful one, culminating in the two blue rectangles and the violet polygons. What a transformation of the earthly into the musical, the transitory into the incomparable, and all achieved merely by projecting the theme as a field of tensions composed of polygonal areas of various sizes and colors! Whether the viewer looks at the outlines or the overall ground plan is up to him, but it would seem that both views are combined here.

Painted 1936

SOUTHERN GARDENS

Oil on paper, mounted on cardboard, $10^3/_8 \times 12^1/_4$"

Collection Norman Granz, Geneva

An apotheosis of the south, all light and color, dating from 1936 when Klee was ill and executed only twenty-five works. A few pastels of 1937 are just as cheerful, but they are grasped less readily. Here we see a Mediterranean landscape with red and green tree signs, a black heavenly body left of center, and a white moon next to it. Is this the silver moon of Tunisia? The earlier *Southern Gardens* (1919, page 85) kept to the schema of the Kairouan pictures, but here we have something different. The shifting planes fit no schema, at the very most we may be reminded of the lower part of *Hammamet with Mosque* (1914, page 75), where intersecting fields supply the impulse. Here the fields are clearly marked off and exhibit three distinct colors. Pale olive-green areas appear next to white, bluish, and orange ones. They are all worked with brush and palette knife, and suggest laboriously cultivated land, not merely vegetable gardens or flower beds.

The painting is somewhat sketchy, the individual areas to all appearances are confined to a specific type of plant, but within each field the execution is masterly; color and treatment suggest thriving vegetation with, here and there, brown spots denoting the soil. This is a bird's eye view of the land, and only at the top left is there any clear indication of perspective. There, a wall turns a sharp corner, and it may be disputed whether the rectangles with the diagonals at bottom left are a house of which the orange area is the roof. But what about the small violet square at the top left corner, the only spot that does not fall into the scale of colors elsewhere used? Is this point zero, from which the viewer is to measure the temperature of the colors in the picture? That one has to look to find it was surely intended, for placed where it is, it is especially emphatic. Suddenly the blue of the sea at the top seems more African, and the red of the trees more tropical.

Painted 1937

CHILD AND AUNT

Oil on plaster-coated burlap, 28⁵/₈ × 20³/₄″
Galerie Beyeler, Basel

An autumnal picture—yellow, brown, pink, cinnabar, violet, and a bit of green are the colors that determine its character, not the lines. When the picture is turned sidewise, it suggests a landscape rather than a woman with a child holding her hand. As in the case of *German Dryad* (1939), we become aware of the faces only at the last moment, on noticing the line of the nose and the semicircular eyes. The plaster coating serves to animate the surface structurally. Klee "perforates" individual areas (as he also does with his "flying" three-dimensional bodies), which rise diagonally from bottom left to top right, not in order to achieve transparency, but, on the contrary, to give them the character of murals—the "perforations" are made with plaster.

The autumn leaves are falling along the house fronts and even on the two figures. They represent a little girl and her aunt, but this is only incidental—the lines that define them are as though fortuitously inserted among the mass of leaves, they just manage to put a little coat around the child's shoulders and the hat on the aunt's head with its interlocking U-curves. A larger U-curve of the same type connects the child's hand and arm with those of the aunt. The result might have been very different, for Klee uses such U-curves in landscapes with hills; the circle on the child's body would have been the moon, not the child's head. The bent line leading from the little hat to the mouth would then be a branch or a letter, rather than a division of the face into left and right. There are two letters at the top, a distinct "P" and a "T"—what is their function?

The main accent lies on the colors, on the yellow and the subtly differentiated pink violets—sunshine on the foliage and the two figures being metamorphosed into foliage. This is an Ovidian metamorphosis, translated into line and color and narrated with great skill so that even the anecdotal element comes fully into its own. The child assumes the typical defensive attitude, the aunt the solicitous and at the same time imperious attitude of the older person conscious of her responsibility. And all this is achieved by purely pictorial means, which on the one hand assert a will of their own and, on the other hand, make associations possible which can in the end be interpreted.

Painted 1937

ORIENTAL GARDEN

Pastel on cotton, 14 × 10³/₄"

Collection Mr. and Mrs. James W. Alsdorf, Winnetka, Illinois

1937 was the year for pastels, on cotton or on burlap, less frequently on paper; the chalks were often applied to a wet ground and absorbed by it. Linear elements are reduced to a minimum and consist of bars of varying thickness; these also make their appearance for the first time in 1937. Klee executes these pictures in bright, sunny colors or in dark, nocturnal ones *(Blue Night*, for instance). Some contain allusions to objects, while others are meditative pictures with very sparse hieroglyphic signs, like *Yellow Signs*.

Oriental Garden stands midway between recognizable form and pure harmony. It is full of recollections of Kairouan and Egypt, probably more of the latter here, which Klee had visited only nine years before. Klee is not evoking the image of the five-thousand-year-old land in this work—he does that in *Legend of the Nile*, painted the same year. There he tells a story, such as he found on the walls of tombs dating from the third millennium B.C. In the work shown here he portrays an Arab property, an elegant house with a staircase leading up to the entrance, and there are other allusions to architecture, windows, even a curtain. As in *Small Room in Venice* (page 129), the inside and the outside are not opposed here. Two hieroglyphs of trees suggest a garden. Pastel tones are better suited than oils to evoke the fairylike character of an Arab garden. The surface is divided into rectangular fields colored turquoise blue, light pink, and dark violet. The blue remains the same throughout, the violet is full of gray, carmine, and blue nuances.

Violet is twilight, blue is moonlight; the garden is the protagonist in this picture, indeed, the exclusive actor. As is often the case with Klee, one has the feeling that someone is expected, that something is about to happen. The principle of Hetoimasia, the empty throne. But the viewer is richly rewarded by the appearance of the colors within a clearly outlined *décor*.

It would be false to imagine that the whole year 1937 was given to meditation or melancholy. It was just as rich in quite different works, among them *Superchess* (now in Zurich), *Revolution of the Viaduct* (in Hamburg), *A Sheet of Pictures* (The Phillips Collection, Washington, D.C.), and *Traveling Circus* (Baltimore Museum of Art).

937/S 7 Garten im Orient

Painted 1938

HEROIC FIDDLING

Paste color on newsprint, mounted on panel, 26³/₈ × 19¹/₄″

Private collection, New York, N.Y.

In painting this picture, Klee had in mind his old friend Adolf Busch. It is a tribute to the great violinist and commemorates his vigorous, inspired playing. Klee, who played the violin himself, greatly admired Busch. The thick bars which Klee first used in 1937 proved very suitable for direct translation of music into the pictorial medium. They leave little room for differentiation, however, unless one can interpret as such the few unpainted spots left by the relatively dry brush at the bottom of the picture. There are a few "objective" allusions—to the peg of a violin, the bridge, and a portion of the scroll, but divorced from their objective functions. The dots may be notes, but they seem more like indications of rhythm. Klee may have been alluding to some specific composition, which would account for the signs at right (the circle, the half-circle, the wheel) and of course also for the color—royal blue within the bowings, a tinge of gray outside them, and a more turquoise blue around the borders. The blue has a deep, full sonority, like the music of Bach, and it is possible Klee had a fugue in mind.

The most amazing thing about this picture, however, is that when Klee attempted a second version he was led in an altogether different direction. Titled *The Gray One and the Coastline*, it was executed two months later. The bowings became greenish-blue, narrow spits of land projecting into a deep blue sea (or the other way around, the sea encroaching upon the coast). On the beach we see a starfish or a wind wheel, half-moons, teardrops, and, in the sea, three dots over one black stroke—a boat? But what is the meaning of the "Gray One," a half-figure whose right cheek is cut across by one of the spits of land? Is he a fisherman who feels that his catch is endangered, or is he looking for something at the left edge of the picture? At all events, as in other works, Klee was using the same schema here for two entirely different themes—in the one version, the theme is musical and spiritual; in the other, it is the struggle between the sea and the land, in which man is the sufferer.

Painted 1938

INSULA DULCAMARA

Oil on newsprint, mounted on burlap, 31 $1/2$ × 69"

Klee Foundation, Bern

In 1938 Klee painted seven large panels in horizontal format. Besides the one shown here, these were: *Spring of Fire, Fruit on Blue Ground, Intention, Rich Harbor, An Artist's Bequest,* and *Rusting Ships.* All of them are sketched with charcoal on newsprint, which Klee pasted over burlap or linen, thus obtaining a surface at once smooth and differentiated. The printed paper often shows through the color, and we read snatches of old ads and editorials. This did not trouble Klee in the slightest—he enjoyed such effects of mild surprise. More generally, he now makes greater use of unusual materials such as wrapping paper and burlap, paste colors, and plaster coatings. Similarly, from 1937 on, he employed bar strokes of varying thickness for his sign language.

Insula Dulcamara and *Fruit on Blue Ground* are cheerful works in contrast to *An Artist's Bequest,* with its sparse appurtenances on a dark ground. The two former pictures suggest warmth and the South, *Insula Dulcamara* also mythology, the world of Homer. Klee rejected the suggestion that this picture be named "Calypso's Island" as too "direct," but his sketch fits that idea. The black contours are coastlines, the head is an idol, the other curved lineaments point to some tragic entanglement. On the horizon a steamer is sailing by; this does not affect the myth any more than the heavenly signs are contradictory—one of them stands for the rising, the other for the setting moon. The colors are springlike—a May green, a blossom pink, and a sky blue. This is spring on one of the Cyclades, which Ulysses passed on his way to Ithaca. The Homeric Age has not yet ended, yet our own has long since begun, and the future with it. Transparency of time and transparency of space, for where would the latter begin or stop, where would be the difference between the sea and the land? Klee has entered the multidimensional without being aware of it, though in his youth he thought of this state as his supreme goal.

146

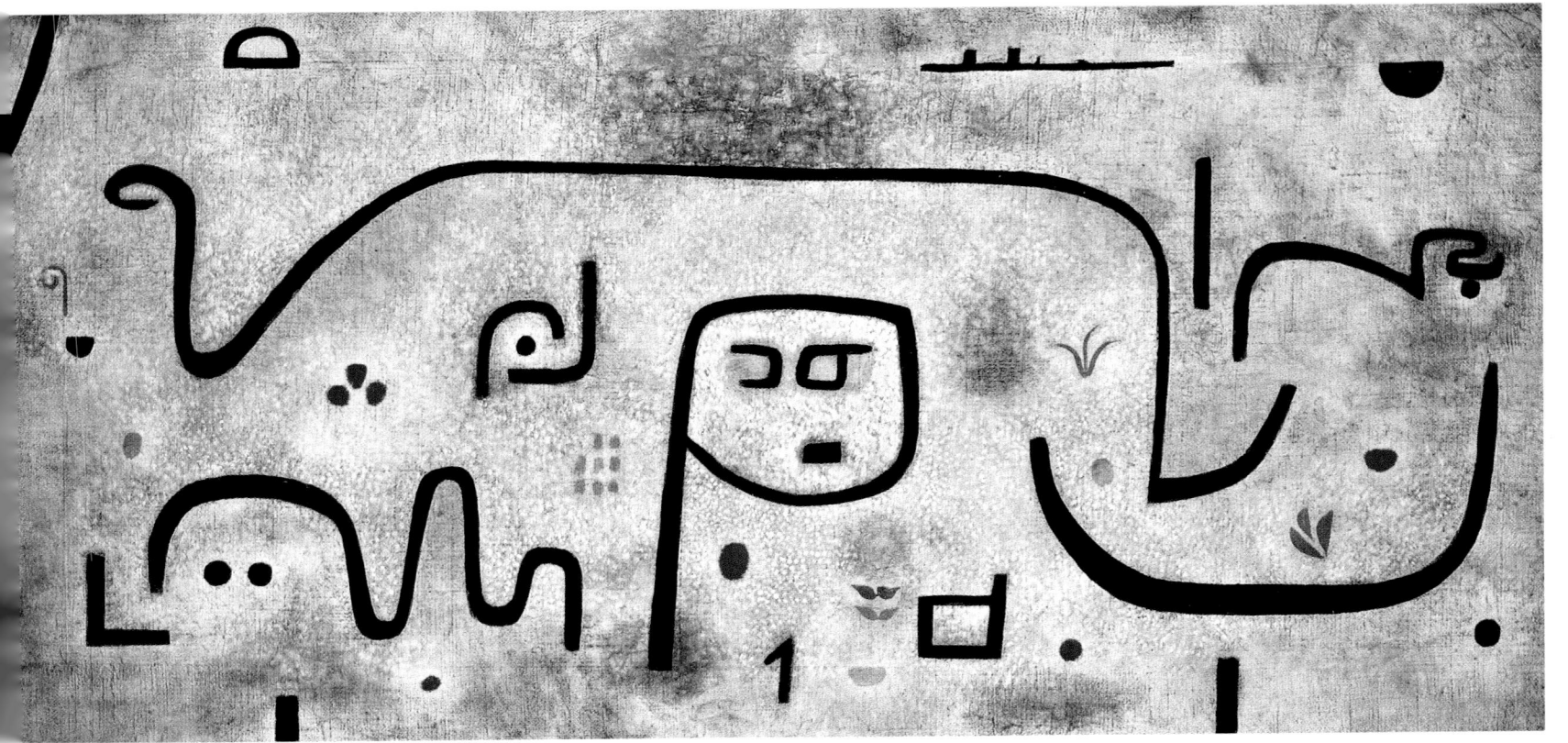

Painted 1939

DEEP IN THE FOREST

Tempera and watercolor on oil-coated canvas, $19^5/_8 \times 16^7/_8''$
North Rhine–Westphalia State Collection, Düsseldorf

Executed during the first half of 1939, about a year before Klee's death, this picture already points to the end. In 1921 he executed a work akin in spirit, *God of the Northern Forest*, which shows the difference between the Weimar years and the last years in Bern. In the 1921 work, the green is a romantic setting behind which a nature god is concealed, whereas *Deep in the Forest* is close to the *Green in Green* of 1938, a purely meditative picture made up of tensions between closely related colors. To work with such tensions is especially hard, but Klee was capable of coping with the dangers inherent in such color combinations.

This work exhibits the same green throughout, in varying degrees of brightness. The ground is darker than the vegetation, and the latter does not exactly look like plants in a forest. The form at the bottom brings a helianthemum to mind, the two forms at its right little trees in the wind, and the central figure a kind of face. A god of the northern forest, again? Surely not. What matters here is the varying intensity of the green and the plant forms outlined in black. These last are not readily identifiable, though they look as though they must belong to different species. Kandinsky spoke of green as an inert color—is it so here? Rather than inert, I should say inviting into depth, inducing to meditation. But where is the depth? Isn't this interplay of tones and shapes taking place on the same plane? The picture seems all ground and pattern, with very little depth. It is a quiet interplay between round, pointed, and blunted forms, more elegy than romantic song; not so much sad as expressing extreme reserve, a feeling about nature raised to the level of mystery. The resonances between the self and the world are shifted slightly in the direction of poetry and inwardness.

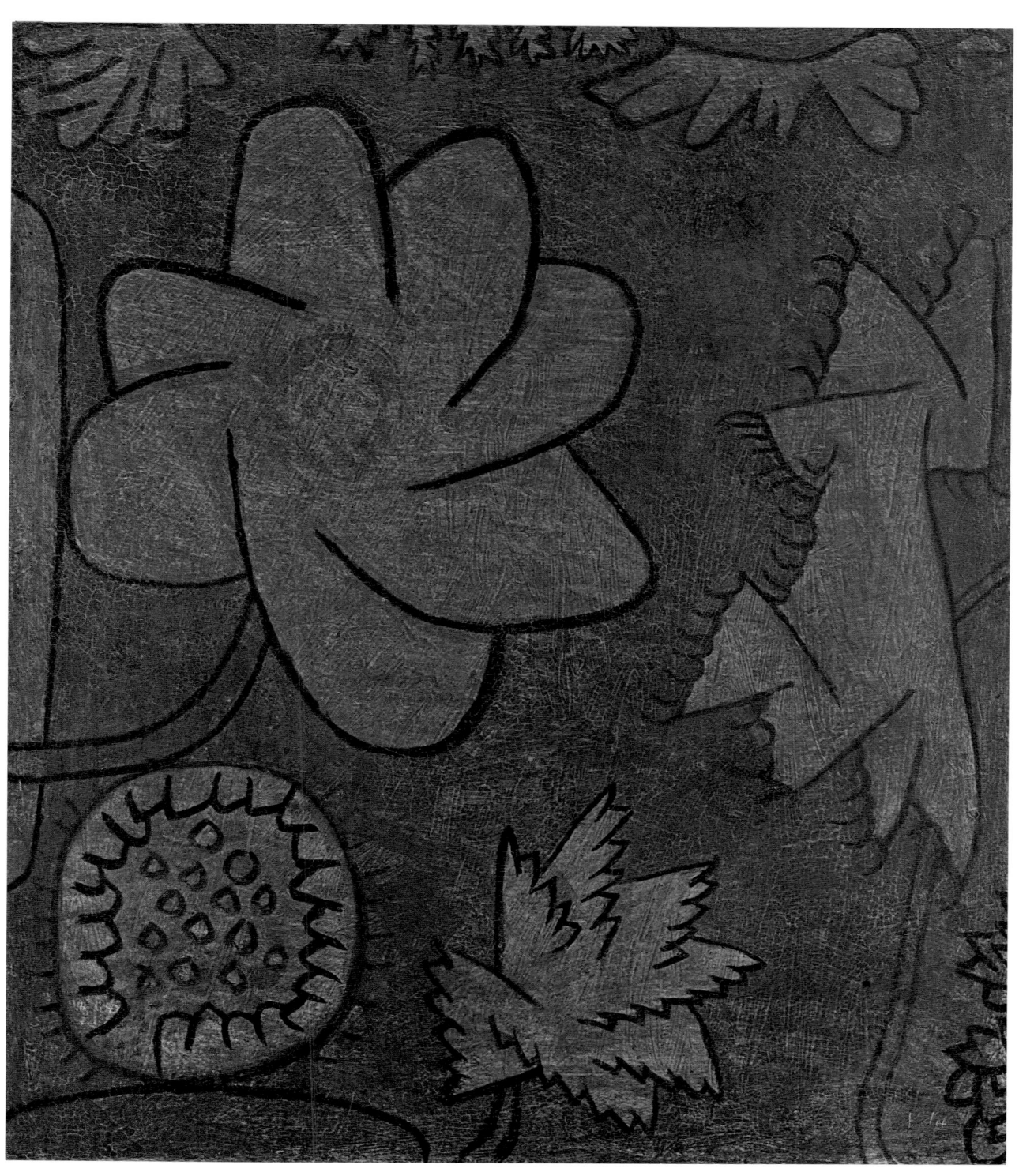

Painted 1939

PARK OF IDOLS

Watercolor on blackened paper, 14 × 8¹/₄"

Collection Felix Klee, Bern

The last chapter in Klee's creative career is taken up with demons and angels. As early as 1937, the last phase in his life and work opened with the dictatorial bar strokes and the euphoric pastels. Not until 1939, however, did the realm of primal fears irrupt. With works such as this one, we are getting closer to the Requiem Klee composed for himself. Now what comes to the fore is tension between time and eternity, the question of the questioner's existence, and the meaning of his art becomes the elucidation of existence.

Titles such as *Fear Erupting, Tragic Metamorphosis*, and *Intoxication* (1939) are indicative. Frequently all connection of things to one another appears to have been lost, color explodes like a geyser, yet looks on the point of turning rancid or disintegrating. The term "Baroque" occurs in several titles, as though to underline the exaggeration.

What are these "idols," and what sort of a "park" is it? Here and in other works of the period, Klee inhabits the realm of the oldest mysteries and the magical element is taken for granted. The three idols have clearly delimited forms, and the colors are not exactly decaying, they are nacreous. The forms are greenish yellow and reddish brown, the landscape is blue and gray-blue, the round ball of the sun is red—unless this is not meant as a heavenly body, but as another object of worship like the idols. Pictorially speaking, the latter are in good company: *Mephistopheles as Pallas* (1939) is closely related to them.

Because of the black ground, the colors of the forms seem the more imaginary and the park the more exact. The black areas are paths—or are they Nothingness that confers numinous quality upon this picture? Everything looks different on black—this discovery was made by Klee and by Kandinsky more or less simultaneously. On any other color, and on white, these improbable forms and their placement would be much less striking than on this unfathomable ground.

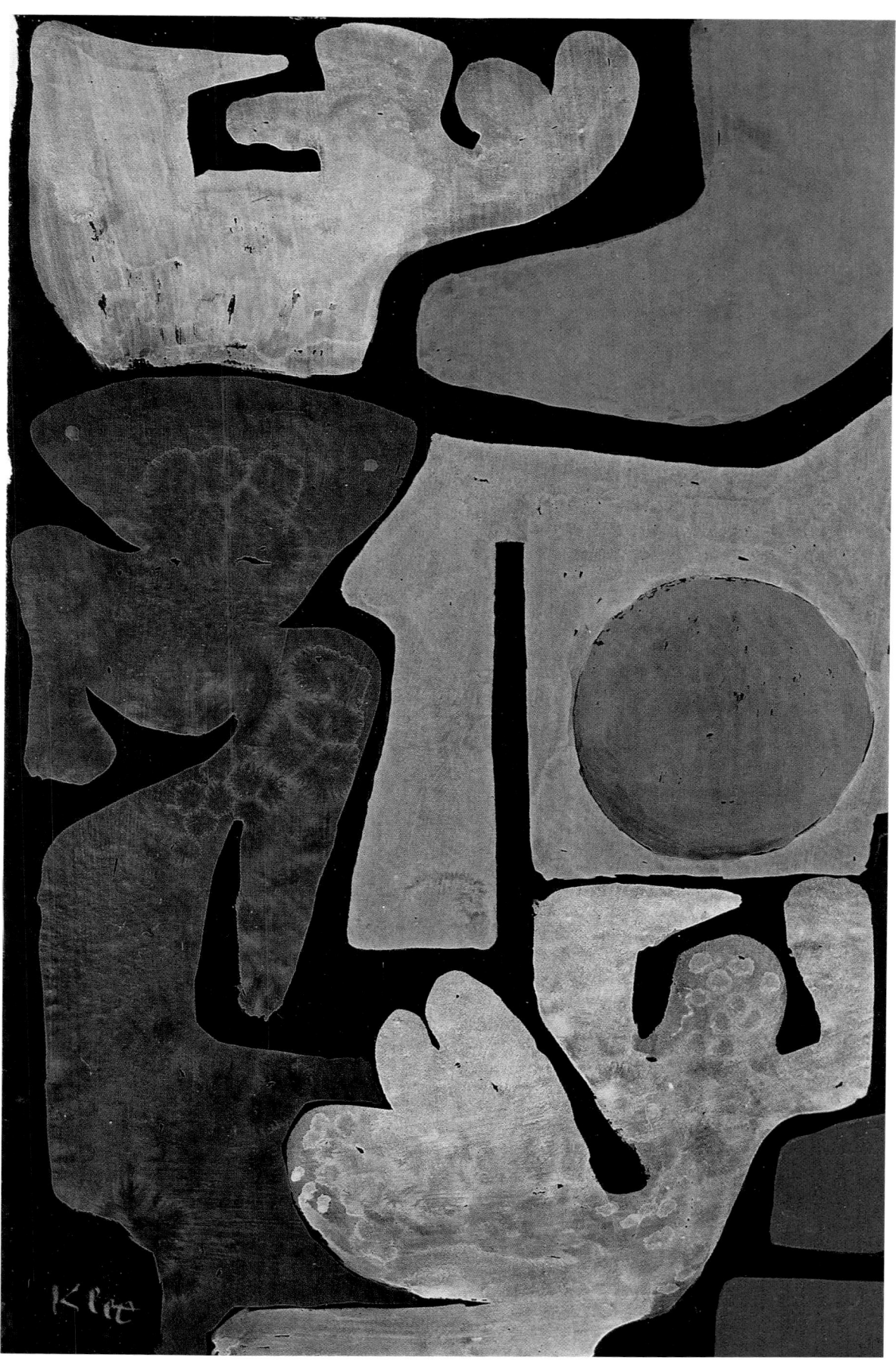

Painted 1939

BLUE-BIRD-PUMPKIN

Paste color on colored paper, 11 × 16⁷/₈″

Collection Heinz Berggruen, Paris

This work looks almost like a ceramic. Picasso would have made a plate of it, but Klee is content with a picture. Still, the brown form on the black ground does look like an oval bowl or platter. When, shortly after he moved to Weimar, Klee painted a study "for a mural," he was asked if he would accept a commission for a mural. His reply was, give it to some other artist—he must stick to his own last, which is painting pictures. He might have made the same observation in connection with *Blue-Bird-Pumpkin*.

The conception is a simple one. The light-blue forms of the bird and the pumpkin are defined with vigorous black outlines and fitted into the brown area. The work is superficially related to *Emotional Germination* of the same year, a mysterious picture in which a phenomenon of growth is reduced to a few strokes. Klee may have had something similar in mind here, for otherwise why this title? What has the bird to do with the pumpkin? Why are they blue? In earlier works we find anatomical, physiological, or biological complications of such themes, but not here. The blue bird is just a blue bird, with a black skeleton, two eyes, and a crest that looks more like a little crown. Next to it is the pumpkin with seeds, food for the bird, but the situation is fantastic, rather than realistic. The same fairytale quality is produced by the blue against the brown of the unreal landscape. Moreover, the blue has been mixed and applied in such a way that the outer edges of the brush strokes seem blue-violet, whereby the whole becomes somewhat more graduated. Klee was a poet, too, who made up his own fairytales, and this particular fairytale is a poem that harks back to the Romantic period and the style of Clemens Brentano's *Des Knaben Wunderhorn*. The simplicity with which it is told cannot be surpassed, and this is why it has a mystical quality.

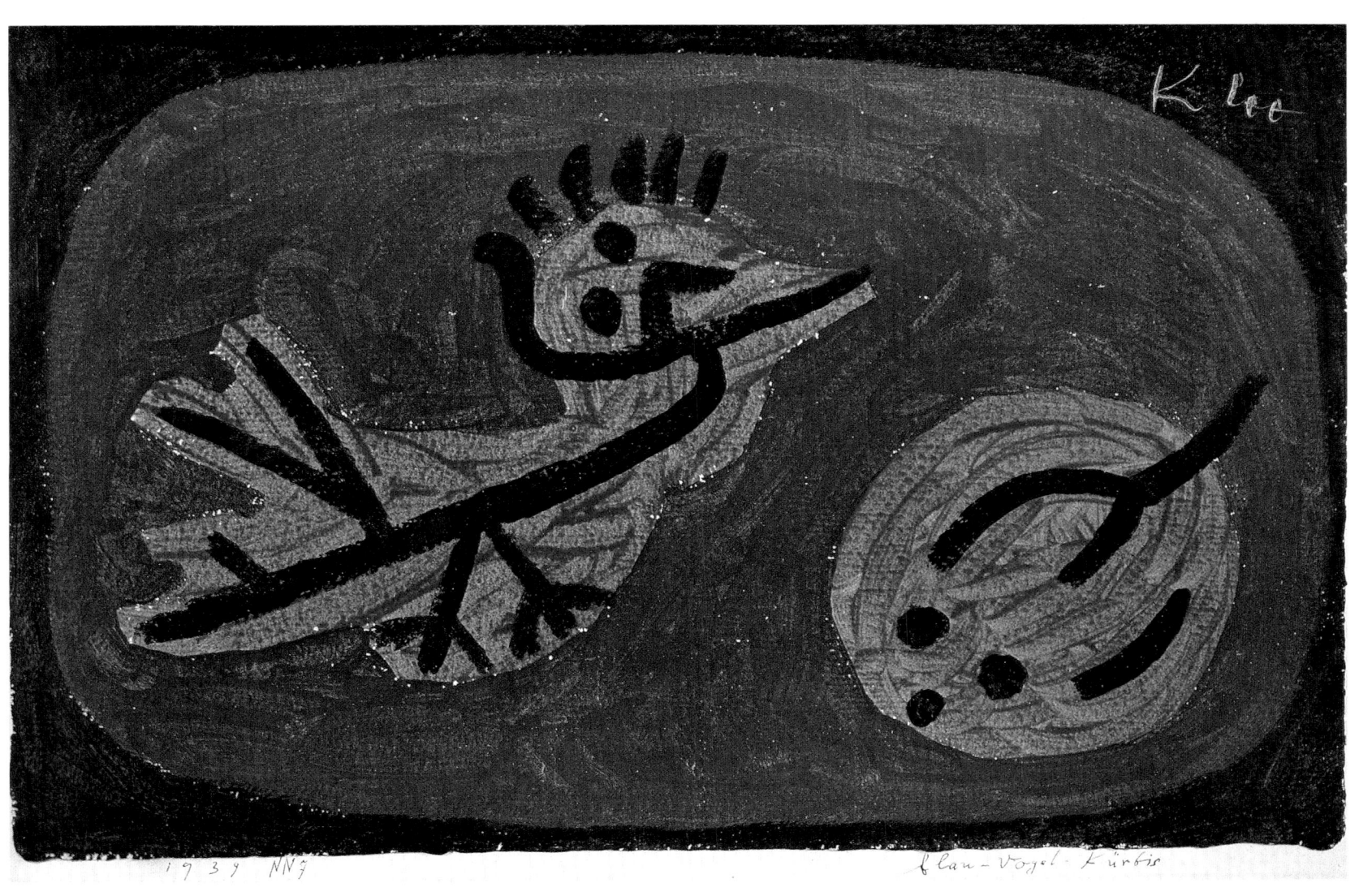

Klee

1 9 3 9 NN7 Blau-Vogel-Kürbis

Painted 1939

LOVE SONG BY THE NEW MOON

Watercolor on lined burlap, $39^3/_8 \times 27^5/_8$"

Klee Foundation, Bern

The titles alone show the change in Klee, as he invents ever more surprising combinations of situation and idea: *Love Song by the New Moon, Mephistopheles as Pallas* (1939), *Still Life on Leap Day* (1940). The world is growing darker, and the only voices Klee harkens to are Persephone's or angels'.

Love Song is an ecstatic vision, an assemblage of things being broken up and reconstituted; but the new unity is not incorporeal, for then it would elude metaphor. This figure in dirty gray-pink with a blue heart, blue eyes, and a blue mouth is a tragic metamorphosis. Is this blue the color of the new moon? The moon at top left is the same color, and opposite it is the blue curtain (the outside and the inside). Under the moon is a yellow glove; is the yellow spot at bottom right the other glove? And are the colored beads a bracelet, like the beads at the left? The lemonlike form at the bottom is the lower part of the body turned sidewise, like the breasts in the upper part of the picture. Except for the color accents in the bracelet and the spots of green, all that is not blue or yellow is dirty gray, pink-gray, and blue-gray. A song without hope of being heard, without seductiveness, a message from the world of Gaea. In his last months Klee was interested only in the darker, higher powers; pictorially speaking, he was interested only in extremes of realization, no matter what the schema employed: patchwork, Baroque exaggeration, spare signs, or the ghostly sort of grid in *La Belle Jardinière (A Biedermeier Ghost)* (fig. 47). Others of the last works take us to the domain of angels, of the numinous, of death.

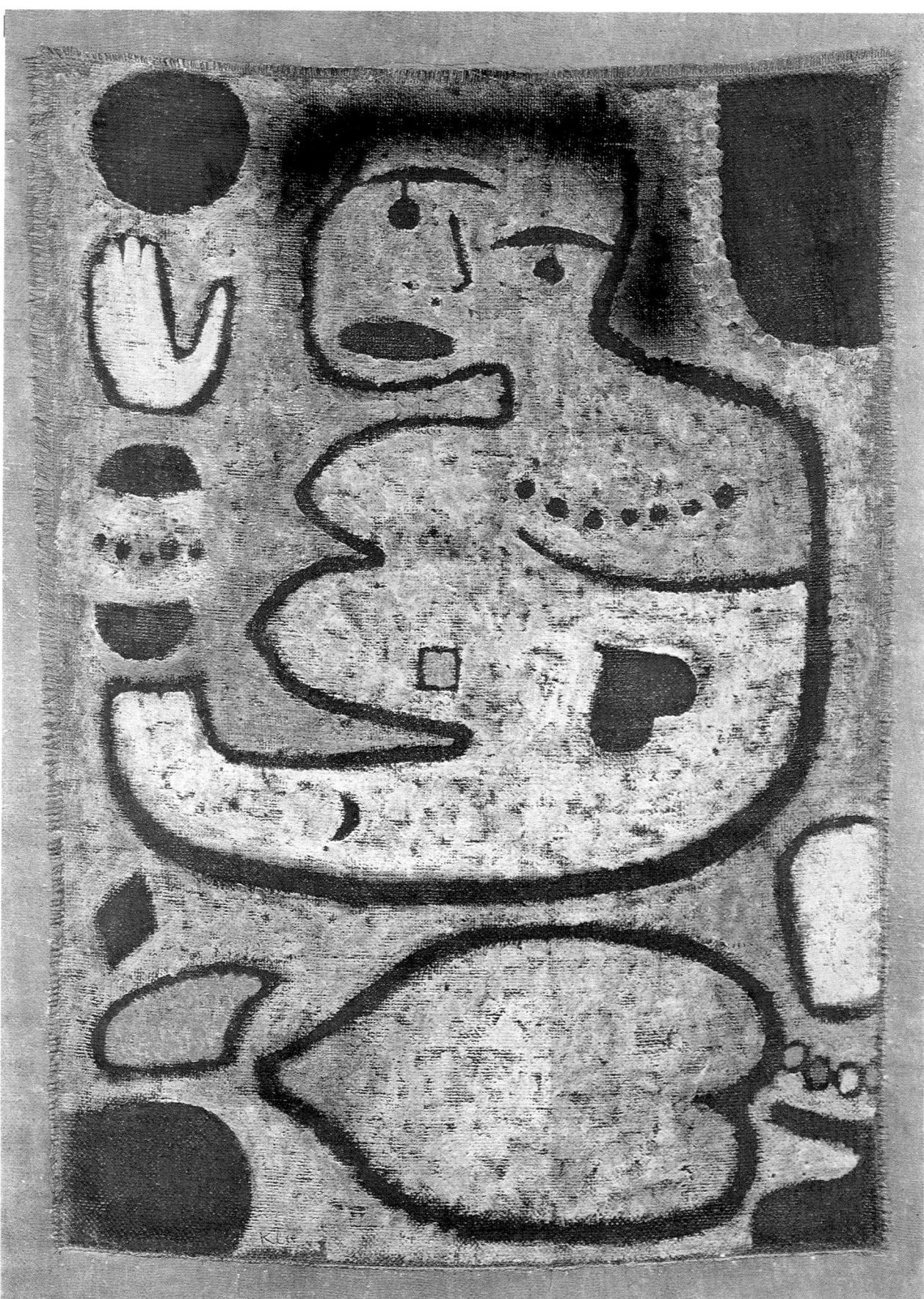

Painted 1939

EMBRACE

Paste color, watercolor, and oil on paper, $9^1/_2 \times 12^1/_4{''}$

Collection Dr. Bernhard Sprengel, Hanover

This creature reduced to a few predominantly curved lines is more symbol than living thing. The semicircular head with two black eyeholes is set on the narrow columm of the neck. The right half of the torso is visible, the left half confined to the propped-up arm. At the right is a seal which has the effect of a stamp of approval or of an exclamation point. Top left is a black heavenly body, farther down a smaller one. The bar strokes are applied with a dry brush in black, so that differentiations are produced in the thick lines, thereby creating movement in themselves.

A fearful figure, this "embrace." Who is being embraced, by whom? Is this threatening being a goddess of death from the archaic Greek, a sort of Persephone, the wife of Hades? Is it a conceptual picture like *Fear* (1934)? In treatment it comes closest to *A Face Also of the Body* (1939), where the theme is similarly reduced to a few bar strokes and the head contains nothing but eyes. Both figures are of the same family, a family from the kingdom of the dead. The picture shown here is the more nearly classical of the two. There is dignity, after all, in an encirclement, an embrace, even in death's embrace.

The pale, whitish blue and the pale brown colors, with the cloud of more intense brown around the head, around the heavenly body, and at the bottom of the picture, are solemn, grandiose, entirely in keeping with this symbol of death.

In his last years Klee created several such ultimate works, which have something disquieting about them. Presentiments of death, we must think, when alongside this picture we place a work like *Oppressive Message*. We are witnessing the last act of the drama.

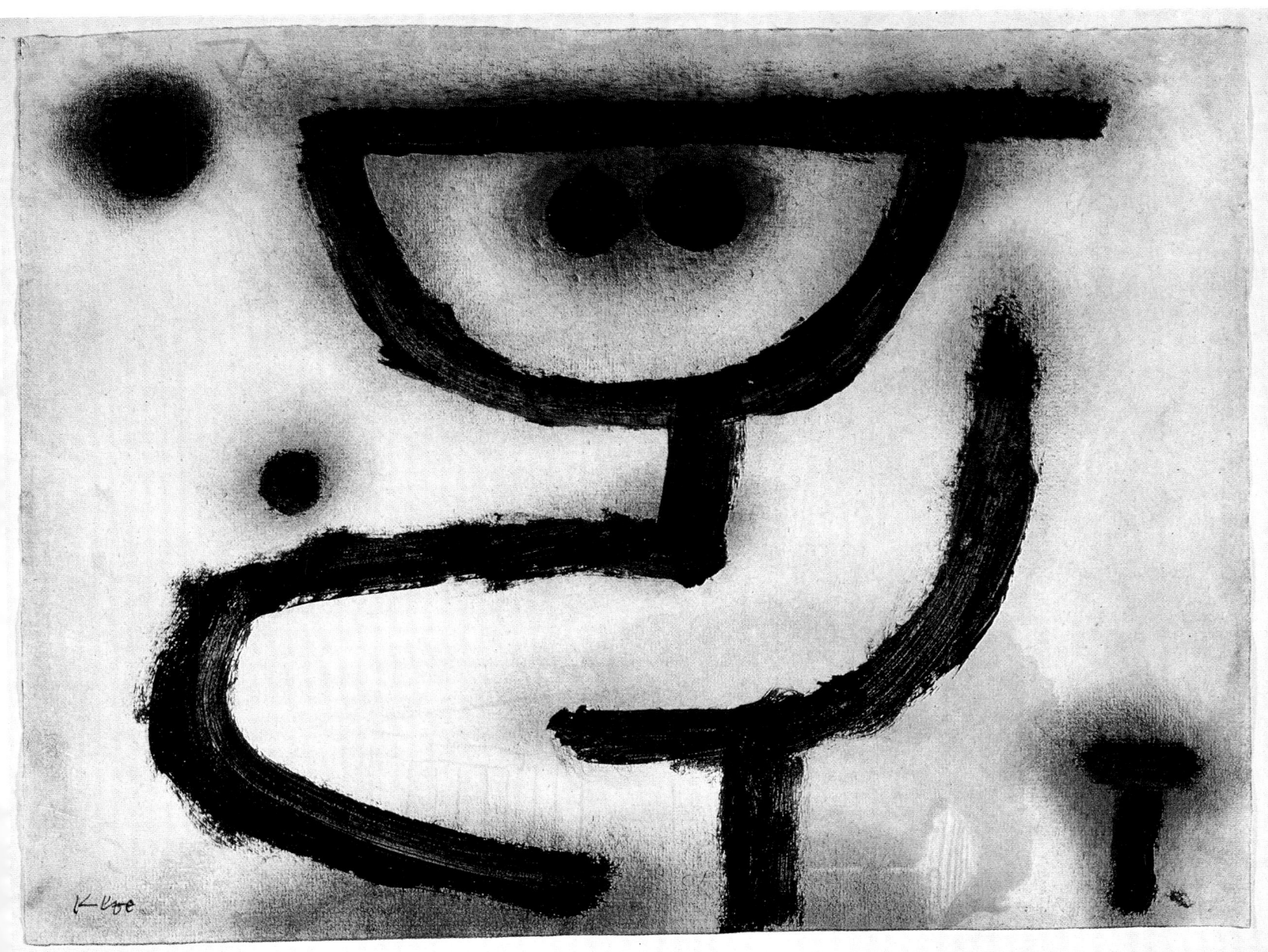

Klee

1939 JK 1 Umgriff

Painted 1940

ROCK FLORA

Oil and tempera on burlap, 35³/₈ × 27⁵/₈"

Kunstmuseum, Bern

One of Klee's last works, a *Rock Flora*. The theme is growth, with plants, flowers, and fruit treated in hieroglyphic abridgment. Many of the signs that here stand for budding life are familiar to us from earlier works: the key in the picture *Broken Key* (1938), for instance.

Here, the growth lies in the imperceptible movements the signs make. Ground and pattern form a continuous tapestry of straight and round bar strokes, behind which one feels the process of life. At the bottom are buds and shoots, in the middle a nine-petaled flower, at the two upper corners growing fruit with seven dots representing seeds. Between the fruit growing upward is a flaring form which, attached to the fruit at upper left, extends upward and cuts across the stem of the nine-petaled flower. A carefully worked out pattern unfolds before us, spreading in every direction, an interlocking of flexible forms for bud, flower, and fruit, rhythmically linked so as to produce an almost overpowering, polyrhythmic structure.

The bar strokes are dark green and are surrounded by areas of carmine red which show through the ground like the brighter areas in *Park near L.* The pattern rests against a ground of both dark and light colors: violets and violet-reds, pinks and oranges, with an occasional touch of yellow to complete the color scheme. The carmine red of the flower is repeated at a few places as an accent and contributes to the rhythmic order of the whole. Whether the darker areas are gullies or depths, and the brighter areas patches of rock in sunshine, is hard to say; presumably, such an interpretation would be too naturalistic. What Klee was concerned with was the pattern against a ground, ranging in color from yellow to pink and dark violet; *Rock Flora* becomes a metaphor. "This is now my Matterhorn," as Klee put it one day during his illness, referring to the slight uphill slope of the Kistlerweg where his apartment was located. Everything is at once real and dreamlike, one last sunrise over the Swiss mountains.

GLASS FAÇADE

Crayon on burlap, 27⁵/₈ × 37³/₈"

Klee Foundation, Bern

This picture stands between *Kettledrummer* and *Death and Fire*, presumably designed to suggest a stained-glass window such as we find in cathedrals. If so, this would be another part of the Requiem Klee composed for himself in the last years. It brings to mind at first the "magic squares" with their supernatural connotations, which are entirely rooted in meditation. But in this colorful painting with its dominant reds there is something else, something over and above the hellish reds of the death pictures and the "Wood Louse" series, yet which does not even remotely refer to any object.

We believe this work becomes more understandable once it is placed in the sequence of the death pictures. However, to begin with, *Glass Façade* is a kind of fugue, with its rectangles and triangles in cinnabar red, emerald green, royal blue, and related tones such as violet-blue—a fugue whose themes are repeated, reversed, and given other developments. This is the sort of fugue composers of the Romantic era liked to provide as a high point in concluding an extended work. Certainly this picture represents a high point in Klee's work just before it came to an end. It leads naturally and without strain to the sphere of religion, while yet remaining perfectly pictorial—just as the second part of *Faust* remains perfectly poetic. Klee had no need of any "conversion" before his death—so far as being religious goes, he was religious in the same sense Goethe was. The boundary was crossed when the concept of self-transformation pointed beyond itself at this stage, became eschatological.

The above applies to all the late pictures, even those with such different themes as *Woman in Native Costume* (with its thick leadings) and *Kettledrummer* (fig. 48), where the color red defines the painter's spiritual homeland.

Of course, Klee would never have called this a cathedral window, still less have regarded it as a model for such a window. He remained to the last a painter of easel pictures: the 1922 work, *Mural for Temple of Desire*, was not a mural, either. Then he had availed himself of arrows, ideas as intermediaries between the earth and the universe: "The longer the journey, the more one feels the tragedy of having to become movement without already being movement. . . . Never quite to get there, where there is movement without end! The discovery that where there is a beginning, there is never infinity." Now that all this is behind him, the tensions resolve themselves into harmonies, rendered through color rather than through the checkerboard schema. As is often the case, the title confirms this conjecture: *Glass Façade*, i. e., transparency, a glimpse into the ultimate mysteries.

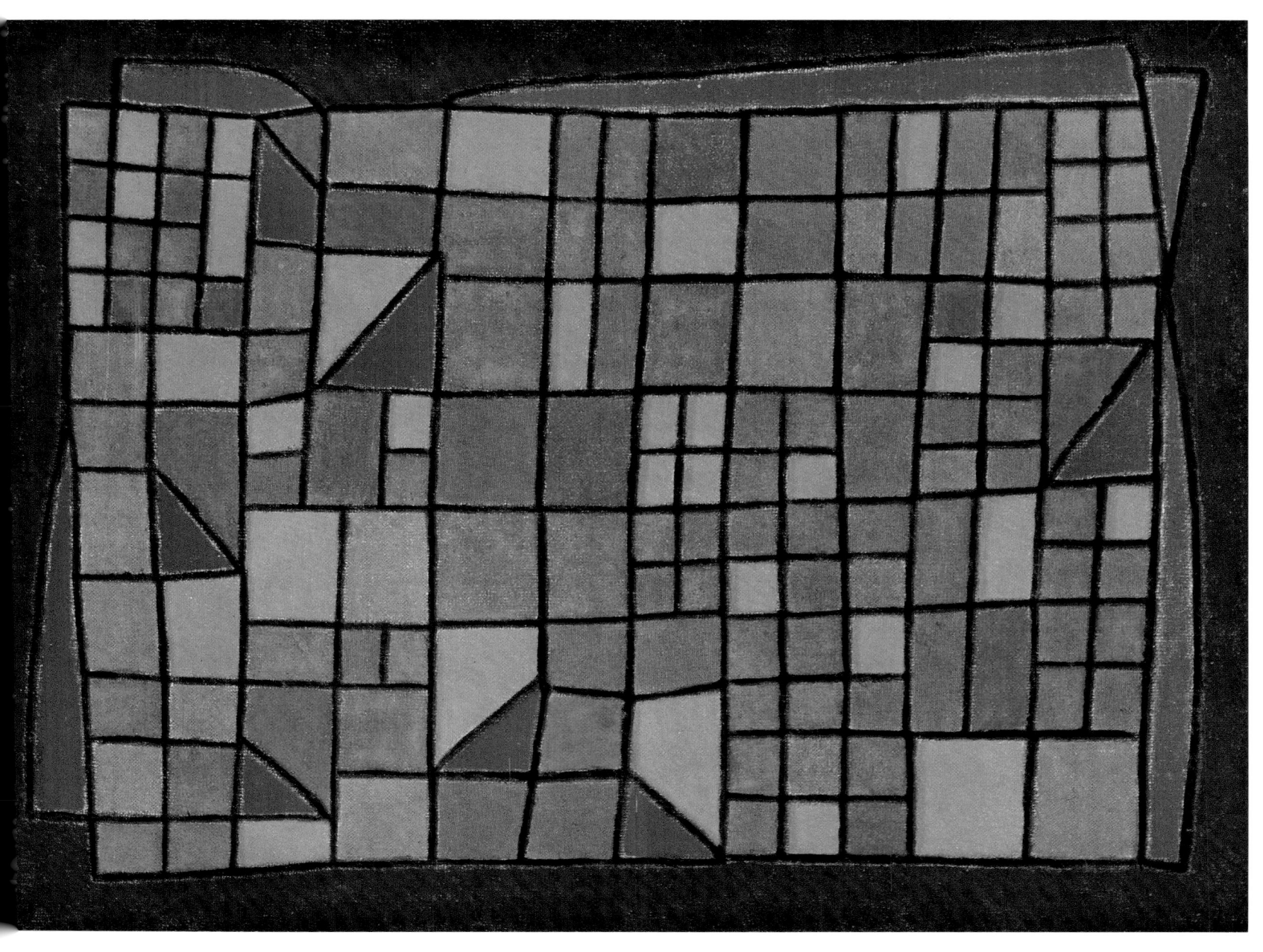

Painted 1940

CAPTIVE

Oil on burlap, 18⁷/₈ × 17³/₈″

Collection Mr. and Mrs. Frederick Zimmerman, New York, N. Y.

We don't know whether Klee regarded this work as finished, but it looks finished. The fact that it is unsigned does not mean much, since the last, certainly completed *Still Life* is also unsigned and undated. *Captive* belongs to the same group as *Death and Fire*, with the bluish-white skull on glowing dark red, in which the Ferryman is carrying the dead across the (blue) Acheron.

In *Captive*, blue obtrudes itself as the only color, the bar strokes are black, and the brown border recedes. The crux here is the unhappy figure outlined in black and the grid in which it is entangled. This last brings to mind the *Wood Louse in Enclosure* and the animals in *Enclosure for Pachyderm*. But why is the figuration blue, a deep blue touched with whitish blue? What has death to do with blue—for there can be no doubt that the figure with the U-curved eyes represents someone dead, someone who has already passed beyond. We associate death with fire and the color red, but we have often seen that Klee's pictorial means can be ambivalent. *Arctic Thaw* (1920), a polar landscape, and *Tropical Garden* (1919) are constructed to this very schema and in the same colors. In Klee, this choice of means is determined neither by the theme nor by expressive considerations; the whole, in which all opposites and contradictions are resolved, is Klee's only world.

For him, death is not only the one, but also the other, and who can say how much more besides in the eyes of this Western sage? For the crystalline being that Klee had vaguely in mind even in his early years as the goal of his development, there was no single ending, once and for all. Life and death were relative ideas, to him, and death is at once the end and the beginning. This "captive" is not old but young, his identification not quite complete, for who can interpret the signs at bottom left? The hieroglyphs of trees on the left could just as well be hieroglyphs of the Cross, life and death in perfect ambivalence, split into contradictory contents. The blue with its icy highlights becomes as understandable as the red in *Death and Fire*, but the work as a whole is no less a metaphor than the picture of the Ferryman transporting the dead into another kingdom.

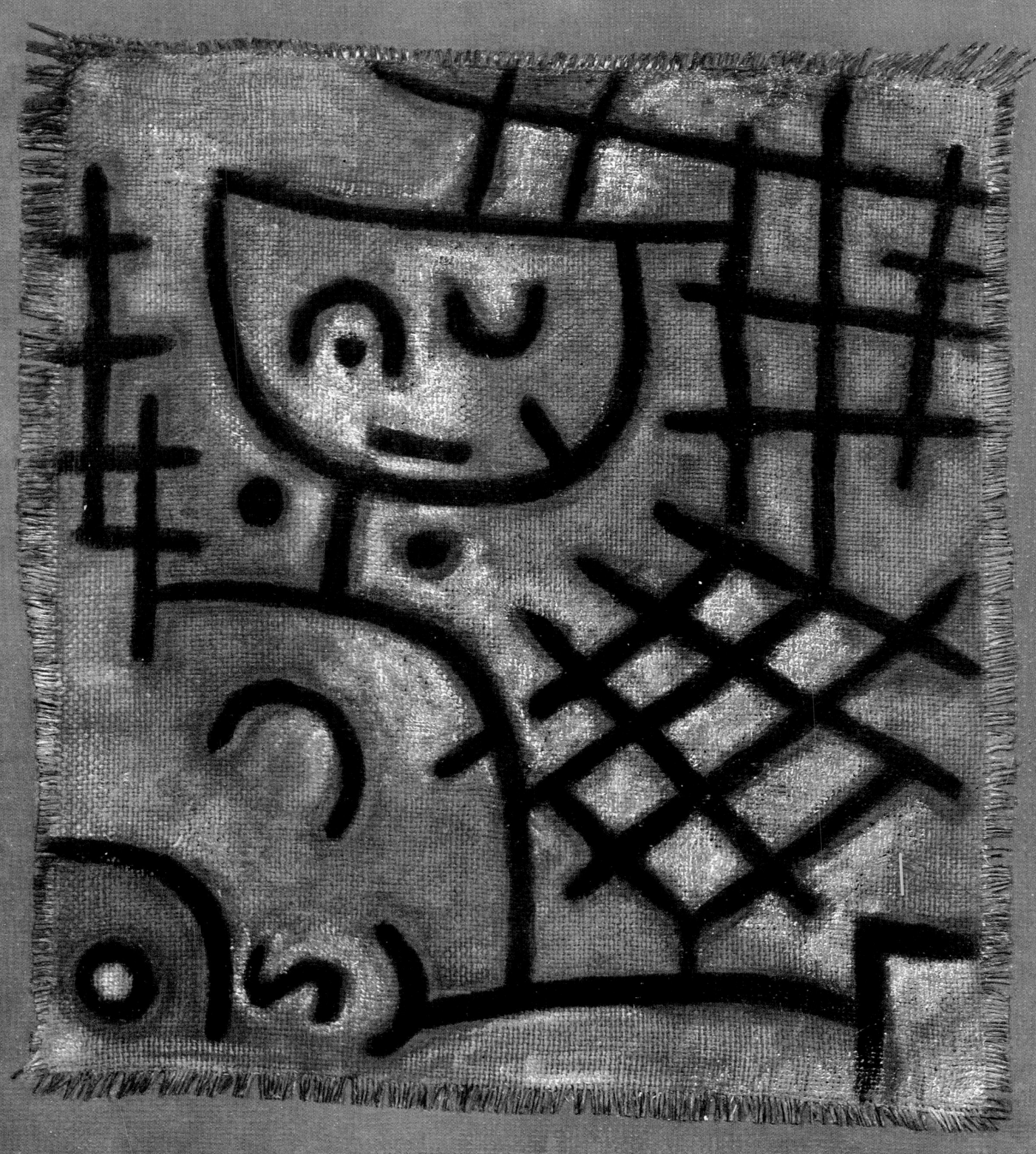

BIOGRAPHICAL OUTLINE

1879 Born December 18 at Münchenbuchsee near Bern. His father, Hans Klee (1849–1940) is a music teacher at the Cantonal School for Teachers; his mother, Ida Maria Frick (1855–1921), is a native of Basel who had studied music at the Stuttgart Conservatory.

1886 Primary school in Bern.

1890 Preparatory school *(Progymnasium)*. Plays violin as a supernumerary in the municipal orchestra of Bern.

1898 Graduates from Literarschule *(Gymnasium)* in Bern. Goes to Munich and studies with Knirr and, at the Academy, with Stuck. Attends lectures on anatomy and art history, concerts, and operas.

1901–2 Travels to Italy with the sculptor Hermann Haller: on June 30 from Munich via Bern to Milan and Genoa; in Rome on October 27; Naples at Easter, 1902; back in Bern on May 7, 1902. Works little, but assimilates a great deal.

1902 Becomes engaged to pianist Lily Stumpf in Munich.

1902–6 Bern. Paintings, drawings, and ten etched "Inventions" exhibited in the Munich Secession in 1906. Plays violin at home, reads a great deal (E.T.A. Hoffmann, Poe, Gogol, Baudelaire, Cervantes, Rabelais, Goethe's *Elective Affinities*, and Latin and Greek authors). During visits to Munich, sees engravings by William Blake and Goya in the Print Room of the Pinakothek.

1905 Trip to Paris with his friends Hans Bloesch and Louis Moilliet (May 31–June 13). Sees works by Leonardo, Rembrandt, and Goya in The Louvre. No contact with contemporary painters.

1905–6 Twenty-six drawings and watercolors on glass.

1906 Brief trip to Berlin; visits Centennial Exhibition and the Kaiser-Friedrich Museum. Marries Lily Stumpf, and in October settles in Munich.

1907 November 30, birth of his son Felix.

1908 Attends two Van Gogh exhibitions and a Marées exhibition in Munich.

1909 Cézanne exhibition at the Munich Secession, Matisse exhibition at the Thannhauser Gallery.

1910 Fifty-six works shown at the Bern Museum and later in Basel, Zurich, and Winterthur.

1911 One-man show at the Thannhauser Gallery. Contact with the Blaue Reiter group. Meets Kubin, Kandinsky, Jawlensky, Macke, Marc, Campendonc, Werefkin, Münter.

1912 Meets Carossa, Rilke, Meier-Graefe, Walden. Works by him included in the second Blaue Reiter exhibition. Attends Futurist exhibition at the Thannhauser Gallery. Second trip to Paris, April 2–18, visits Delaunay, Kahnweiler, Uhde; sees pictures by Picasso, Braque, Rousseau. Translates essay by Delaunay.

1913 Works by Klee shown in *Der Sturm* exhibition and in the First German Herbstsalon.

1914 Trip to Tunisia with Moilliet and Macke, April 5–22. Discovers color.

1916–18 Military service in the German army, garrison and transportation unit. Romantic watercolors.

1918 *Der Sturm* picture book with fifteen drawings by Klee.

1919 Fairly large number of oil paintings. Long sojourn in Switzerland. Contract with the Goltz Gallery in Munich for three years, later extended to 1925.

1920 Exhibition at the Goltz Gallery of 362 works; the illustrated catalogue is published as a special issue of the magazine *Ararat*. Erich Reiss in Berlin publishes *Schöpferische Konfession*, including an essay by Klee. Kurt Wolff in Munich publishes Voltaire's *Candide* with twenty-six pen drawings by Klee. November 25, appointed to the faculty of the Bauhaus in Weimar.

1921 Moves to Weimar in January. His family follows him in the fall.

1923 Bauhaus exhibition and festival. Klee's essay, "Ways of Studying Nature," published in the *Bauhaus-Buch*. Summer vacation on the island of Baltrum. "Magic squares," grid pictures, theater pictures. Exhibition at the Kronprinzenpalais, Berlin.

1924 First Klee exhibition in America (Société Anonyme, New York). Founding of *Die Blaue Vier* with Kandinsky, Klee, Feininger, Jawlensky. Léon-Paul Fargue visits Klee in Weimar. Summer vacation in Sicily. Lecture on modern art at the Jena Kunstverein. In December, Bauhaus at Weimar closes.

1925 The Bauhaus moves to Dessau. Publication of the *Pedagogical Sketchbook*. Works by Klee shown at the Surrealist exhibition in Paris. First one-man show of his works in Paris (Galerie Vavin-Raspail).

1926 In July, moves with family to Dessau. Summer in Italy (Elba, Florence, Pisa, Ravenna). "Parallel figurations."

1927 Summer in Corsica and the Île de Porquerolles.

1928 Summer in Brittany. Visit to Egypt from December 17, 1928, to January 17, 1929.

1929 Klee's fiftieth birthday marked by a one-man show at the Flechtheim Gallery in Berlin. Egyptian pictures and three-dimensional studies.

1930 Klee exhibition at the Museum of Modern Art, New York. Birthday exhibitions also in Dresden, Düsseldorf, Saarbrücken. Summer trip to the Engadine and to Viareggio. Divisionist pictures.

1931 Named professor at the Düsseldorf Akademie as of April 1. Exhibition at the Düsseldorf Kunstverein. Trip to Sicily.

1932 Summer in northern Italy.

1933 Summer in southern France. Dismissed by the Nazi regime. Moves to Bern in December.

1934 First Klee exhibition in England (Mayor Gallery, London). D.-H. Kahnweiler becomes his dealer.

1935 Important exhibition at the Kunsthalle, Bern, and in Basel. Beginning of his fatal illness.

1936 Summer in Switzerland, at Tarasp and Montana. Exhibition in Lucerne.

1937 Picasso, Braque, and Kirchner visit Klee in Bern. Summer at Ascona. Seventeen of Klee's works included in the Nazi exhibition of "Degenerate Art" in Munich. First bar stroke pictures and tragic-demonic figures, pastels.

1938 Bauhaus exhibition in New York. Klee exhibitions at Buchholz (Curt Valentin) and Nierendorf Galleries, New York, and at the Simon (Kahnweiler) and Carré Galleries in Paris. Seven large panel pictures.

1939 Visits the Prado exhibition in Geneva. Autumn on Lake of Morat. "Angel" series (28 in 1939, 4 in 1940). Pictures reflecting a premonition of death.

1940 Major exhibition at the Zurich Kunsthaus in February. Last work. Klee paints his own "Requiem." On May 10 goes to a sanatorium in Orselina-Locarno, then to the Sant'-Agnese Clinic at Muralto, where he dies on June 29. Memorial service at the Bürgerspital, Bern, on July 4. In 1942 his ashes interred in the Schosshalden cemetery, Bern.

SELECTED BIBLIOGRAPHY

WRITINGS BY PAUL KLEE

"Die Ausstellung des modernen Bundes im Kunsthaus Zürich." Review in *Die Alpen* (August 1912), Bern.

"Über das Licht," in *Der Sturm* (January 1913), Berlin. (Translation of an essay by Delaunay.)

"Kunst macht sichtbar . . ." in *Schöpferische Konfession*, Berlin, 1920. Translated as "Creative Credo" in *The Inward Vision: Watercolors, Drawings, Writings by Paul Klee*. New York, 1958.

"Wege des Naturstudiums," in *Staatliches Bauhaus in Weimar, 1919-1923*. Weimar, 1923.

Pädagogisches Skizzenbuch. Munich, 1925. English translation: *Pedagogical Sketchbook*. New York, 1944 and 1953.

"Exakter Versuch im Bereich der Kunst," in *Bauhaus*, vol. 2 (1928), Dessau.

Über die moderne Kunst. Lecture at Jena, 1924. Bern-Bümplitz, 1945. English translation: *On Modern Art*. London, 1948.

Das bildnerische Denken. Edited by Jürg Spiller. Basel, 1956. English translation: *The Thinking Eye: The Notebooks of Paul Klee*. New York, 1961.

Tagebücher 1898-1918. Edited by Felix Klee. Cologne, 1957. English translation: *The Diaries of Paul Klee, 1898-1918*. Berkeley, California, 1964.

Paul Klee: Leben und Werk in Dokumenten. Edited by Felix Klee. Zurich, 1960. English translation: *Paul Klee: His Life and Work in Documents*. New York, 1962.

Gedichte. Edited by Felix Klee. Zurich, 1960.

GRAPHIC WORK AND BOOKS ILLUSTRATED BY KLEE

"Sema"-Vereinigung. Munich, 1913. One lithograph.

Zeit-Echo, vol. I. Munich, 1914-15. One lithograph.

Expressionismus. Edited by H. Walden. Museum edition. Berlin, 1918. One etching.

Das Kestnerbuch. Hanover, 1919. One lithograph.

Münchner Blätter für Dichtung und Graphik. Munich, 1919. Five lithographs.

Die Schaffenden, portofolio I. Weimar, 1919. One etching.

Die Freude. Burg Lauenstein, 1920. One hand-colored lithograph.

PFISTER, K. *Deutsche Graphiker der Gegenwart*. Leipzig, 1920. One lithograph.

VOLTAIRE. *Kandide, oder Die beste Welt*. Munich, 1920. Twenty-six drawings.

CORRINTH, CURT. *Potsdamer Platz*. Munich, 1920. Ten photolithographs.

Neue europäische Graphik, portfolio I. Weimar, 1921. Two lithographs.

TZARA, TRISTAN. *L'Homme approximatif*. Paris, 1931. One etching in special edition.

NOVALIS (Friedrich von Hardenberg). *The Novices of Saïs*. New York, 1949. Sixty drawings.

GENERAL WORKS

HAFTMANN, W. *Painting in the Twentieth Century*. New York, 1965.

MYERS, B. S. *The German Expressionists: A Generation in Revolt*. New York, 1957.

NEWTON, E. *The Romantic Rebellion*. New York, 1962.

RAYNAL, M. *Modern Painting*. Lausanne, 1956.

MONOGRAPHS

BERNOULLI, R. *Mein Weg zu Klee*. Bern, 1940.

BLOESCH, H. and G. SCHMIDT. *Paul Klee: Reden bei seiner Totenfeier*. Bern, 1940.

COOPER, D. *Paul Klee*. Harmondsworth, England, 1949.

COURTHION, P. *Klee*. Paris, 1953.

GEIST, H. F. *Paul Klee*. Hamburg, 1948.

GIEDION-WELCKER, C. *Paul Klee*. New York, 1952.

GROHMANN, W. *Paul Klee*. Paris, 1929. Texts by Aragon, Eluard, etc.

———. *The Drawings of Paul Klee (1921-1930)*. New York, 1944.

———. *Paul Klee*. New York, 1954.

———. *Paul Klee*. New York, 1959. (Unesco Art Series.)

———. *Paul Klee: Drawings*. New York, 1960.

HAFTMANN, W. *The Mind and Work of Paul Klee*. New York, 1954.

———. *The Inward Vision: Watercolors, Drawings, Writings by Paul Klee*. New York, 1958.

HAUSENSTEIN, W. *Kairuan, oder Eine Geschichte vom Maler Klee und von der Kunst dieses Zeitalters*. Munich, 1921.

HUGGLER, M. (ed.). *Paul Klee. Dokumente in Bildern*. First part (1896-1930), Bern, 1949. Second part (1930-1940), Bern, 1960.

HULTON, N. *An Approach to Paul Klee*. New York, 1956.

NIERENDORF, K. *Paul Klee*. New York, 1941.

READ, H. *Klee*. London, 1948.

SAN LAZZARO, G. DI. *Paul Klee*. New York, 1959.

SOBY, J. T. *The Prints of Paul Klee*. New York, 1945.

ZAHN, L. *Paul Klee*. Potsdam, 1920.

CATALOGUES

Basel: *Paul Klee*. Galerie Beyeler. 1965.

———: *Paul Klee: Late Works*. Galerie Beyeler. 1965.

Berlin: *Nachlass Paul Klee, aus dem Besitz von Felix Klee*. Akademie der Künste. 1961.

Bern: *Paul Klee*. Exhibition in association with the Paul Klee Foundation. Kunstmuseum. 1956.

Düsseldorf: *Paul Klee*. North Rhine–Westphalia State Collection. 1960.

New York: *Paul Klee 1879–1940: A Retrospective Exhibition*. The Solomon R. Guggenheim Museum, New York. 1967.

Tokyo: *Paul Klee*. Exhibition at the Seibu Warehouse. Introduction by M. Huggler. Text and commentaries by S. Takigushi. 1961.

PHOTO CREDITS

Spreng, Basel 7, 22, 30
Gnilka, Berlin 23, 35
Bruno Schuch, Berlin 36
Kurt Blum, Bern 57, 61, 65
Martin Hesse, Bern 56
Hans Wagner, Hanover 28
Buchholz Gallery, New York 33, 40, 81, 84
Walter Rosenblum, New York 9
John D. Schiff, New York 24, 64, 76
Solomon R. Guggenheim Museum, New York 63
Adolph Studly, New York 38, 58
Max Bill, Zurich 82
Conzett & Huber, Zurich 50, 72

*All other photos were provided by Felix Klee, Bern,
and by the author.*